Selfie
Aesthetics

Selfie
Aesthetics

DUKE UNIVERSITY PRESS *Durham and London* 2022

Seeing Trans Feminist Futures

in Self-Representational Art

Nicole Erin Morse

© 2022 Duke University Press. All rights reserved
Printed and bound by CPI Group (UK) Ltd, Croydon, CR0 4YY
Design collaboration by A. Mattson Gallagher
and Courtney Leigh Richardson. Typeset in Minion Pro
and Helvetica Neue by Copperline Book Services

Library of Congress Cataloging-in-Publication Data
Names: Morse, Nicole Erin, [date] author.
Title: Selfie aesthetics : seeing trans feminist futures in
self-representational art / Nicole Erin Morse.
Description: Durham : Duke University Press, 2022. |
Includes bibliographical references and index.
Identifiers: LCCN 2021039223 (print)
LCCN 2021039224 (ebook)
ISBN 9781478015512 (hardcover)
ISBN 9781478018148 (paperback)
ISBN 9781478022756 (ebook)
Subjects: LCSH: Selfies (Photography)—Social aspects. |
Portrait photography—Social aspects. | Portrait photography—
Political aspects. | Self-presentation in art. | Transgender people
in art. | Transgender artists. | Transgender women. | Feminism
in art. | BISAC: PHOTOGRAPHY / Criticism | SOCIAL SCIENCE /
Media Studies
Classification: LCC TR575 .M59 2022 (print) |
LCC TR575 (ebook) | DDC 770—dc23/eng/20211012
LC record available at https://lccn.loc.gov/2021039223
LC ebook record available at https://lccn.loc.gov/2021039224

Cover art: Instagram selfie, Tourmaline Productions.
Courtesy the artist.

Contents

In a pool of water we could find or lose ourselves. Our reflections look back at us. And beneath the reflective surface are the dark and unknowable depths of the water. In the myth of Narcissus, the young man does not recognize himself and, as a result, wastes away by the pool desperately in love with this being he found in the waters. Today, this myth seems to be inescapably present, referenced in countless conversations about selfies—these ubiquitous and ephemeral digital self-portraits.

Yet in some ways it's surprising that this myth has become such a prominent allegory for selfie culture, since there are in fact stark distinctions between Narcissus and selfie creators.[1] Narcissus doesn't recognize his own image, discovered by chance, while selfie creators knowingly craft self-representation. The myth describes a closed loop between Narcissus and his reflection, unaware that they are being observed by the helpless Echo. This solipsistic circuit between self and image seems to exclude all others. By contrast, selfies are often created to be shared. The problem isn't just that the Narcissus myth doesn't accurately capture how selfies connect creators and viewers; because the myth links selfies to narcissism, it also metonymically connects selfies with negative conceptions of effeminacy, queerness, and femininity. I suggest that the myth of Narcissus beside the pool falls short of describing, allegorically, the context, situation, and social relations at the heart of selfie production and selfie viewership. Rather than shoring up and preserving an agential, autonomous, and even narcissistic self, I argue selfies can make us vulnerable to others and impose ethical demands on us.

To better understand what selfies can say, as well as how their meanings are constructed through collaborations between creators and viewers, I suggest that we begin by turning to a different story about a reflection seen by chance. Recall how Frankenstein's monster encounters their image in the pool of water near the woods by the cottage they have begun to see as their desired community. Unlike Narcissus, the monster is self-aware, quickly rec-

ognizing that this image is their own reflection. They muse upon this image and what it means for their interactions with others. For the monster, this moment of self-recognition is also the beginning of a project of self-fashioning, as they consider what they must do to counteract the fear that they worry they will inspire in others. In this case, what matters is not just the monster's relation to themself, but, crucially, how they will be looked at and seen by others. The monster tells us: "I had admired the perfect forms of my cottagers—their grace, beauty, and delicate complexions; but how was I terrified when I viewed myself in a transparent pool! At first I started back, unable to believe that it was indeed I who was reflected in the mirror; and when I became fully convinced that I was in reality the monster that I am, I was filled with the bitterest sensations of despondence and mortification."[2] For the monster, this encounter with reflection isn't a closed loop, cut off from society, self-knowledge, and the flow of time. Instead, it is a devastating instant of intense self-awareness and comparison of self to other, an experience that inspires their efforts to master human language in the hopes of connecting with others, despite their frightening appearance. As readers, we are invited to sympathize with the monster's tragic fate. However, we are never explicitly asked to imagine any outcome in which those others might be asked—or might become able—to see the monster with compassion and solidarity.

I don't think either of these tales captures what I want to know about selfies, but they do encapsulate how selfies are frequently understood. Narrated through the Narcissus myth, self-imaging is implicitly punished with death, and even outside of this particular mythicization, selfies are routinely dismissed and stigmatized as frivolous, dangerous, and abhorrent. Meanwhile, *Frankenstein* explores how self-imaging is connected to self-knowledge, but the encounter is charged with pain because of the potential and actual attitudes of others. Despite the empirical popularity of selfies, which suggests that many people love taking and looking at selfies, cultural attitudes toward selfies are fraught with judgment and anxiety.[3] When I have shared that I am writing a book about selfies, many people tell me that they simply don't take selfies because they can't handle their own negative judgments of their appearance. For those who do take selfies, there's often social pressure to express embarrassment and deny pleasure, especially in the face of negative comments from others. Meanwhile, some people claim proudly that they don't take selfies and then show me their camera rolls to prove it—but their phones are full of images of themselves (and often their children) that they captured with front-facing smartphone cameras. Somehow these private

family portraits don't quite feel like selfies to them, perhaps because selfies are assumed to be solitary and starkly exhibitionist. Even more emphatically, many people are insistent that they are annoyed, and even disgusted, by encountering selfies taken by others. In these anecdotal accounts, seeing others' selfies is almost more disturbing than taking selfies. Selfies—and people's responses to them—are profoundly shaped by the fact that selfies are associated with narcissism and, by extension, with effeminacy and femininity.[4]

The stories we tell about selfies reinforce that there is something feminized, embarrassing, and even repulsive about the entire process of taking, sharing, and seeing selfies. Pro-selfie responses to the dominant discourse, however, often preserve the Narcissus myth while simply refusing the negative connotations associated with narcissism. For example, the media scholar Greg Goldberg draws on queer negativity to suggest that selfie narcissism offers an opportunity to interrogate and reject queerphobia.[5] Meanwhile, feminist selfie scholarship has tended to focus on selfies by young, cisgender white women, frequently arguing that these selfie creators perform critical political work through embracing narcissism. This reversal isn't fully satisfying to me, however. For one, it sidesteps the very real problems of narcissism as a psychological disorder, involving "an impaired ability to recognize the feelings and needs of others and pathological personality traits like antagonism, grandiosity and attention seeking."[6] More important, it pretends that the issue is whether narcissism is good or bad and, as a result, avoids examining the larger context in which people with power wield the charge of selfie narcissism against those with less power, especially those who are feminized (e.g., young people, women, and queer and trans people). As Katrin Tiidenberg argues, the "moral panic" about selfie narcissism is actually a strategic response by privileged groups "worried about the stability of their privilege."[7] Ultimately, what feminist selfie scholars seem to value isn't narcissism per se but, rather, self-esteem or self-love.[8] And it isn't just cis women who find self-love in selfies; many trans women have told me that the practice of taking selfies is a critical part of their experience of becoming who they want to be and coming to love the person they see.

However, a narrative of self-empowerment is neither the beginning nor the end of the story, because when selfies are shared, they are addressed to audiences. In the Narcissus myth and in Shelley's *Frankenstein*, we get glimpses of these audiences—the lovelorn nymph Echo, for example, or the community that Frankenstein's monster wanted to join. Strikingly, however, when the Narcissus myth is used to understand selfies, Echo is never discussed, although she is there as a silent witness, beside the pool. And as I

mentioned earlier, my alternative mythmaking through *Frankenstein* captures only the tragedy that those around the monster will never see beyond the surface. Selfies, however, are not just self-contained images; like photographs, they are also networks of social relations.[9] As such, selfies pose questions to their viewers about how we are going to participate in this encounter with others, with the image, and with technology. These questions have particular urgency for feminists, since selfies seem to provoke cultural fears and anxieties about femininized forms of self-authorship. I approach these questions as a trans feminist, which I use to describe a political orientation that commits me to work toward gender liberation in dialogue with an ethics of self-transformation.[10]

As viewers of selfies, our commitments shape what we see in selfies. Ultimately, neither Narcissus by the pool nor the monster's direct testimony from Mary Shelley's nineteenth-century novel can offer a trans feminist account of what self-representation demands of and offers to viewers. Therefore, I turn to a twentieth-century text: Susan Stryker's performance piece and manifesto "My Words to Victor Frankenstein above the Village of Chamounix: Performing Transgender Rage." Stryker is a transgender historian and a member of the direct-action group Transgender Nation. When she first performed this piece, she had just participated in a protest of medical and psychiatric gatekeeping, the kind of gatekeeping that prevents all but the most conventionally attractive heterosexual trans women from transitioning. As she describes it, she stood onstage in ripped jeans and a black lace bodysuit, with "a six-inch long marlin hook dangling around my neck on a length of heavy stainless steel chain."[11] With her leather jacket emblazoned with messages from "dyke" to "fuck your transphobia," Stryker self-consciously constructed an image that was as far as possible from what medical gatekeepers would consider acceptable transgender femininity.[12] This is how her monologue begins:

> The transsexual body is an unnatural body. It is the product of medical science. It is a technological construction. It is flesh torn apart and sewn together again in a shape other than that in which it was born. In these circumstances, I find a deep affinity between myself as a transsexual woman and the monster in Mary Shelley's *Frankenstein*. Like the monster, I am too often perceived as less than fully human due to the means of my embodiment; like the monster's as well, my exclusion from human community fuels a deep and abiding rage in me that I, like the monster, direct against the conditions in which I must struggle to exist.[13]

Stryker notes that she is not the only person to see transgender people as analogous to Frankenstein's monster; nor is she the first person to identify the natural-and-unnatural binary as one that trans people (among others) destabilize. Cisgender scholars such as Mary Daly and Janice Raymond have also described trans people—especially trans women—as scientifically and technologically constructed monstrosities. The difference is that Daly and Raymond compare trans women to Frankenstein's monster to dehumanize them, while Stryker reclaims monstrosity. Like the monster, Stryker is profoundly aware that others recoil from her because they fear what they consider unnatural, but she has moved beyond the terror of that first encounter with her reflection—with the image of how (some) others see her. Describing the vitriol some cisgender lesbians direct toward trans women, Stryker says: "When such beings as these tell me I war with nature, I find no more reason to mourn my opposition to them—or to the order they claim to represent—than Frankenstein's monster felt in its enmity to the human race. I do not fall from the grace of their company—I roar gleefully away from it like a Harley-straddling, dildo-packing leatherdyke from hell."[14]

Stryker's determination to embrace "unnatural" ways of being and becoming provides a model for rethinking selfies beyond the usual criticisms that they are artificial, superficial, narcissistic, and fake and therefore harmful. There is an echo here of Donna Haraway's famous "A Cyborg Manifesto."[15] Like Haraway, Stryker doesn't suggest that we must replace technophobia with optimistic technological determinism; instead, she calls us to attend to technological *facilitation*. Just as Stryker's performance, costume, and vivid self-description alienate her critics while they solicit identification and desire from those who would align themselves with her, selfies are tools that can forge relations of many kinds. Photographs of our faces don't simply replace "natural" ways of interacting with a technologically determined posthumanism. Instead, they are among many technics that can be used as tools for being, becoming, and relating. Crucially, they depend on viewers, audiences, and addressees.

By focusing on how we see selfies I am not simply suggesting that looking at selfies strengthens our relationships to others and is therefore a purely positive experience. Quite the contrary. In Emmanuel Levinas's ethics of the face-to-face encounter, the intersubjective relation is far more complex: "The other impacts me unlike any worldly object or force."[16] Images, too, as Hagi Kenaan argues, are not mere objects to be read but, rather, exceed a relationality based on subject and object. In Kenaan's words, the "image's face [is] the mark, the trace—apropos Levinas—of the uncontainable."[17] The face is not

just there to be read, to connect us to others, and to reassure us that we are not alone. It carries with it an ethical demand.

If as images selfies can convey a mark of alterity, a trace of the uncontainable, and an ethical demand, then I contend that every account of selfies that imagines them through the scene of Narcissus beside the pool falls far short of understanding their true potential. Simultaneously, every account of selfies that describes them as a purely positive tool of self-empowerment is also inevitably lacking. Neither of these stories about selfies grapples with the fact that selfies express *and create* complicated relationships to the self and to others; furthermore, neither of these stories helps us understand what it means that selfies are designed to be shared and seen—which makes us vulnerable to the eyes, assessments, manipulations, and solidarity of others. Instead, the true possibilities of selfies become clear only when we examine them through the story of the reflection in the pool seen by Frankenstein's monster—by reading Frankenstein's monster through Stryker's monologue. This reveals an alternative mythology for selfies in which self-representation produces the self as relational, resistant, fragmented, and collectively created. In this story about self-representation, the audience not only participates in constructing meaning through interpreting the text. We are also asked to examine our commitments and understand what these commitments mean about ourselves. By doing so, we can start to understand images not only as conveying *what once was* but also as encounters with liberatory futures. Through reading signs hinting at *what could be* out of something that exists right here, we can start to imagine the path from where we are to what we want to bring forth. As Tina M. Campt defines it, these encounters with the futurity of images involve bringing into being "that which is not, but must be" by "living in the future *now*."[18]

Toward the end of "My Words to Victor Frankenstein," Stryker creates her own poetic account of monstrous self-transformation through her evocative description of moving through water—perhaps the water of the pool in which the monster finds their reflection. The poem explores how drowning in deep waters can serve as a metaphor for Stryker's experiences of being at "war with nature." She describes struggling to swim toward the surface, finding that each time she thinks she is breaking through the waves she finds yet more water. She writes:

> This water annihilates me. I cannot be, and yet—an excruciating
> impossibility—I am.
> I will do anything not to be here.

I will swim forever.
I will die for eternity.
I will learn to breathe water.
I will become the water.
If I cannot change my situation I will change myself.[19]

Reading transition as movement through water offers new ways of understanding the mythic origin scene of self-imaging. Instead of Narcissus's frozen isolation before his own static reflected image, movement through water attunes us to the ripple effects that expand outward from reflection. Amid capitalist seizure of natural resources and anthropogenic climate change, water connotes the politics of exploitation, materiality, and embodiment. As the After Globalism Writing Group describes, water "stands as the symbol and vehicle for inequality, vulnerability, racism, labor, land-based relationality, and capitalist infrastructure."[20] Simultaneously, however, "Water is both common and in the commons, inside and outside of us—in the rain and the clouds, in the rivers and the seas. Water is the great mediator and equalizer, around which cities grow and nations often form their borders, but it is also where empires crumble and pleasure domes collapse. Water levels."[21] If movement through water is a metaphor for self-transformation, then gender transition must be understood as a powerful force that has the potential to break through barriers, undermine empire, propel cultural transformation, and support human and nonhuman flourishing. In Dora Silva Santana's work, water is a metaphor for the embodied materiality of trans experience, particularly her experience as a Black trans woman from Brazil.[22] According to Santana, movement across water recalls the transatlantic crossing of the Middle Passage and represents the material labor of "resisting systematic oppression through embodied knowledge."[23]

Stryker's performance piece allegorizes transition as movement through water to offer a metaphorical mirror as she invites her audience to understand this experience as a reflection of their own—to see themselves with Stryker as reflections of the monster. Gesturing toward the nineteenth-century novel, Stryker writes that, "by using the dark, watery images of Romanticism . . . I employ the same literary techniques Mary Shelley used to elicit sympathy for her scientist's creation."[24] Like the monster, Stryker *and all those allied with her* refuse the laws of nature that would confine us, "for we have done the hard work of constituting ourselves on our own terms, against the natural order." She concludes with a benediction and an invitation that functions as a manifesto:

Though we forego the privilege of naturalness, we are not deterred, for we ally ourselves instead with the chaos and blackness from which Nature itself spills forth.

If this is your path, as it is mine, let me offer whatever solace you may find in this monstrous benediction: May you discover the enlivening power of darkness within yourself. May it nourish your rage. May your rage inform your actions, and your actions transform you as you struggle to transform your world.[25]

From Narcissus to Shelley's novel to Stryker's performance piece, the figure beside the pool is never isolated. Instead, the scene of self-recognition/representation is deeply implicated in complicated, painful, and powerful encounters with others. Plunging into the waters described in Stryker's version of Frankenstein's monster, I want to tell a story of selfies that strays far from how they are popularly understood. Like Stryker reclaiming monstrosity, selfies embrace the unpredictable, unnatural, and technological construction of the self. Selfies emerge from a relay of reflections produced by cameras, computers, social media platforms, and creative collaboration with others through online networks. Here, the reflection in the pool is not limited to the surface but extends downward into the digital depths in a mise en abyme of images, data, code, creators, and—of course—the viewers to whom these images address themselves: those of us who see selfies.

Acknowledgments

I love to read acknowledgments in books, just as I love to watch the entire closing credits of a movie—a reminder of how much we always depend on others to construct ourselves and make meaning in this world. This book relies first and foremost on the work of the artists and creators it follows. My deepest gratitude to Shea Couleé, Zackary Drucker, Che Gossett, Zinnia Jones, Vivek Shraya, Tourmaline, Alok Vaid-Menon, and Natalie Wynn.

This project was profoundly shaped by the attentive, generative, and careful guidance of Elizabeth Ault of Duke University Press. It has been a joy and an education to work with her, as well as with Benjamin Kossak and others at Duke. I am incredibly grateful for the thoughtful and comprehensive reader reports from two anonymous peer reviewers. Their suggestions, challenges, questions, and recommendations for secondary literature helped make this project into what I had hoped it could be.

During my time in academia I have greatly benefited from generous mentorship, and I strive to provide to others the support and solidarity that my mentors have given me. First and foremost, I thank Soyoung Yoon for guiding, encouraging, and challenging me at the State University of New York, Purchase College, and for introducing me to Roland Barthes's *Camera Lucida*, which shaped my love both of photography and of writing about photography. At the University of Chicago, Allyson Nadia Field offered me rigorous feedback and generous support, and Patrick Jagoda provided creative questions and patient mentorship. I cannot adequately thank Daniel Morgan for his incredibly generative conversations, painstaking revisions, intellectual challenges, and inestimable advice and for believing in this project, in me, and in labor organizing. At the School of Communication and Multimedia Studies at Florida Atlantic University (FAU) I have had the curious privilege of being mentored with generosity by Gerald Sim and have also had the pleasure of being in dialogue with Jane Caputi and Stephen Charbonneau, both of whom have modeled what it means to be passionate about

research and teaching. Chris Robé has taught me how to balance intellectual work and political agitation. Finally, through the Alexander Doty mentorship program organized by the Queer and Trans Caucus of the Society for Cinema and Media Studies, I had the good fortune to be matched with the incomparable Chris Holmlund.

Writers need readers, and the most consistent and careful readers I have found are the members of the writing group organized by Mikki Kressbach. "Thank you" feels like far too little to say to Mikki, Jordan Schonig, Will Carroll, Matt Hubbell, Ian Bryce Jones, and, always, Hannah Frank. Their time and attention are present throughout these pages. Noa Steimatsky's critical eye and generative questions prompted me to discover my interest in the visual rhetoric of doubling. Jennifer Wild's Counter Cinema/Counter Media project gave me the chance to meet and work with Zackary Drucker. Chase Joynt, Kristen Schilt, and Jacqueline Stewart provided incredible opportunities to develop as a researcher. Working for Aymar Jean Christian's Open TV–Beta gave me the chance to explore cultural production through the role of audience engagement. At the University of Chicago, the Writing Program gave me tools to think about academic writing in new ways, and sections of this project benefited from feedback and discussion in the Gender and Sexuality Studies Workshop (coordinated by Annie Heffernan and Rebecca Oh), the Mass Culture Workshop (coordinated by Katerina Korola and Dave Burnham), and the Sound and Society Workshop (coordinated by Amy Skjerseth and Brad Spiers). At FAU, Carol Mills organized a manuscript workshop for this book at which I received detailed, challenging, and wise feedback from Jane Caputi, Stephen Charbonneau, Chris Robé, and Gerald Sim. An early version of my discussion of some of Alok Vaid-Menon's work was published in M/C Journal 20, no. 3 (2017), and a reading of two selfies by Vivek Shraya accompanied my interview with her that was published in TSQ: Trans Studies Quarterly 6, no. 4 (2019). This project also benefited from research funding from the Peace, Justice, and Human Rights Initiative; the Morrow Fund; and the Distinguished Lecture Series Faculty Research Award at FAU and the Arts, Science, and Culture Initiative at the University of Chicago. Research assistance by Zakaria Herzlich was supported by the Center for Women, Gender, and Sexuality Studies at FAU and the Howard Greenfield Foundation. Portions of the book were presented at the University of Notre Dame's Visual Culture Workshop, SymbioticA at the University of Western Australia, several annual conferences of the Society for Cinema and Media Studies, the Association for the Study of the Arts of the Present 9, and the Film & Media Conference at the University of California, Berkeley.

My colleagues, comrades, and friends make research and life possible. Thanks especially to Joel Neville Anderson, Lindsay Harroff, Lauren Herold, Tien-Tien Jong, Gary Kafer, Andrea Miller, Marek Muller, Solveig Nelson, and Dan Udy for conversations and collaborations. To Noa Merkin, Sarah Schroeder, and Tyler Schroeder, my love and gratitude forever. My comrades in Graduate Students United were a source of pride, inspiration, and support throughout my time at the University of Chicago. Andrew Gothard and Kelly De Stefano teach me valuable lessons about the power of labor and what it takes to win.

Thanks to my blood family and chosen family, including the prison abolitionists of South Florida who are chipping away at the prisons' walls and the Chicago Chapter of Black and Pink. My thanks to Sam Albright for questions, curiosity, and unfailing support; to Chris Carloy and Sierra Wilson for companionship and joy; to Jamie Saoirse O'Duibhir, whose love and friendship I treasure; and to my parents, Marjorie Bekoff and James Morse, who fostered my love of learning. Finally, my thanks and my love to my sister and quantum twin, Ada Nicole Morse. Baruch HaShem. To all named here, let me quote Zackary Drucker's 2011 film *At Least You Know You Exist*: "Because of you, I know that I exist."

Selfies are usually assumed to make a simple and individualistic claim: "I am." Sometimes, if the background or location of a selfie is sufficiently interesting, the message might expand to "I am here." In both cases, selfie creators are the ones imagined as speaking—they are the ones saying "I am" or "I am here." However, they don't speak in isolation. In this book, I am interested in how selfies interpellate *viewers*, and in how viewers might respond to selfies. As the trans cinema studies scholar Eliza Steinbock writes, building on Paul Frosh's research, selfies express an intersubjective, mutual act of recognition: "I see you showing me you."[1] This phrase doesn't only track a relation taking place in time; in this formulation, the first-person singular pronoun is spoken not by the selfie creator but, instead, by the selfie viewer. *Selfie Aesthetics: Seeing Trans Feminist Futures in Self-Representational Art* follows this move away from understanding selfies as symbols of narcissism to pay close attention to how selfie viewers can read the formal structures of specific images. By doing so, I argue that formal strategies common within selfies and self-representational art—what I call "selfie aesthetics"—provide a foundation for politically committed interpretations that contribute to our ability to imagine and work toward trans feminist futures.

Through formal analysis, *Selfie Aesthetics* reads work by trans feminine artists and activists to interrogate key insights of queer theory, expand our understanding of self-representation, and construct collective and collaborative modes of being. Analyzing the formal strategies used by trans feminine creators in digital self-representational art challenges a set of intersecting beliefs that can interfere with our ability to see the political force of their work. These beliefs include the assumption that femininized cultural production is frivolous, the idea that transgender existence emblematizes postmodern fluidity, and the conviction that ephemeral digital images are unbound to materiality. Against these fantasies of immateriality, I argue that selfie aesthetics are formal strategies that invite us into collaborative spectatorial encounters

with self-representational art and that these spectatorial relationships have political potentiality. These formal strategies include the visual rhetoric of doubling, the seriality of selfies, their openness to collaborative improvisation, and their nonlinear temporalities.

In this book, I use close reading to demonstrate the transformative possibilities of careful acts of viewing. These possibilities aren't limited to formal analysis; indeed, ethnographic selfie research points to these possibilities in selfie viewership, as when one of Katrin Tiidenberg's research subjects describes how engaging with selfies "alters what they [selfie viewers] consider beautiful," providing ways of seeing that challenge dominant ideas of beauty.[2] But *Selfie Aesthetics* is not a qualitative study of what selfie viewers are currently doing and experiencing. Instead, it's a call to dwell with images that viewers typically only glance at, in passing, amid the endless scroll of social media timelines and newsfeeds. Inspired by Ariella Azoulay's politicized call to "watch" images and Tina M. Campt's method of "listening" to images, I propose that "seeing" selfies can be a practice of closely reading these ephemeral images for the futures they might make possible.[3]

To be blunt, I love looking at selfies. (I like taking them, too, but I see far more selfies in my social media feeds each day than I could ever take.) In the trans and queer digital spaces I inhabit, selfies often function as gifts, and seeing selfies is a privilege and a pleasure. At the same time, the social relations made possible by selfies exceed just this experience of joy or delight. I first became interested in studying selfies when I noticed how the trans activist Zinnia Jones used them: not only did she have a recognizable aesthetic, which allowed her to use selfies creatively to explore multiple facets of her identity, but she also used selfies strategically to fight back against the persistent transmisogynistic online harassment she faced, harassment that was explicitly intended to shame her for taking selfies. I wasn't the only one noticing this—many of Jones's online followers were seeing these resistant, critical, and liberatory possibilities in her selfies. At the same time, many others refused to see Jones's selfies as anything other than a manifestation of their worst prejudices against trans women. Jones isn't alone in negotiating this dichotomy. Trans women and trans feminine people often describe how their selfies increase their risk of online harassment and other forms of violence. A significant portion of this harassment is clearly an expression of what Julia Serano has called "femmephobia," or hatred of femininity and those who are feminine.[4] Yet at the same time, selfies connect trans women and trans feminine people to community support and to expressions of love and solidarity, as in the digital spaces I described. What changes isn't the image itself, its con-

tent, or its denotation. The image itself doesn't entirely control how it is interpreted; the viewer—and their biases, fears, allegiances, and commitments—is critical to producing the image's meaning.

Like much of visual culture, selfies are polysemic and ambivalent, and they make meaning within the affordances, social relations, and technologies of photographic mass media. As Azoulay writes in *The Civil Contract of Photography*, photography offers an opportunity that comes with responsibility: "To see more than they could alone, individuals had to align themselves with other individuals who would agree to share their visual field with one another."[5] Each image is more than just an image; as a node within networks of social relations, it offers the opportunity to examine ourselves and our commitments and to align ourselves with others. Who am I when I look at selfies? I am a white genderqueer Jewish person, scholar, and organizer who believes that my liberation is bound up with trans and Black liberation. I am also a person who loves close analysis because creators, images, and viewers can collaborate to make meaning through the practice and method of looking closely. From this position, I turn to trans feminist theory and trans of color critique to understand how I—and how people with similar commitments—can look at selfies differently to see trans feminist futures in self-representational art.

Like all feminisms, trans feminism has many definitions, but there are several specific advantages that trans feminism offers selfie viewers in negotiating the ambivalent and nuanced relationship among selfies, narcissism, femininity, and femmephobia. Trans feminism counters the tendency within some feminist communities to entirely reject femininity, and at the same time, trans feminism challenges the social and legal pressures that demand that trans women embrace a form of hyperfemininity to be legible as women.[6] Trans feminism explicitly prioritizes knowledge production by trans people, turning attention away from the expert analyzing trans people to the forms of knowledge trans people themselves produce—including selfies and other forms of self-representational art.[7] Trans feminism centers trans women and trans feminine people (without excluding trans masculine people, trans men, nonbinary and genderqueer people, or cisgender people) to grapple with the compromised choices that are required of both transgender and cisgender people as we navigate systemic oppressions and structural inequalities that are founded on femmephobia. Talia Mae Bettcher writes that trans feminism offers "an account of trans oppression out of which the category woman can rise as a resistant option," one that "opens up clear possibilities for understanding the intersections of trans, intersex, and sexist op-

pressions."[8] In "The Transfeminist Manifesto," Emi Koyama provides a capacious definition of trans feminism that emphasizes solidarity, writing that trans feminism is a movement for trans women and those who "consider their alliance with trans women to be essential for their own liberation."[9] In Koyama's work, trans women's liberation is tied to disability justice, sex workers' rights, and anticolonial prison-abolition politics.[10] Following elders of the trans liberation movement such as Miss Major Griffin-Gracy, Jian Neo Chen writes that the term *trans* "describe[s] and bring[s] together those who share experiences and (otherwise undocumented) histories of devaluation by—and resistance against—gender policing, racism, and enforced poverty."[11] *Trans* crosses over and connects, building alliances. Understood in a trans feminist context, selfie aesthetics are shaped by the connection between creators and audiences, a connection constructed through images *and* how those images are read, interpreted, and seen.

It should already be becoming clear that *selfie* means much more than "an image of the self, captured with a digital camera." Etymologically, the term itself first appeared in the late 1990s, when selfies emerged alongside the development and proliferation of camera phones.[12] As Tiidenberg notes, the diminutive "-ie" carries negative, feminized connotations in US and British English, but the term likely first arose in Australia, where the "-ie" ending implies "something endearingly self-aware of its own mundaneness."[13] By the time *selfie* was declared Oxford Dictionaries' 2013 Word of the Year, the neologism had become ubiquitous, even though it is applied widely—and inconsistently—to a variety of images, not all of which are even recognizable as self-portraits.[14] According to Katie Warfield, "The selfie is a mirror, and a camera, and a stage or billboard all at once."[15] As a result of her wide-ranging selfie research, Tiidenberg describes selfies as "expressive acts; photographic objects; cultural practices; gestures; means for communicating and understanding ourselves; tools for reclaiming our sexuality, experiencing our bodies or performing particular versions of ourselves; addictive practices that lead to, or amplify psychopathy; tools for gaining visibility," and more.[16] As relational aesthetic practices, selfies tend to involve networked interactivity, extending from consumption-based "liking" to more participatory practices of selfie exchange, modification, and recirculation—but they can also be stored privately to be shared with no one, unless a privacy breach exposes them.[17] "Selfie" is also used to describe images from well before the advent of digital photography, particularly images that show people taking photographs of themselves; it is used to describe images that are not self-representational (e.g., French fries tagged #selfie on Instagram); it is used

to describe images that include multiple people (even though some refer to such images as "usies" and "groupies," these terms have not really caught on); and, finally, it is frequently used to describe images that are clearly *not* produced by the subject of the photograph but that still seem to capture the subject's authorship or agency.[18]

Selfies are varied, diverse, dispersed, and ubiquitous, but the very fact that so many different representational practices are called "selfies" suggests that there are aesthetic similarities or properties that unite these images—commonalities that viewers recognize. As I argue, these commonalities include doubling, seriality, improvisation, and nonlinear time, all of which constitute selfie aesthetics. While these four strategies are exemplified within the work I examine here, I contend that they can be used to understand selfies and self-representational art more broadly, including work by creators who are not trans feminine. The approach outlined here can and should be used to engage with self-representational works by a wide range of trans and queer people, as well as straight, cisgender people. After all, allies and accomplices can and should take up trans feminist politics.[19] Nonetheless, I have chosen to focus on work by trans feminine creators who are themselves committed to politics that are explicitly or implicitly trans feminist. I believe that it is critical to center trans women and trans feminine people to understand the varied perspectives they offer on their material conditions—that is, if we are going to learn to see trans feminist futures through their art. Of course, trans feminine identity doesn't automatically produce trans feminist politics. I have thus selected the artists and creators featured in this book because of the particular ways they use digital self-representation; their distinct experiences and perspectives; and the aesthetic, political, and theoretical richness of their work.

This introduction opened with Steinbock's claim that selfies articulate an intersubjective encounter: "I see you showing me you." Intersubjectivity is prominent within selfie scholarship, and "What do selfies say?" has been a central question, perhaps most notably in "What Does the Selfie Say? Investigating a Global Phenomenon," Theresa M. Senft and Nancy K. Baym's introduction to the *International Journal of Communication*'s 2015 special issue on selfies. Framing selfies this way assumes that selfies are addressed to audiences—that selfies are not just about selves, but also about selfie viewers. Opening with a section titled "Against Pathology," Senft and Baym write that, far from narcissistic isolation, selfies are concerned with "the transmission of human feeling in the form of a relationship."[20] Crucially, this relationality is not necessarily positive; nor does it determine how viewers engage with

selfies. If selfies are relational, then what selfies say depends, in part, on who understands themselves to be addressed by a particular selfie and how they interpret its message. We bring our own perspectives, histories, and desires to intersubjective encounters. By accepting the address and participating in a communicative situation, the audience contributes to its meaning. How we engage with selfies is the larger question of this book, and to explore it, it's necessary to examine broader questions of how self-representation invites and structures relationships between selves and others.

Intersubjectivity

Self-representation has always been about more than just self-assertion. I find a particularly compelling account of how self-representation articulates reciprocal intersubjectivity in *At Least You Know You Exist* (2011). This self-representational film about trans feminist solidarity was made by the trans multimedia artist Zackary Drucker in collaboration with New York City's longtime drag pageant organizer and performer Flawless Sabrina. Working in photography, video, television, and performance art, Drucker creates self-representational work that explores doubling and intergenerational mirroring, and her work with trans icons such as Flawless Sabrina, Holly Woodlawn, and Vaginal Davis documents and explores trans feminine history. Drucker and Flawless Sabrina's experimental film opens with flashes of pink, orange, and red as the colorful fluidity of an overexposed tail of the reel of film is framed by the soft, rounded corners of the 4:3 frame. Then the whir of the projector halts with a click, the rounded edges disappear, and the screen expands to 16:9 as it displays the bright yellow letters of the digital title card, with its second-person address affirming the fact of the addressee's being: *At Least You Know You Exist*. In the film that follows, the two filmmakers explore their relationship through an imperfect digital transfer of a 16 mm original. Because the frame rates of the 16 mm original and the digital transfer differ, Drucker and Flawless Sabrina are trailed by a ghostly halo of their own reflected light, producing an auratic image that speaks to the role of history in self-knowledge—a self-knowledge that is inseparable from the encounter with the face of the other. In a pivotal sequence, the camera advances progressively closer to Flawless Sabrina, cutting from a wide shot to a medium shot and, finally, to a close-up, as Drucker describes their first encounter in voiceover. She says: "I was eighteen when I met you on the other side of my camera." Mediated by the camera they turn on each other, they reflect each other across generations and across time. In the final sequences they appear

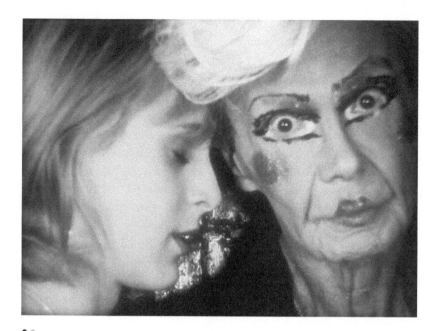

● ○

Figure I.1 *At Least You Know You Exist*, directed by Zackary Drucker and Flawless Sabrina, 2011. Screen grab by the author.

on-screen together, doubling each other. As Drucker leans her head against Flawless Sabrina's (figure I.1), the audio track fills with the sound of a loudly ticking clock that abruptly stops. Then Drucker speaks the final line of the film in voice-over. "Because of you," she says, "I know that I exist." In Drucker's voice-over, identity is intersubjective rather than individualistic, as her language shifts fluidly from second-person to first-person pronouns—from "at least you know you exist" to "because of you, I know that I exist."

Such linguistic play connects Drucker and Flawless Sabrina's film to a longer tradition of using formal strategies to produce intersubjective encounters within self-representational art. This tradition is strikingly evident in photographic and literary collaborations by the surrealist artists Claude Cahun (Lucy Renee Mathilde Schwob [1894–1954]) and Marcel Moore (Suzanne Alberte Malherbe [1892–1972]). Photographs by these two queer lovers are often described as a kind of precursor to selfies, making their body of work a rich prehistory for my project. In the semiautobiographical text *Les jeux uraniens* (1914–15), Cahun describes a scene of magical mirror substitution in which her reflection dissolves into the image of her lover and artistic partner,

Moore. "You come up behind me," Cahun writes, addressing the reader and, presumably, Moore in the second-person pronoun. "You lean over my shoulder, suddenly, the cloud of your breath condenses on the tarnished glass, and when the round cloud has evaporated, your image has replaced mine."[21] About fifteen years later, Cahun and Moore continued exploring representation as a kind of boundary-blurring exchange. In *Aveux non avenus* (1930), they move from first-person plural to first-person singular, writing: "Sweet, nevertheless . . . the moment when our two heads leaned together over a photograph (ah! How our hair would meld indistinguishably.) Portrait of one or the other, our two narcissisms drowning there it was the impossible realized in a magic mirror. The exchange, the superimposition, the fusion of desires. . . . Postscriptum: At present I exist otherwise."[22]

Self and other coincide not only in Cahun and Moore's play with pronouns, but also in the way their language evokes formal visual effects such as eye-line matches and superimposition—formal strategies that they employ in their photography. Throughout their body of work, Cahun and Moore document their collaborative partnership through double exposures, superimposition, and reversals (compositions shot first with one artist and then the other as the subject). In one of their best-known photographic collaborations, Cahun looks into the lens of the camera while she is simultaneously doubled in the mirror (figure I.2). The mirror reflects Cahun, but the two images of Cahun are distinct; Cahun's eyes at once draw us into the image and turn our attention to the unseen off frame right. What the image doesn't tell us explicitly is that her look into the lens is directed not only toward the camera and the eventual viewer, but also almost certainly toward the photographer: Moore. In Cahun and Moore's work, photography is not simply a record of a collaboration. It is a technology that makes possible an intersubjective experience—the experience of looking at oneself and another simultaneously.[23] The two artists continue exploring intersubjectivity in Cahun's *Vues et visions* (1914), which is illustrated by Moore and features the following dedication: "'To Marcel Moore' I dedicate this puerile prose to you so that the entire book will belong to you and this way your designs may redeem my text in our eyes."[24] As the two artists become one, and as the balance between "you" and "me" is resolved into "we," the dedication ends by invoking the look—*our eyes*. In their photography, an exchange of looks is captured by the camera; as viewers, we are then invited to share that look, so that "our eyes" means the looks of Cahun, Moore, *and* their audiences.

Understanding Cahun and Moore's work as "self-portraiture" makes it more available as a prehistory of selfies, but it also poses several problems

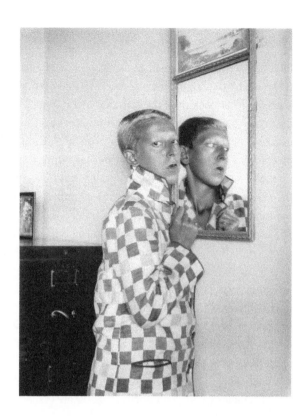

Figure I.2 *Self-Portrait*, by Claude Cahun and Marcel Moore, ca. 1928. Used with permission of New Jersey Heritage Trust.

that can be used productively to explore self-portraiture's intersubjectivity. As Tirza True Latimer argues, perhaps the photographs of Cahun—almost all of which have been posthumously titled "Self-Portrait"—should, in fact, be understood not as self-portraits but as collaborative performances instead, since they were created with Moore. Through close analysis, Latimer identifies what she describes as formal "statements of or about Moore's participation in the creative process within the work itself."[25] Undoubtedly, calling Cahun and Moore's work "self-portraiture" reinforces the idea that the individual artistic genius must be identified as the single origin of art, and its persistence in discourse about Cahun and Moore's work also undoubtedly elides or denies their queer relationship.[26] Nonetheless, referring to these images as "self-portraiture" does open up alternative ways of understanding selfhood and self-representation. Instead of asking whether their work is in fact self-portraiture, I want to ask *what is made possible* by describing their collaborative photography *as self-portraits*. If Cahun and Moore's work is self-portraiture, then the selves that emerge from their photography are social, relational, intersubjective, and collaborative.

In fact, such collaborative, relational selves are consistent with a tradition in art historical criticism that contends that intersubjectivity rather than individuality is central to self-portraiture. For Michael Fried, self-portraiture is shaped by the "right-angle dispositif," a recurring pose in which the artist seems to look back over the right shoulder toward the viewer. In this pose, the artist's hand often disappears from view because it wasn't reflected in the mirror that made the self-portrait possible.[27] Though Fried focuses on the production process, Joseph Leo Koerner writes that this hand we can't see implicitly intrudes into the space we occupy.[28] Koerner doesn't ask whether the disappearing hand that held the paintbrush might be metaphorically painting the viewer, but other scholarship suggests such an interpretation. For James Hall, the look back transforms self-portraits into mirror reflections, conflating the positions of the viewer and the artist before the image.[29] According to Anthony Bond, the look back means that we lock eyes with the artist, repeating the exchange of looks that created the painting. We are not only connected to the artist through the look back; formal strategies make our space contiguous with the space of the painting, including unfinished lower edges, elements that seem to spill outside of the painting plane, or scenes staged to produce a space or a character for us to inhabit.[30] Like Bond, T. J. Clark says that the viewer's position is that of both the artist and the mirror.[31] Elsewhere, Koerner concurs that we are placed either in the position of the painter or the painter's reflection.[32]

Here, "self-portraiture" is fundamentally characterized by the triangulated look exchanged among the viewer, the artist, and the painting/mirror, a look that is dispersed across decades and even centuries. Of course, formal analysis of self-portraits often identifies compositional strategies that assert individual authorship; however, as I detail here, scholars have been as interested in how reception produces intimate intersubjective bonds between the artist/subject and the viewer. Many of these theories don't grapple with gender, even as they explore the possibilities of seeing ourselves as mirrors of others; as John Berger pointed out in *Ways of Seeing*, misogyny has long transformed formal strategies such as mirroring, reflection, and other modes of doubling into evidence of female narcissism, giving male spectators a sense of stable subjecthood in relation to representations of women.[33] Yet ultimately, self-portraiture scholarship actually describes ways of looking that challenge—and even undo—the presumptively male spectator's secure position as a subject in relation to an object, producing intersubjective relationships through form. As contemporary iterations of self-portraiture, selfies similarly construct the self through engagement with others, and formal

analysis reveals how these relationships are represented and produced.³⁴ Selfies aren't limited to the reflexive relationship to the self, a solipsistic encounter that excludes all others. Instead, selfies—and the mirror reflections they stage—foster relationships between self and other through their very form.

Form

I turn to formal analysis for multiple reasons. First, the method of formal analysis directly challenges the assertion that most selfies aren't worth studying closely because they aren't "art," and it excavates the formal richness that is available within ordinary selfies. Second, it prioritizes the material, the tactile, and the specific, elements that all too frequently are elided in theories about both digital media and trans identity. Taken together, formal analysis of selfies by trans women and trans feminine people explores how ephemeral media can document—and work to transform—the material conditions that trans feminine people face, providing a foundation to build from the present to a trans feminist future.

By blurring the boundary between artistic selfies and vernacular selfies, *Selfie Aesthetics* rejects gatekeeping structures that try to legitimate certain artistic practices by distinguishing them from feminized cultural work. There's a strong suggestion of anxiety in some of these gatekeeping efforts. For example, the #artselfie project collects only selfies taken near classical artworks; the creator of the Museum of Selfies notes the "emptiness" of selfies while hoping that the project will offer "a deeper way in"; and an exhibition of selfies in London was organized around the principle that artistic intention is required if selfies are to be considered art.³⁵ These efforts seem to be shaped by a commitment to maintain the power of individual artistic genius, a tradition that has a distinctly patriarchal flavor, yet feminist artists and critics also at times have tried to differentiate between artistic selfies and vernacular selfies. In addition to Cahun and Moore, the feminist photographers Cindy Sherman and Nan Goldin have been described as artists who "made taking selfies an art form before the word even existed."³⁶ For Sherman, selfies are a natural extension of her long-standing work in self-performance, and her Instagram account has been received as one of the few instances in which selfies achieve the status of art.³⁷ Audrey Wollen and Melanie Bonajo explore selfies as art by rejecting those qualities of selfies that are strongly associated with their vernacular use, such as their polished self-presentation and positivity, creating what Bonajo calls "anti-selfies."³⁸ In *Selfie Aesthetics*, I move deliberately between amateur selfies and works that are more readily recognizable as art

precisely because juxtaposing these practices demonstrates the theoretical, political, and aesthetic contributions of ordinary and accessible media.

Formal analysis allows us to better understand how form shapes the experience of seeing our own or another's face in a selfie—this phenomenological encounter with the image. However, it is rare for individual selfies to be studied using formal analysis. Because selfies are often analyzed in bulk, scholars tend to identify general patterns in composition rather than looking closely at individual images.[39] Understandably, scholars in sociology, anthropology, and psychology tend to focus on the social context, value, and impact of selfies; similarly, the overwhelming number of selfies may lead scholars in media and communication studies to use quantitative and qualitative methods that emphasize behaviors, trends, and demographics.[40] Yet perhaps this is not just about the uncountable quantity of selfies. Studies of amateur photography— including photo booth self-portraits—are dominated by the general rather than the particular, reinforcing the divide between vernacular creative practices and artistic representation.[41] Often, the pose is the only significant area of aesthetic investigation, and Matthew Bellinger and Paul Frosh suggest that selfies are defined less by technology than by pose and gesture, arguing that viewers receive images as selfies when the pose is sufficiently deliberate.[42] However, the same could be said of self-portraiture more broadly, since the look back plays such a significant role in producing self-representational art's intersubjective address. Nonetheless, self-portraiture is readily understood as deserving close formal analysis, and I argue that the same logic applies to ephemeral digital self-representation.

Because of its attention to form, *Selfie Aesthetics* grounds its central theoretical issues in the material realities of trans and queer lives. This isn't a naïve essentialism or rigid identity politics; following the feminist philosopher Sara Ahmed, I contend that the experience of conducting formal analysis invites us to understand self-constitution as formed, assembled, constructed, *and* "felt as inherent and bodily or even as essential."[43] By contrast, in queer theory and in critiques of postmodernism, "trans" is repeatedly disconnected from the actual experiences of transgender people and instead is constructed as merely a metaphor for fluidity, flexibility, and change.[44] Although this trend has been criticized for decades, it persists relentlessly, a kind of zombie version of queer theory that will not disappear. According to V Varun Chaudhry, some scholars within queer theory keep positioning transness as "a kind of *ultimate* queer," with the result that queer theory "continues to invoke transness as a category of potentiality, expansiveness, and diversity," neglecting trans people's "often-precarious realities . . . through theoretical

emphasis on transgender in name and idea alone."[45] As a result, trans people are forever figures of other people's fantasies about queerness—and postmodern existence more generally. These fantasies include the late capitalist investment in trans identity as a site of flexibility, the "transnormative" positioning of white trans masculine bodies as promising access to an "exceptional futurity," and the demand that transgender people continuously make manifest the possibility of gender fluidity.[46] As the trans critic Andrea Long Chu writes, the result is an "intellectual move in which the trans person, just through the act of existing, becomes a kind of living incubator for other people's theories of gender."[47] It's not only cisgender people who approach trans studies this way, and it is also troubling when trans scholars neglect the material needs of trans people in favor of abstraction. The trans scholar Jack Halberstam writes that "trans*" (with an asterisk) is not about trans people, their experiences, and the material conditions that impact their lives, but instead about a "politics of transitivity."[48] This approach is a kind of trans exceptionalism (or spectacularization) that appears to center trans people while neglecting their actual political demands.

The asterisk means many things.[49] However, it often signals that an author is taking this kind of approach to their subject, one where "trans" as a concept is abstracted from trans people's actual experiences and then opposed to identity politics, which is assumed to be rigid and conservative. At the heart of this book is the belief that this is a reductive understanding of both identity and politics. As Mari Ruti writes, "identity" is too readily imagined as stable and fixed, whereas in fact it is always "an open-ended process of becoming."[50] While all trans people are affected when "trans" is thus abstracted, trans women and trans feminine people tend to be particularly spectacularized as figures who are asked to represent or embody identity's fluidity.[51] Given this, I avoid the asterisk in this book except when quoting others, because I am interested in the material political demands that trans people are making through media production.

Of course, queer theory and trans studies don't just diverge; they also intersect. These intersections produce provocative discussions that can help to trace the importance of aesthetic form in understanding materiality. For example, recent work in trans media studies envisions cinema itself as "trans*" because it is a "medium-in-flux," or describes cinema as a trans technology because "transgender and cinematic aesthetics alike operate through the bodily practice and technological principle of disjunction."[52] There's a strange kind of trans exceptionalism (and medium-specific technological determinism) in these theories; after all, many media explore disjunction, and trans

people are not the only subjects who are "sutured" together—metaphorically or literally. Such projects seem to further entrench the association between trans experience and fantastic, free-floating fluidity, or they risk reducing trans experience to surgical intervention. At the same time, these analogies between trans existence and the cinematic *can* remain rooted in the material reality of visual, aural, and even tactile experiences of spectatorship. Although Eliza Steinbock's *Shimmering Images: Trans Cinema, Embodiment, and the Aesthetics of Change* is in many ways an example of trans exceptionalism in that it reads "trans" *as* change, the work emphasizes how spectators collaborate in meaning making. As the trans cinema studies scholar Cáel M. Keegan suggests, following work by the field's founder, Susan Stryker, digitality and transsexuality are linked *not* by some complete escape from embodiment, materiality, or referentiality but, instead, through how they allow us to phenomenologically explore alternative modes of being.[53] While I have reservations about the idea that there is an ontologically unique connection between trans existence and cinematic form, I believe that one of the critical insights of Steinbock's and Keegan's work is their discussion of spectatorship and cinema's ability to teach us how to see and feel differently. In these accounts, focusing on spectators isn't just a relativistic celebration of subjectivity. Their phenomenological approach to film form elaborates how the potential effects produced by films emerge from an "experience of reception" that is technologically and formally facilitated rather than determined.[54]

Just as "trans" can be asked to represent all kinds of change, digital media are frequently imagined as endlessly modifiable and hence unbound to specific, material referents. This conception of digitality shaped discussions of "the death of film" at the beginning of the twenty-first century, exemplified by the film theorist D. N. Rodowick's medium-specific argument that the digital image is uniquely characterized by the infinite separability of its elements. As a result, the kinds of control the digital image appears to make possible are similarly, seemingly infinite.[55] Of course, this fantasy of control is deeply precarious, as the media theorist Neta Alexander demonstrates in her analysis of buffering, digital glitches, and other "noise." Rather than the "efficiency, immediacy, and flow" that digitality promises, these ordinary moments of delay and boredom actually compel us to confront the material supports that make digital images possible.[56] Our actual encounters with selfies show that their digitality does not wholly sever them from referential reality; after all, the realism we experience in our encounters with aesthetic objects is less ontological or technological than it is an effect—and one that long

predates the digital.[57] As the film theorist Miriam Bratu Hansen writes in her introduction to Siegfried Kracauer's classic *Theory of Film: The Redemption of Physical Reality*, our experience of photographic realism is constructed and interpreted rather than inherent.[58] When I see a friend's selfie, I may be well aware that the color temperature has been altered by a filter or that it has been edited in other ways, but that does not prevent me from feeling that the image captures my friend's existence in a particular place and time.

Trans femininity and digital images thus have an important commonality: both are frequently taken up as figures that produce meanings that are mobilized for other ends. On the one hand, there is the "trans feminine allegory" that Emma Heaney traces through sexology, psychoanalysis, literary modernism, and queer theory. This allegory interrogates trans femininity to reveal something about cisgender identity.[59] On the other hand, there is the way digital image making has been taken up as a sign of the end of art's relationship to reality to assert something about the postmodern condition. Politically, of course, these two phenomena have dramatically different stakes. At the same time, they are connected by the anxieties they provoke, since referential meaning and sexual difference have long been understood as deeply intertwined. This is an antifeminist, essentialist position that is too often presented as materialist philosophy, with castration anxiety as the ultimate source of meaning.[60]

By contrast, trans theories and practices of embodiment offer alternatives that are grounded in the materiality of those bodily modifications that trans people may actually experience. These modifications include, but aren't limited to, medical procedures; they also encompass technologies of language, imagination, and representation. As C. Jacob Hale describes, trans-affirming leatherdyke communities can construct ways of relating to bodies, organs, and form that defy binary essentialism.[61] Within certain witnessing relationships, what Hale calls a "culture of two," it becomes possible for one person to "resignify" the cultural, sexual, and phenomenological meaning of their embodiment through the collaboration of another.[62] When his "recoded" embodiment is legible to a witnessing play partner, Hale writes, he is "able to disrupt the dominant cultural meanings of [his] genitals and to reconfigure those meanings."[63] In this reading, bodily form is not a fixed foundation from which meaning arises but, instead, a space of cultural, personal, and collaborative work that depends on *being seen*. Selfie viewers, I argue, can participate in similar collaborations when we act as witnesses to another's exploration of embodiment through image and form. Through closely reading selfies by

trans feminist creators, I show how formal analysis values the materiality of both digital media and trans lives, and I argue that dwelling on form is far from apolitical, because form attunes us to the materiality of experience.

Seeing Selfies

Although this book focuses on the visual aspects of selfies, studying selfies can involve attending to their metadata, the flows of networks through which they move, and the dystopian surveillance society to which they contribute. Such projects are crucial, not only if we are to understand selfies, but also if we are to grapple with how visibility, representation, and surveillance are implicated in transmisogyny, racism, and other systemic violence. Selfies have been described as producing a hypervisibility that increases surveillance, as a tool that facilitates state surveillance through compelling people to relinquish any investment in privacy rights, and as a disciplining practice of self-surveillance.[64] In response, artists and theorists have refused to participate in representation. The artist Zach Blas has responded to a surveillant society by investing in anonymity, while the theorist Hito Steyerl explores the politics of "withdrawal from representation" and the aesthetics of "how not to be seen."[65] Since facial recognition technology is based on normative assumptions about personal appearance, drag queens have found that their selfies are sometimes automatically tagged as the faces of their friends, collaborators, and competitors, making algorithmic tagging itself into a technology that produces opacity rather than visibility.[66]

There are compelling arguments in favor of withdrawal from representation. Yet trans people have long been required by doctors and by the law to live "stealth" lives after transition, concealing their pasts to the point of erasing many of their life experiences entirely.[67] As a result, anonymity, withdrawal from representation, and disappearance can be complicit with this long, troubling history. Moreover, surveillance is not only a form of power that represses; like all biopower, it is also productive. As the media scholars Gary Kafer and Daniel Grinberg note in their introduction to a special issue of *Surveillance and Society* on queer surveillance, "Queerness is produced within surveillant processes as its very condition of possibility," since it operates against norms that can be recognized, tracked, and categorized as such.[68] Finally, even Blas's and Steyerl's antirepresentational work is dependent on form and invites us not simply to reject representation but to interrogate it.

Looking at selfies turns our attention to the texture of the experiences that images produce. This is why the subtitle of *Selfie Aesthetics* emphasizes

the act of *seeing* self-representational art. Selfies are *images*, and we encounter them that way: we read them as images, and we attend to the shapes and forms of their surfaces. They are media objects that solicit our attention and engage our emotions, perception, and curiosity. Moreover, through their formal experimentation, selfies do not necessarily produce an uncomplicated visibility. In chapter 3, I discuss how improvisation and seriality allow selfie creators to interrogate the racialized binary of hypervisibility and obscurity. In these selfie series, I argue, form allows for iterative political work. Through selfies, key issues within the academy (a politics of refusal, an analysis of racialized precarity, and a challenge to racialized hypervisibility) emerge and are elaborated within the sphere of popular culture. In this way, I argue that selfies can contribute to an "undercommons" of resistant knowledge production and circulation, depending in part on how they are created—and how they are read.[69]

Given how they circulate online, selfies pose specific research challenges. On a basic level, selfies are what Steyerl calls "poor images," and they can move as freely as they do because of their small file size and low resolution.[70] For example, selfies that are taken and edited within Instagram are restricted in their dimensions, with images from before 2018 limited to approximately 640 by 640 pixels. Sometimes a larger original is available, but as the artist Vivek Shraya told me, she regards those files as rough drafts, since they haven't been edited and filtered through the platform's software.[71] Many of the selfies I study are difficult, if not impossible, to reproduce in a printed publication. Created to circulate on social media platforms, selfies not only resist being transplanted into print media; they also disappear. This isn't a problem unique to studying selfies; rather, it is a persistent tension between new media objects that circulate online and the academic practice of fixing, preserving, and studying our objects in print. Throughout my research, broken links, deleted selfies, and public accounts-turned-private have altered both the images I can access and the images that I believe I can ethically study. In this book, I do not analyze any images that were never public, but I do discuss images that were once public and were subsequently deleted or made private. Sometimes these images have moved back and forth multiple times between being publicly and privately available. If an image is no longer publicly available, I work from my own archive of downloaded images and screenshots, and I limit my work to close analysis and description unless I have received permission to reproduce the image here. For all selfies in this volume, I reproduce images only with permission from the creator, and only when the image is of sufficiently high resolution to make print reproduction possible.

Selfie technology is constantly changing. As a result, any account of selfies that is too deeply tied to specific platforms and apparatuses risks becoming quickly obsolete. Yet attending to the platforms, networks, and technology that make selfies possible is necessary, even as I focus on certain images and the experience of encountering them. Technological advancements seem to expand what is possible for selfie creators, yet improved technology also produces the loss of certain approaches to self-representation. An advertisement for the Google Pixel 3 from 2018 offers a case in point.[72] In the ad, people repeatedly attempt and fail to take group selfies, stymied by lenses that are not wide enough to capture a large group of people even when the smartphone is held out at arms' length. Ultimately, the ad demonstrates how the Pixel 3 smartphone's wide-angle lens appears to guarantee that it is now possible to take a group selfie that fully captures everyone present. It seems that this is a narrative of technological success, yet I find myself drawn to the earlier failures and how they fragment the groups gathered together. In these images, limbs and faces are only partially within the frame, producing an image of the group that is composed of pieces of its members. Even in the "successful" selfie, the one that does not fragment bodies by cutting them off at the edge of the screen, self and other are still sutured together, for spectatorship positions the viewer as a cocreator of the image's meaning. A haunting absence and anticipated presence, the viewer is always part of the image. In self-representational art, we are not only interpellated into the image but invited to join the collaborative and collective selves that are constructed through the interaction of viewer, creator, and image.

As Shraya says, "A good selfie is one where you know where to look."[73] Although Shraya is describing the look of the figure within the image, I borrow her phrase to propose that the quality and value of a selfie depends in part on whether the viewer knows where—and how—to look. Instead of skimming quickly past selfies in the endless scroll of social media, the tools of close analysis can reveal theoretical insights within ephemeral media that might help us to forge trans feminist futures. The work I examine in this book represents a present that dominant culture attempts to erase—or to recapture as merely visibility with the goal of inclusion in the status quo. However, these images are concerned with radically different potentialities, and through their form they anticipate, vision, and manifest such futures. Close reading allows us to see what might otherwise disappear amid the proliferation of ephemeral media. In *Selfie Aesthetics*, I demonstrate how viewers can build on the formal elements within ephemeral, vernacular images—formal strategies that creators may be using intentionally or unintentionally—to

produce interpretations that honor and extend the visions, politics, and commitments of the creators. This is what "seeing trans feminist futures in self-representational art" means to me.

This book is far from an exhaustive account of self-representational art by trans women and trans feminine people, and there are many other artists whose work can and should be examined through close analysis in relation to selfie aesthetics. Nor, as I've been insisting, are selfie aesthetics traceable only in work by trans artists. Nonetheless, the work I address here exemplifies how meaning emerges out of the formal strategies of selfie aesthetics: doubling, seriality, improvisation, nonlinear temporalities. Linked together and working independently, the creators I study are frequently in dialogue with one another, and their audiences often overlap, though they also have distinct positions within the art world, activism, and trans cultural production. As a result, the aesthetic, political, and theoretical insights within their work have to be considered in relation to one another—as well as in connection to many other creators I could not include here. From the multimedia artist Zackary Drucker to the musician and writer Vivek Shraya, the filmmaker and activist Tourmaline, the scholar Che Gossett, the activist and educator Zinnia Jones, the vlogger Natalie Wynn, the performer Shea Couleé, and the designer Alok Vaid-Menon, the selfies and self-representational art I discuss exist along a spectrum from clearly vernacular to explicitly gallery-based work, revealing continuities, intersections, and dialogue between popular culture and art world self-representation. In addition, these works include both still- and moving-image media, encompassing those digital self-portraits most easily recognizable as selfies, as well as works that are influenced by or explore the themes that constitute selfie aesthetics.

Selfie Aesthetics is organized around its main thematic conceits; as a result, although certain creators are central to individual chapters, others are featured in several chapters. Taken together, their work reveals political, theoretical, and aesthetic possibilities of selfies. While these possibilities are not realized by every selfie, their work demonstrates the potential of what selfies might—and, in fact, often—do, in collaboration with selfie viewers. In chapter 1, I explore how the visual rhetoric of doubling structures selfie production and reception. Through formal strategies—including shadows, reflections, and multiple figures—selfies represent selves as multiple and relational. This doubling is not restricted to the realm of representation alone; it also exists in the spectatorial encounter. Generating proliferating reflections that evoke the mise en abyme, selfies and self-portraits by Drucker, Shraya, and Tourmaline demand that we reconsider how spectatorial experience has

been analogized to the Lacanian "mirror stage." Queering the mirror stage through doubling, their work shows selfhood to be relational and messy as they demonstrate the labor and formal strategies that construct images of selves as separate, bounded, and intertwined. Exploring fluidity through the shifting positions and proliferating reflections of the mise en abyme, these digital images do not merely celebrate digitality as an opening to flux and transformation. Doubling in selfie aesthetics also resists queer theory's demand that "trans" stand in for formless, unfixed flexibility, for it makes transformation a possibility and an effect that must be mediated and constructed.

Chapters 2 and 3 explore how selfie creators use improvisation and serial form to negotiate the pressures, promises, and perils of visibility, particularly in dialogue with gender performativity theory. When selfies are understood as political, their political utility is typically confined to creating visibility for causes or for underrepresented groups. However, selfie seriality can also be ambivalent toward visibility politics. Rather than a binary choice between visibility and invisibility, selfie seriality produces improvisational encounters that shift and transform over time. By constructing or identifying series of selfies, selfie creators and their audiences generate new ways of engaging with queer theories of performative resistance. In chapter 2, I demonstrate how Tracy McMullen's concept of the "improvisative" can help explore how selfie seriality reimagines iterative self-constitution.[74] Using the case study of Zinnia Jones's selfies, I show how selfies can become a technology of self-constitution that facilitates improvisational, unpredictable, and collective creation of digital selves. Here, iterability is not a site of transmission between the active creator and the passive audience but, instead, becomes the basis for contestations among multiple cocreators. Then, in chapter 3, I show how Alok Vaid-Menon suggests that authentic visibility is an impossible demand of trans femmes of color while Che Gossett uses selfie seriality to visualize resistant knowledge production among trans of color scholars and artists. As audiences actively construct selfie series through reading connections among disparate images, it becomes evident that the performativity of identity is far more complicated than a relationship between an individual actor and hegemonic norms that are either reproduced or resisted. Instead, the iterative improvisatives that constitute digital selfhood include the active engagement of audiences reading coherence into proliferating and diverse selfie series.

The final two chapters draw on doubling, seriality, and improvisation to explore selfie temporality in relationship to "queer time." Theories of queer time have celebrated nonlinearity in response to the way power works with

and on temporal experience. As Elizabeth Freeman writes, "Far from being a set of empty containers—minutes, hours, days, weeks, months, years, decades, periods—into which our experience gets poured, time is actively constructed by the powerful."[75] However, queer temporality loses its critical political charge when it is reduced to nonlinearity and when we assume that nonreproductive time is inherently resistant. In chapter 4, I show how digital self-representation produces the potential for nonlinear temporalities and argue that these nonlinear temporalities are not automatically or transparently queer. Instead, they are antinormative and resistant as the result of creators' material labor. Exploring how liberatory temporalities build from the past to imagine trans feminist futures, chapter 5 examines how selfie aesthetics produce alternative histories and what Allyson Nadia Field calls "speculative archives."[76] In these chapters, I look at how anxieties about postmodernism shape our understandings of both trans people and historical archives, and I explore what digital self-representation by trans people can contribute to this discourse. Using digital tools to revise, reimagine, and renarrate personal and collective histories, creators such as Shea Couleé, Vivek Shraya, and Natalie Wynn show how selfie aesthetics open up alternative temporalities and transformative futures.

These futures can be trans feminist possibilities if we see them that way. In *At Least You Know You Exist*, Zackary Drucker and Flawless Sabrina explore how a film camera produces and transforms their intersubjective encounter as they continue to build a relationship that began with a photograph. Going far beyond being visible, this encounter is about seeing and being seen.[77] You know you exist, they suggest, because you see the other and you are seen by the other; because of how we look at each other, we know that we exist. As the film strip seems to chatter, blur, and break, and as their voices alternate in a call-and-response monologue for two speakers, the film inhabits the past as it documents the present and gestures toward the future—a future that is made possible by the connections and collaborations between generations of trans feminine artists. Watching the film, spectators participate in this relationship, our existence affirmed because we see the film—just as our act of seeing implicates us as witnesses to the lives that we see.

● · · · ·

Doubling

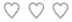

Spinning dots create the impression of circles spiraling over the screen, while two white lines—digitally created but resembling scratches on celluloid film—slowly extend across the frame and form an X. The sound of a car radio mixes with haunting, electronic sound effects as the flickering square frame shows a couple filming each other on a road trip. Occasional lens flares streak across the frame, reduplicating the arms of the X of the opening title. Abrupt jump cuts and the absence of diegetic sound reinforce the analog, home movie aesthetic. As the image flickers, we feel a sense of intimacy—but an intimacy that is very clearly of the past. Amid the distorted tones of the soundtrack, the trans artist Zackary Drucker begins speaking in voice-over, describing a couple who plunged into deep waters where "letting go was our only chance of survival." She continues the story, recalling, "We could only swim to the surface alone, and when we reached air, we both looked . . . different." In a muffled, muted voice, the trans filmmaker Rhys Ernst echoes Drucker, adding, "The whole world looked different."

Evocatively titled *X*, a homonym of *ex-*, Drucker and Ernst's 2014 video functions as a making—*and* unmaking—of documentary, exploring the dissolution of the partnership that the duo documented in their self-portraiture series *Relationship* (2008–14).[1] Capturing six years in the lives of the two artists, *Relationship* follows them as they build their relationship and transition

together. Originally a private record, this archive of portraits became public almost accidentally when it became a last-minute companion piece to a different film that the artists exhibited in the 2014 Whitney Biennial. Eventually, *X* also became part of the project, accompanying other gallery installations of *Relationship*. The series explores how individuals and the world can change together, and it does this through repeatedly invoking the visual rhetoric of doubling—including mirrors, shadows, reflections, and multiple figures. Through doubling, selfie aesthetics transforms the mirror from a symbol into a formal strategy, inviting us to reimagine how self-constitution and transition are represented.

Within photography, doubling has particular power, for photographs themselves have long been understood as doppelgängers, and even as skins or films that peel off the surface of the body and pursue a distinct though never entirely separate existence.[2] An image of Drucker from *Relationship* displays the haunting effects of photographic doubling, evoking the long exposures that were required by early film stocks. In the image, Drucker reclines on a bed and, through double exposure, a semitransparent echo of the artist seems to be rising out of her body as one self pulls or peels away from the other (figure 1.1).[3] This particular image dramatizes the photographic double separating from the body, an effect that is implicit throughout analog photography, because photographs preserve the light that reflected off the subject's body at a particular moment in the past.[4] In *Camera Lucida: Reflections on Photography*, Roland Barthes describes this phenomenon, writing that when we look at a photograph we experience a complex relationship to time and to the photograph's referent: "What I see has been here, in this place.... [I]t has been here, and yet immediately separated; it has been absolutely, irrefutably present, and yet already deferred."[5] In digital photography, including selfies, the transfer of light from the subject to the image is less direct than in the analog practice Barthes describes. Yet when we encounter a digital photograph, our experience is not as different from analog photography as some medium-specific theories might claim.[6] Far from blocking photography from articulating "that-has-been," digital photographs remain phenomenologically connected to their referents.[7] It's this bond between image and referent that Amanda du Preez draws on in describing selfies as "doppelgängers."[8] Indeed, our sense that photographs operate as our doubles persists across the analog-and-digital divide, requiring us to reexamine the assumption that digitality frees images entirely from their referents.

Doubling draws attention to identity's relationality, highlighting that "identity" means both individually held identity and shared sameness or re-

• • • • • • • • • • •

Figure 1.1 *Relationship, #47*, by Zackary Drucker and Rhys Ernst, 2008–13.
Courtesy of the artists and Luis De Jesus Gallery Los Angeles.

semblance.[9] Doubling—whether through mirroring, reflections, shadows, or other forms of duplication—is also a formal effect, emphasizing the role that technics play in constructing selves as individual or as relational. Thus, doubling is not merely an invocation of some kind of essential duality. Rejecting the trope that trans people are forever in flux between the fixed positions of man and woman, my reading of *Relationship* shows how doubling, duality, transition, and transformation are materially produced and carefully constructed ways of seeing and being selves. Through this reading of the visual rhetoric of doubling in *Relationship*, I interrogate how mirroring contributes to self-constitution. As its companion piece, *X* complements *Relationship*'s exploration of doubling by revealing another mode of doubling that goes beyond simple mirroring: the mise en abyme. Both vertiginous and structured, a hall of mirrors reflects and refracts without dissolving into total fluidity.

In this chapter, I offer readings of selfies and self-portraits by Drucker and Ernst, Vivek Shraya, and Tourmaline in which doubles proliferate. Through doubling, I argue, these images invite us to revisit two recurring tropes within trans representation: how spectatorial experience is analogized to the Lacanian mirror stage and the trope of the mirror scene. Gender transition

is often imagined as a rebirth from which a new self is constructed; therefore, it is unsurprising that *Relationship* has been analyzed through the mirror stage.[10] Capturing the artists as they transition, build their romantic and artistic partnership, and eventually break up, *Relationship* could appear to replicate the mirror stage's linear trajectory. However, a closer look at these images reveals that Drucker and Ernst are not merely re-creating the Lacanian encounter with reflection. Instead, they use formal strategies to deconstruct the way Lacan's theory is often deployed in media studies. Thus queering the mirror stage, their work shows selfhood to be relational and messy, and through doubling they demonstrate how creative labor constructs images of selves as separate, bounded, or intertwined. Meanwhile, the trope of the mirror scene is pervasive within trans representation. As the cinema studies scholar Cáel Keegan notes in his work on trans representation, it usually represents a "perceptual limit."[11] Doubling the trans subject, the mirror scene conventionally begins and ends with gender dysphoria. Yet by incorporating additional reflections into the image of mirror reflection, selfies can explore the shifting positions and proliferating doubles within the mise en abyme. In doing so, these images do not merely celebrate selves as sites of postmodern fluidity. Through the visual rhetoric of doubling, selfie aesthetics resist queer theory's demand that "trans" stand for formless, unfixed flexibility by showing how transformation is not an automatic fact of trans experience but, instead, a possibility and an effect that must be materially constructed.

Through its formal specificity, doubling helps us see both transition and digital self-representation as realist techniques that have particular, world-building potentialities. Instead of functioning as figures of imaginary fluidity, trans experience and digital image making can be literalized, actualized, and materialized through the visual rhetoric of doubling. In this way, selfie aesthetics can help us to see obscured realities that are already present, that challenge the status quo, and that can be the grounds for liberatory futures. Here, I'm indebted to Grace Lavery's discussion of "trans realism," which she develops by reading realist aesthetics through George Eliot's novels and Sigmund Freud's theory of psychoanalysis. As Lavery explores it, realism is as much about subjective knowledge as it is about objective observation, and she writes that realism offers "a negation of the actually existing world's conventional pieties."[12] For Lavery, "trans realism" captures how trans self-knowledge refuses the constraints of cisnormative society. In this chapter, I show how doubling operates as a technique of trans realism, deconstructing the "conventional pieties" that shape how reflective aesthetics are typically understood in relation to trans self-representation. Here, self-

representation is a form of *techné*—"dynamic means in and through which corporealities are crafted, that is, continuously engendered in relation to others and to a world."[13] My book focuses on the possibilities that emerge from trans self-representation, but I am not proposing any extraordinary or privileged connection between selfies and trans identity. Following scholars in somatechnics such as Susan Stryker and Nikki Sullivan, who contend that all bodies "are always already enmeshed/enfleshed in (and through) a sociotechnical apparatus," I seek to explore how embodiment and technology are mutually constituted without drifting into either technological determinism or identity-based exceptionalism.[14]

Ultimately, whether the selfie creator is trans or cis, selfies have an overt and apparent relationship to self-constitution, given how selfie doubling allows us to see, stage, document, and reflect on the self. In an interview, the trans artist Vivek Shraya describes her relationship to her self-as-selfie. For Shraya, selfies are central to her transition, and she argues that some of the very qualities that are commonly held against selfies—for example, their potential solipsism and the way they freeze a moment, disconnecting it from "real life"—are the precise qualities that make selfies able to facilitate the sometimes private process of self-discovery.[15] Shraya, an award-winning author, poet, musician, and artist, is a creative writing professor at the University of Calgary; her books include the poetry collection *even this page is white* (2016), the children's book *The Boy and the Bindi* (2016), and *Death Threat* (2019), a graphic novel about receiving transphobic hate mail. With her brother, she is part of the musical duo Too Attached to Pop, and her solo albums include *Part Time Woman* with the Queer Songbook Orchestra (2017), featuring her coming-out song, "Girl, It's Your Time." In addition to her gallery-based photographic work, Shraya explores self-representation through selfies. She says selfies were central to her transition, with her selfie doubles reflecting possibilities that she then explored beyond photography. "During my transition," Shraya says, "I have often wished I was a photograph because, as a photo I am not reduced to a pronoun or an identity. As a photo, I don't have to answer invasive questions and worry about physical violence. As a photo, I get to be me."[16]

Along similar lines, Drucker describes herself as part of "a long tradition of trans people using photography to construct identities outside the constraints of their physical and social realities."[17] I would add that this is a tradition that often relies on the visual rhetoric of doubling. Drucker's words appear in the exhibition catalog for the San Francisco Museum of Modern Art's exhibition of thousands of private Polaroids taken over thirty years by

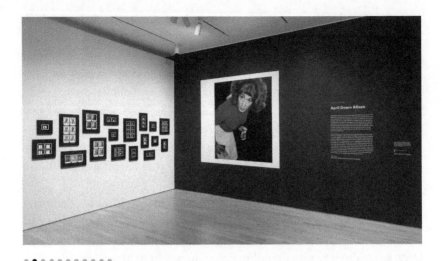

Figure 1.2 Installation view of "April Dawn Alison" exhibition, San Francisco Museum of Modern Art, July 6–December 1, 2019. Photograph by Katherine Du Tiel. Used with permission of San Francisco Museum of Modern Art.

an Oakland photographer who used the images to produce, explore, and document a femme identity using the name April Dawn Alison. Discovered and exhibited posthumously, these analog self-portraits stage their own vertiginous explorations of the mise en abyme, even as the entire project was almost entirely confined to the photographer's apartment. For example, in one important image from this collection, the photographer poses while holding multiple Polaroids, a set of semidisposable snapshots that depict other poses, costumes, and moments. This image offers a glimpse into how doubling was operating within vernacular, ephemeral self-representation prior to selfies. Furthermore, its subsequent history, especially its inclusion in the exhibit where it is blown up to fill an entire wall, points to the ripple effects of doubling (figure 1.2). Through deploying doubling's ripple effects, selfies can construct and communicate complex ways of being and becoming. Indeed, as Drucker and Ernst describe, self-transformations also mean that "the whole world look[s] different." Allowing us to imagine futures that are different from our present, selfie aesthetics can trace how self-transformation is tied to collective liberation, helping us to see how trans feminist futures might emerge from our encounters with self-representational art.

Posted in 2016, a mirror selfie by the artist and filmmaker Tourmaline asserts that reflective aesthetics in selfies can help us envision utopian politi-

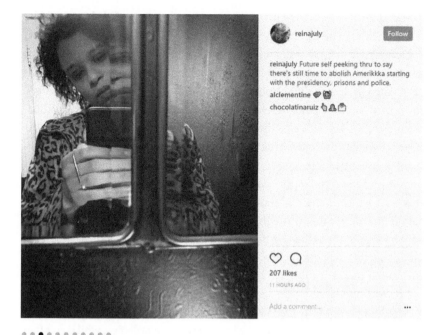

reinajuly

Follow

reinajuly Future self peeking thru to say there's still time to abolish Amerikkka starting with the presidency, prisons and police.

alclementine 💚 📷

chocolatinaruiz 👏 💪 🖐

207 likes

11 HOURS AGO

Add a comment... ...

Figure 1.3 Selfie by Tourmaline captioned "future self peeking thru," 2017. Screen grab by the author. Used with permission of Tourmaline.

cal potential. Tourmaline, an activist, writer, historian, and filmmaker based in New York, has worked in the art world, in nonprofits, and in academia, formerly under the name Reina Gossett. Tourmaline's work combines detailed historical research with social justice. She is one of the editors of *Trap Door: Trans Cultural Production and the Politics of Visibility* (2018). Her time-traveling film *Salacia* (2020) retells history to imagine a past in which the trans feminine sex worker Mary Jones escapes incarceration in the 1830s to join the free Black community of Seneca Village, intercutting this story with archival images of the trans revolutionary Sylvia Rivera in the twentieth century.[18] Her archival research uncovered and preserved Rivera's speech, "Y'all Better Quiet Down," from the Christopher Street Parade of 1973, and her artistic practice celebrates trans feminine resistance.[19]

Selfies, like Tourmaline's other work, are not only a creative outlet but also a vehicle for imagining liberatory futures. In an exemplary selfie (figure 1.3), Tourmaline captures her reflection in a beveled mirror. The image resonates with a sense of history, for Tourmaline wears a leopard print coat, and the mirror is set into a richly textured metallic wall that also feels vintage. Cap-

tioned "Future self peeking thru to say there's still time to abolish Amerikkka starting with the presidency, prisons and police," this selfie pairs its reflective, contemplative image—resonant of an unspecified historical moment—with a vision of a world beyond white supremacy and state control. This vision is articulated by Tourmaline's double, or "future self," who is "peeking through" the mirror. Because of its beveled edges, the mirror distorts and twists Tourmaline's reflection. It seems that Tourmaline's "future self" is not the undistorted double that occupies the main body of the mirror but, rather, the fragment of a face peeling, pulling, or dripping away across the beveled edge. As viewers, we seem to be poised between the past of the actual photographic moment, which is highlighted by the vintage clothing and mirror, and the future that is "peeking through," calling us forward. Without directly representing liquid, the selfie rhymes with the visual effect of ripples dispersing and distorting reflections in a pool of water. Through doubling, selfie aesthetics can transmit a utopian message about the future, with rippling effects on the world today.

Doubling is not restricted to the realm of representation, for it also shapes spectatorial experience—particularly so in the case of selfies, which so often are viewed through the very technologies and applications that make selfie creation possible. When we look at selfies using the same technology that creates them, the result is mirroring among image, creator, and audience. This resembles—and extends—how similar mirroring effects operate in self-portraiture. As I discuss in the introduction, self-portraiture often employs aesthetic strategies that reach out toward the viewer, positioning the viewer and the image as each other's doubles. The look back bridges the gap between the space of the image and the space of the viewer, but other techniques also deconstruct and cross this boundary, including unfinished edges and objects that seem to spill out of the frame. Implicitly, any hand that disappears beyond the edge of the frame could be the hand producing the image. In selfies taken with front-facing smartphone cameras, at least one hand usually extends just outside of the frame. This creates a striking effect as the selfie's subject reaches out toward the viewer with exaggeratedly long, distorted arms. The media scholar Marina Merlo describes this as the essential selfie pose, but selfies in which the pose is far subtler also produce this effect of a hand extending into the space occupied by the viewer.[20] Furthermore, selfies are not just created using smartphones. They are also often consumed on smartphones and, as we look at selfies, our hands end up holding our phones in a gesture like the gesture that produced the images we see. As a result, doubling involves a mutual gesture of reaching out toward the other, yet never

quite touching. This fact of contemporary selfie production and reception is neither necessary nor sufficient for a selfie to function as such, but it shows how doubling extends beyond the visual to incorporate the physical and tactile. As viewers, we reproduce the gesture that created the image, an image that metaphorically reflects us on the same screen that might, in another moment, literally mirror us, as selfie-viewer-turned-selfie-creator. This mise en abyme of proliferating reflections—both literal and metaphorical—is one more ripple effect made possible by doubling.

Queering the Mirror Stage

Using doubling to create "a perfect X," Drucker and Ernst's *Relationship* explores the role of mirroring and doubling in self-constitution.[21] One review of the series states evocatively that it "documents the bittersweet coming-of-age of two people in love, who grow into their gender identities as if passing each other through a looking glass."[22] Because the artists mirror and reflect each other during this mutual process of becoming, critics have read the series in dialogue with the Lacanian psychoanalytic theory of the mirror stage.[23] Indeed, when I first met Drucker, I asked her whether she and Ernst saw their work as re-creating the mirror stage; she said it was possible that Jacques Lacan's theory was in the back of her mind when she was developing self-representational work but that she would leave the interpretation of her art to critics.[24] Over time, as I have continued studying Drucker's work, I've realized that her self-representational art is doing far more than illustrating the theory of the mirror stage. In *Relationship*, for example, the series' use of doubling, I contend, actually challenges the mirror stage's model of self-constitution, particularly as it is sometimes understood within media studies—as a developmental process that is repeatedly re-created through spectatorial experiences that idealize normative wholeness. The selfies and self-portraits in the series challenge the idealism of the singular, unified self *because* the series uses formal strategies to interrogate the surface of the mirror, our fantasies about digitality, and the subgenre of "transition selfies."[25] As a result, the series does not limit the connection between self and reflection to the narrow teleology described by media studies' accounts of the mirror stage—or by dominant narratives about transition. Part of the subgenre of transition selfies, *Relationship* has been analyzed through the same teleological framework that is often applied more broadly to such images. However, the series undoes a model of self-constitution in which the self aspires to and mimics the idealized wholeness represented by an image. By doing so, *Rela-*

tionship offers us other, more complicated ways of understanding relationality and transition.

Although the series began with several selfies shot with an inexpensive, digital point-and-shoot camera, *Relationship* eventually evolved to include more elaborately staged and professionally produced portraits and self-portraits, employing the visual rhetoric of doubling to capture fleeting moments from Drucker and Ernst's relationship. In this way, the series offers a chance to explore how selfie aesthetics shape both selfies (as they are commonly understood) and other art practices, from portraiture to experimental film. Appearing in the 2014 Whitney Biennial as a companion piece to Drucker and Ernst's short, experimental narrative film *She Gone Rogue* (2012), *Relationship* was exhibited later that same year at the Luis De Jesus Los Angeles Gallery along with *X*. For this show, the title of the self-portrait series was sandwiched between terms that mark the temporality of a breakup: *Post/Relationship/X*. Across both the series and the video, Drucker and Ernst double each other through pose, gesture, and other formal strategies, producing a record of a relationship that emphasizes the importance of intersubjective reflection. As Drucker says, describing their relationship, "We converged, we collided, we intertwined, inseparable for years."[26] Drucker's words evoke the closeness of their connection, but the phrase "inseparable *for years*" also gestures to the temporal limits of their closeness. As *X* documents, and as some of the final photographs in *Relationship* reveal, the visual rhetoric of doubling not only represents relationality as the intimacy of closeness, resemblance, and love, but it can also speak of distance, inscrutability, and break.

As Drucker describes it, *Relationship* captures Drucker and Ernst mirroring each other as they created "a perfect X, crossing each other from one position to another."[27] This reflexive "perfect X" emerges through their use of mirrors, shadows, blurring, and double exposure. Drucker and Ernst also serve as mirrors or doubles for each other, for the series juxtaposes their bodies as they resemble each other amid their differences. Through the visual rhetoric of doubling, the series deconstructs the singularity of the subject. What emerges, as Drucker and Ernst double each other, "converging, colliding, and intertwining" before separating and becoming "X," is a vision of the subject as fundamentally relational—a relationality that is collaborative, constructive, and affirming, as well as conflicted, deconstructive, and heartbreaking.

"Flawless through the Mirror" (figure 1.4), an image late in the series, demonstrates how *Relationship* examines the ambivalence of relationality

Figure 1.4 *Relationship, #44 (Flawless through the Mirror)*, by Zackary Drucker and Rhys Ernst, 2008–13. Courtesy of the artists and Luis De Jesus Gallery Los Angeles.

through careful formal construction. Drucker appears to be taking the photograph, her arm outstretched as the frame cuts off the right side of her body. The pose resembles a double selfie, as Drucker and Ernst look off frame left and appear to seek out the moment to capture and freeze this image of themselves. Dramatically staged along a diagonal, the composition draws our eyes into the depths of the image. There, a mirror serves as a frame-within-a-frame, rhyming the doubling of the artists' two bodies by itself reflecting yet another frame. Doubling the framing devices produces a mise en abyme-like impression of endless depths.

In the photograph, the two figures stand near each other, but not touching. The distance between them is emphasized by the wide-angle lens, while shadows mark the line between Drucker's arm and Ernst's body. However, projected onto Ernst's body, Drucker is doubled in two shadows that overlap and intertwine. This creates a single compound figure with four arms and the hint of two faces—a figure that they explore elsewhere in the series. By using shadows and silhouettes, Drucker and Ernst repeatedly represent themselves as a unified, doubled body. These images evoke Aristophanes's account of love from Plato's *Symposium* and, of course, the animated musical version of the

same myth, "The Origin of Love," from the film version of *Hedwig and the Angry Inch* (John Cameron Mitchell, dir., 2001).[28] But here, in "Flawless through the Mirror," the image of the double-bodied being appears as one part of a larger image. As an image-within-an-image, the silhouette's flatness stands in contrast to the three-dimensionality of their material bodies as well as the photograph's exploration of depth. By dissolving boundaries, the doubled silhouette highlights the very real distance between the partners. The melancholy, blue-tinged photograph shows Drucker and Ernst's bodies serving as the literal support for an image of perfect union. By creating an image of love and wholeness that only becomes possible through representational trickery, the photograph stages the desire for this idealized union along with its real impossibility. "Through the mirror," or as an image, their connection can be imagined as perfect and "flawless," yet this possibility is revealed to be a construction that cannot foreclose their eventual breakup. Unlike other images in *Relationship* that play with the idea of the double-bodied being, this photograph lays bare the process that creates this union *as an image*—and only as an image. This production process is both fueled and ultimately undone by the desire for wholeness it seeks to realize.

While the devastating power of this desire is not entirely absent from the canonical account of the mirror stage, it is deemphasized in favor of the imagined wholeness that is the object and fuel of that desire. By contrast, *Relationship* challenges the image's idealized wholeness, staging selfhood as complicated, messy, and intimate—precisely those qualities that the mirror stage understands as *un*desirable. In Lacan's story of the mirror stage, an infant sees *his* reflection in the mirror, understands this reflection to be *himself*, and identifies with it. While the infant has previously experienced himself as messy, uncoordinated, and incomplete, with uncertain borders and boundaries, he sees the idealized image in the mirror as whole and discrete, with clear boundaries. For the rest of his life, the subject will seek to become the idealized image reflected in the mirror. By identifying with the idealized image, the child understands that he is separate from his mother and therefore enters into the Symbolic, which is the realm of language, law, and the Father.[29] As Lacan argues, the mirror stage is not necessarily an actual, literal occurrence in each individual's life. Instead, it describes a process of self-constitution that is clearly that of a patriarchal, hetero- and cis-centric society—hence, why I use he/him/his pronouns to retell this story. The mirror stage bases subjectivity on a constitutive, rather than contingent, recognition of and response to *lack*. This leads to theoretical and ethical problems when the contingent suffering of oppressed subjects is confused with the constitutive

incompleteness all subjects experience.[30] In the mirror stage, subjectivity is mediated by the visual, which privileges the distance required by the sense of sight over the nearness—and the potential boundary confusion—of other senses, such as hearing and touch.[31] As Meredith Talusan writes about *Relationship*, "Like a photograph, the other person in a relationship, regardless of how similar they may seem, is always an imperfect mirror, their sameness a projection of a human desire for complete understanding that ultimately proves impossible."[32] Of course, Lacan's account of the mirror stage emphasizes our *desire* for completeness, along with its impossibility. However, our drive toward wholeness, boundedness, and individuation orients us away from the messiness of intersubjective relations and the nonlinear trajectories of personal growth. When media studies maps the mirror stage onto spectatorial experience, understanding mediated images as ego ideals, this theoretical framework forecloses the possibility of moving outside of this developmental stage to read images as offering other kinds of ideas and imaginaries.

A record of two people transitioning together, Drucker and Ernst's series interrogates the mirror stage's teleological drive toward the idealized image—a drive that also structures stories about transition. The "conventional pieties" around transition narratives are clearly demonstrated in "before and after" transition selfies, a subgenre of selfies that presents transition as a process with a clear, bounded, and idealized destination. In Tulsa Kinney's assessment of *Relationship*, these normative assumptions are obvious: "Typically, men get a little more manly, and women get a little more womanly. But in Drucker and Ernst's cases, it's a bit skewed. At that particular time and period, they were also transitioning. So it's more like Zackary Drucker becomes more womanly, and Rhys Ernst becomes more manly."[33] In Kinney's biographical sketches of the artists, the subheadings reinforce the idea of linear transition: "when he was a she" and "when she was a he." Such language not only goes against the usage recommended by the GLAAD *Media Reference Guide* that was available at the time that Kinney was writing.[34] It also asserts that gender transition begins from a stable origin point and aims at realizing normative, binary gender identities. Yet in *Relationship*, the artists critique the teleological model of transition. They do this through sophisticated artistry and through sophomoric visual puns. Repeatedly, Drucker and Ernst pose with breakfast foods—eggs, sausages, and grapefruit—substituting for the genitals that a teleological model of transition would require them to desire/acquire. Elsewhere, Drucker and Ernst use double exposure to represent selves as multiple, peeling or pulling away from each other through

effects that leave ghostly trails and sticky webs of connections between these selves—imagined as both plural and proliferating. These images are haunted by the desire to escape from a stable and idealized self rather than to realize it perfectly. As Drucker says, the "greatest transition of all" would be a societal or structural escape from gendered categories rather than an individual journey to a clearly delineated destination.[35] Emphasizing "escape from" rather than "trajectory toward," this vision of transition turns away from the certainty and coherence of our present categories and turns to an uncertain future whose possibilities are blurry and ill-defined. If we are to imagine other possibilities, and visualize them through formal strategies, this approach to queering the mirror stage is necessary.

To some extent, this is precisely what Leslie Dick argues that Drucker and Ernst achieve in her article "On Repetition: Nobody Passes."[36] Closely connected to Drucker and Ernst's work, Dick's article appeared in the Fall 2014 issue of X-TRA *Contemporary Art Quarterly*, which was launched at Luis De Jesus Los Angeles Gallery during its exhibition of *Post/Relationship/X*. The centerpiece of the launch party was a conversation between Dick and Drucker.[37] In her article, Dick says that Drucker inspired the title, "Nobody Passes," when Drucker was asked during a Q&A session whether the idea of "passing" as another gender was outdated. Reportedly, Drucker replied, "Yes, I think nobody passes." For Dick, this phrase shows us how the mirror stage becomes undone through digital photography, for "we all fall short and at the same time exceed the limits of the image, that ideal image that promises a control and a completeness that will always elude us." Invoking "the digital" as a symbol of postmodern fluidity, Dick's argument is, ultimately, somewhat technologically deterministic and reductive. Furthermore, Dick does not address whether *Relationship* in fact begins the task of queering the mirror stage. However, I contend that the series explicitly pursues this project and, moreover, that *Relationship* is able to do so in ways that exceed and extend the scope of the undertaking as Dick imagines it.

Within the logic of the mirror stage, subjectivity requires us to continuously identify with the idealized image, which represents the goal to which we aspire. For Dick, photography and subjectivity are intimately connected, and the self is maintained through a process of passing—passing as the whole, complete, and coherent image captured *by* photography. According to Dick, the fantasy of this ideal self was preserved by analog photography, with its material limitations and its indexical ties to referential reality. However, upon the advent of the digital, Dick writes, we realize: "Nobody passes, despite the apparently infinite repetitions of the digital, as the image becomes

● ● ● ● ● ● ● ● ● ● ●

Figure 1.5 *Relationship, #1,* by Zackary Drucker and Rhys Ernst, 2008–13.
Courtesy of the artists and Luis De Jesus Gallery Los Angeles.

inconsistent and cannot be measured against a preexisting reality. Nobody passes, and with that we can perhaps move beyond ideals of control, completion, and totality, to a space of uncertainty that is both impossible and beautiful." In this account, the mirror stage can be queered because digital technology allows doubles and copies to proliferate beyond anything that was previously possible—while simultaneously dissolving our faith in the image's veracity. Therefore, Dick suggests that digital image-making itself automatically queers the mirror stage.

Yet Drucker and Ernst's photographs challenge the concept of the idealized, bounded, complete, and individuated self *not* merely through their status as digital images but, rather, through their aesthetic exploration of doubling. In a blurred mirror selfie in the series (figure 1.5), the mirror reflects the two figures as they double each other, and the photograph's low-resolution digitality confuses the boundaries between their two bodies. Here, selfhood is inextricable from relationality to the other—and to technology. Evoking Steyerl's "poor image," this out-of-focus, pixelated, and low-resolution selfie

flaunts its digital imperfection.[38] Of course, Steyerl's "poor image" circulates freely as a copy of a copy, defying the aura of the original, while this image has been elevated to the status of a gallery-worthy artwork, despite its genesis as a low-quality snapshot taken with a low-resolution point-and-shoot camera. Instead of offering an idealized image that serves as a stable, aspirational goal, this image is in motion, both in its online existence and in its composition, which is blurred by the exuberance of the affectionate gesture it captures. This selfie is titled *Relationship, #1*, indicating that it is the beginning of a story. But unlike the story of the mirror stage, this mirror image offers something else: it is incomplete, a fraction of a moment, and the bodies in this mirror streak and blur into each other. Ernst's nose seems to blend into Drucker's ear, and flashes of silver from the camera get mixed up with the flesh of Drucker's hand. Rather than an image that allows the self to be successfully constituted, or "gathered together," this image appears to be shattering, dissolving into the joyous desire it fleetingly captures.[39] As we look with the camera, its technological limitations allow us to see the couple dissolving into each other in their mirror reflection. The result is a vision where the self is intimately interpenetrated by the body of another and by technologies of vision and recording. Through its form rather than its digitality, the selfie captures the energy and erotics of "technogenesis," the co-evolutionary process through which humans and technics mutually constitute each other.[40]

Indeed, throughout *Relationship*, doubling is less about the nature of digital media than a thematic and aesthetic issue. Across the series, doubles proliferate in images that incorporate literal mirrors and in images that produce doublings that exceed the mirror. In *Relationship, #8* (figure 1.6), Drucker is reflected in a mirror and in another reflective surface; she is additionally doubled by other images and objects within the photograph. Frames within frames abound in this image. They include the makeup mirror that reflects Drucker most clearly; the picture frame that superimposes Drucker (framed by the doorway of a room behind her) over an enormous face; and the small circular frame in the lower right-hand corner that features a double portrait. The makeup mirror not only reflects and doubles Drucker; it links tactile, intimate processes of "image making"—makeup and other practices that stylize the body—to more distanced, detachable, and primarily visual processes, such as taking photographs. As doubles of Drucker proliferate across the frame, singularity scatters into multiplicity. Mobile, destabilized, and multiple, doubling offers an alternative vision of self-constitution: a journey with many potential pathways and no single, normative destination. Instead of an idealized image of the bounded, separable self, this image actively explores

Figure 1.6 *Relationship,*
#8, by Zackary Drucker
and Rhys Ernst,
2008–13). Courtesy
of the artists and
Luis De Jesus Gallery
Los Angeles.

the questions that Dick attributes to digital ontology when she asks: "What happens when the mirror is itself both de-stabilized and mobilized, becoming a disparate collection of different sized screens, multiple windows framing the world in a series of temporary, arbitrary articulations?" According to Dick, digital technology detaches images from their referents, and, as a result, "all the framing devices melt into air," undoing the socially constructed categories that confine us.

Technologically deterministic, Dick's article asserts that digitality is inherently unfixed. As a result, Dick's argument obscures how *Relationship* creatively intervenes in media studies discourses about the mirror stage. In *Relationship*, framing devices don't disappear; they are marked and thus recognizable. Instead of (impossibly) seeking to embody the image, *Relationship, #33* (figure 1.7) shows how mirror reflections can manipulate space and proximity to produce the impression of distance and discreteness. At first glance, Drucker and Ernst appear to stand in separate planes, because the mirrors that reflect them are different distances from the camera. However, it seems likely that they are in the same room, and that Drucker is reflected in a mirror in the bathroom, a mirror just outside the room where Ernst is standing. If this is the case, Drucker is quite close to Ernst while she takes the photograph, and it is the image—rather than the real space—that separates them through the multiple frames of doorways and mirrors. We can sense Drucker holding the camera, a camera that is close to the white wall that

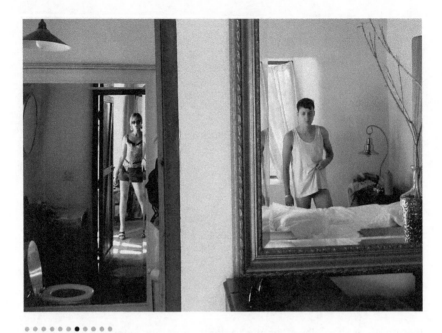

Figure 1.7 *Relationship, #33*, by Zackary Drucker and Rhys Ernst, 2008–13.
Courtesy of the artists and Luis De Jesus Gallery Los Angeles.

splits the frame and visually separates the two artists. The crispness of the image throughout its planes suggests that it was shot with a normal to wide-angle lens, rather than with a telephoto lens, and thus supports this sense of proximity among the camera, the wall, and the piece of furniture—the only elements of this scene that are not refracted through mirrors.

In *Relationship*, the very function of mirroring is transformed as the reflection, the shadow, and the double become a question of unknown depths rather than knowable surfaces, evoking a mise en abyme. The multiple mirrors in *Relationship, #33* may not appear at first glance to represent a mise en abyme, especially given that they are beside rather than opposite each other. However, a Google image search based on this photograph suggests "related images" that include multiple hall-of-mirrors selfies. Building on this algorithmic insight, I suggest that the image's play with multiplicity and depth aligns it with the mise en abyme. The hall-of-mirrors effect is yet another way Drucker and Ernst challenge the logic of the mirror stage. Because it refracts the reflection into an infinite series that disappears into the depths of the

two-dimensional mirror, the mise en abyme dissolves the stability of the very surface that is supposed to produce the coherent image of the bounded self.

Like reflections in water, superimposed on unknown, murky depths, the mise en abyme opens up the flat surface of the mirror and undermines its one-to-one correspondence between body and reflection through multiplicity and depth. Here, I am not speaking metaphorically of a "deeper" or "richer" sense of self that goes beyond the superficial. Rather, I am referring to the aesthetic sense of depth generated by the mise en abyme, or, in other words, the formal effects produced by these photographs. As doubles of Drucker and Ernst multiply, proliferate, and recede into the depths of the images they create, *Relationship* queers the mirror stage by both denying the idealized image of the complete and separable self and challenging the mirror's investment in the coherent surface. In *X*, Ernst says that after the couple emerged from beneath the waters, "the whole world looked different." After *Relationship*, the mirror itself, I argue, looks different. No longer a self-evident object whose relationship to self-constitution can be narrativized teleologically, the mirror is transformed as the relay of reflection, relation, and doubling offers multiple possibilities of being and becoming.

From Mirror Scene to Mise en Abyme

The mirror stage tells a general story of self-constitution, but within trans representation, mirrors—and the doubles they create—have additional significance through the trope of the mirror scene. *Relationship* not only queers the mirror stage; it also shows how the mise en abyme can replace the mirror scene. Selfies by Tourmaline and Shraya refract the mirror scene yet further, as the reflective sunglasses they wear enhance the hall-of-mirrors effect. The mise en abyme challenges the mirror scene's teleological trajectory, but not by privileging unmoored flexibility. Instead, the mise en abyme makes us aware of the material structures, technologies, and choices that produce its dizzying effects. Encountering a hall of mirrors, we enjoy the vertiginous experience and at the same time seek out indications of how it was constructed. We delight in losing track of the distinction between self and reflection and simultaneously desire to understand the mechanics that make this experience possible.

A recurring trope within trans narratives, the mirror scene is the cliché encounter between a trans subject and their reflection. From *Transamerica* (Duncan Tucker, dir., 2005) to *Girl* (Lukas Dhont, dir., 2018), the mir-

ror scene is pervasive in cinema and television about trans characters.[41] In trans autobiographies, mirror scenes are "a trope of transsexual representation" that present self-reflection as "only disidentification, not a jubilant integration of body but an anguishing shattering of the felt already formed imaginary body."[42] According to the trans filmmaker Bea Cordelia, this stereotype has to be deconstructed, and Cordelia calls for artists to restage and reimagine narrative scenes involving trans characters seeing themselves in mirrors.[43] Nonetheless, the mirror scenes in *The T* (2018), a web series by Cordelia and Daniel Kyri, still grapple with the weight of the trope's accumulated pathos. As Keegan writes in "Revisitation: A Trans Phenomenology of the Media Image," the mirror scene not only represents trans subjects as tragic, but it grounds trans subjectivity in a fundamental—and exceptional or unique—sense of lack. Instead, Keegan values images of reflection in which "the face-to-face loop offers us an endless space of becoming in which singular subjectivity is forever forestalled." In such an encounter, he writes, "there is no failure to 'be' because there is no 'self' at which to arrive."[44]

Keegan's language evokes the vertiginous exchange of the mise en abyme. "How might one face ever regard the other?" he asks. "Always this ceaseless movement, always this falling in and through myself, never arriving. Always looping back, never landing."[45] To a certain extent, Keegan's work might seem to indulge the fantasy in queer theory that trans subjectivity symbolizes unfixed postmodern fluidity. Yet as this evocative description makes clear, Keegan is imagining "trans" not as transcending the material but, rather, as a phenomenological experience of embodiment's capacities and limitations.[46] In this way, Keegan's contributions to the project of reading cinema as a "trans*" technology attend carefully to sensation, and I follow his emphasis on spectatorial experience in my reading of mise-en-abyme effects in selfies.[47] By rejecting the mirror scene's teleological model of subjectivity, the mise en abyme brings the spectator into a new relationship to the image. "Always looping back, never landing," it makes us aware of how the *impression* of ceaseless movement and endless fluidity is produced. Material and yet not stable, gender and images are among the many technologies that can help us think, feel, and imagine ourselves taking and working on the forms of our bodies and lives. Through the hall-of-mirrors effect, selfies can evoke the rippling instability that prompts us to read transition through the fluidity of water metaphors, but without losing sight of the actual technologies and formal strategies that make these effects materially possible. This happens both in "mirror selfies" and in selfies that incorporate reflections into the image in other ways.

Captured with a rear-facing camera by a creator posed in front of a mirror, mirror selfies are a recognizable subgenre of selfies. By incorporating the camera's reflection into the image, mirror selfies put pressure on the surface of the mirror and on the boundaries of image (figure 1.8). The reflected smartphone draws us into the depths of the image, and we are positioned simultaneously outside the photograph and within it. Exceeding the multiple positionality possible in painted self-portraiture, the smartphone's perspective is the image that the viewer eventually experiences in a selfie. Thus, our position coincides with the smartphone's position. In mirror selfies, we are confronted by an image that not only presents a human figure to whom we might relate as a metaphorical reflection of ourselves. In addition, we see the reflection of the tool through which the image is created as well as the object with which our look is aligned—even as it also appears to be pointed at, and hence photographing, us. As a result, our position is fractured. We are divided between the positions of the smartphone camera, the subject of the photograph it is creating, and the smartphone's reflection within the image—a reflection that we know holds, on the side that is hidden from us, a reiteration of this same image of reflection, an image that then repeats again and again. Looking at such selfies recalls Michel Foucault's analysis of Diego Velázquez's *Las Meninas* (1665), in which Foucault describes the play of positions within the painting as a "spiral" around a "void" or "blind point," "invisibility in depth," an infinite relay of "pure reciprocity," and "magic."[48] Caught in this spiral, our split position is not merely an esoteric insight into subjectivity, nor is it an inherent truth about trans experience. Instead, it is an effect created and maintained by the image and by the apparatus that makes such spectatorial experiences possible.

While mirror selfies evoke a mise en abyme that we cannot see, selfies taken by creators who are wearing mirrored sunglasses make the hall-of-mirrors effect visible. Vivek Shraya's selfies demonstrate this effect dramatically, both in solo selfies and in a double selfie that captures the artist beside her brother (figures 1.9 and 1.10). In solo selfies, Shraya's mirrored sunglasses reflect the image she sees on the screen of her smartphone, offering us a diminutive and reversed copy of the image we ourselves are seeing. Here, Shraya's selfie is doubled in each lens of her reflective sunglasses. Although the image's resolution is not rich enough to allow us to see the sunglasses and the screen within the reflection, we sense that the mirroring exchange between glasses and screen continues long after we can no longer perceive it. In this selfie, Shraya's hands are brought into the image even though her arms reach beyond the borders of the frame. Through this frame-within-a-frame effect,

Figure 1.10 Selfie by Vivek Shraya and Shamik Bilgi, 2017.
Screen grab by the author. Used with permission of Vivek Shraya.

her hands and her smartphone eclipse her eyes. Extending this collage effect further, a double selfie of Shraya and her brother, Shamik Bilgi, uses reflective sunglasses to superimpose Shraya's hand and smartphone over Bilgi's eye. Shraya appears to be kneeling, with Bilgi leaning into the image over her shoulder. Both siblings look directly toward the lens, and hence directly at the viewer, with Bilgi's sunglasses reflecting the smartphone and Shraya's extended hand. We are caught by the dual looks of the two siblings. Yet though we seek out a reflection of ourselves within the glasses, we find only a tiny black rectangle, a vanishing point in the center of Bilgi's eye. Instead of the loop produced in Shraya's solo selfie, in which her sunglasses reflect her own hands, here Shraya's hand is transposed onto Bilgi's eye, a transfer of one sibling's body parts onto the other.

In this selfie, Shraya and Bilgi play with the tension between their similarities as siblings and their many differences across the binary divides of dark and light, male and female. Dressed in black and wearing dark sunglasses, Bilgi is an inverted reflection of Shraya's bubblegum-pink T-shirt and light blonde, highlighted hair. Exaggerating their differences, the sib-

lings often invoke such inverted doubling. As the musical duo Too Attached to Pop, they frequently perform with Bilgi in black jeans and a black leather jacket while Shraya wears a futuristic, sequined blue outfit with dramatically detailed shoulders. Their album covers also feature inverted doubling, with the cover of their 2015 album *Bronze* featuring the two musicians standing back to back, this time in matching leather jackets. The similarities in their clothing and pose only further emphasize Shraya's longer hair and the bronze crown she wears. For their followers, then, this double selfie is contextualized by many images that play with inverted doubling, images in which the reflection is the complement, rather than the reproduction, of the original.

Shraya and Bilgi's double selfie exaggerates the potential for doubles to complement rather than reproduce an "original," yet this mise-en-abyme effect is a possibility that is generally available in selfies. Front-facing smartphone cameras function like mirrors, reversing left and right to offer a mirror-image reflection to the user. This makes it easier to pose for a selfie, since the image on the screen responds to our movements exactly like a mirror—for example, lean right and the figure on-screen matches that action. Applications such as Instagram and Snapchat take selfies without correcting mirror reversal; as a result, the left-right orientation of the face in the final photograph is the same as that displayed on the screen—but the reverse of the selfie creator's embodied face. Thus, when we create selfies, applications such as Instagram and Snapchat mimic the experience of looking at a mirror reflection. Because they don't correct mirror reversal, these applications generate a variety of other effects, including the disquieting experience of seeing a face we know well reversed across the horizontal axis. At the same time, many smartphone camera applications ultimately correct mirror reversal, allowing us to pose as if standing before a mirror, and then, with the click of the digital shutter, we are confronted with the far less familiar image of ourselves as others see us.[49] Correcting mirror reversal abruptly, our relationship to our selfie transforms from reflection to inverted doubling, as the face that looks back at us becomes suddenly, subtly strange.

In Tourmaline's selfies, the mirrored sunglasses she often wears provide ample opportunity to explore how the mise en abyme employs the visual rhetoric of doubling.[50] Through the hall-of-mirrors effect, we are simultaneously interpellated into Tourmaline's selfies and evacuated from the image. This heightens our awareness of the shifting positions produced by the mise en abyme. Here, Tourmaline celebrates her new sunglasses, and reflections proliferate throughout the image (figure 1.11). Not only is Tourmaline reflected in the mirror, but she also seems to be reflected in the double selfie

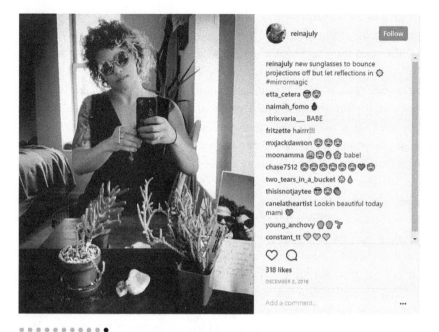

Figure 1.11 Selfie by Tourmaline, 2016. Screen grab by the author.
Used with permission of Tourmaline.

tucked against the mirror's corner. The double selfie features two faces look-
ing back at Tourmaline and at us—their eyes, like Tourmaline's, withheld
by dark sunglasses. One figure resembles Tourmaline, and both Tourmaline
and this reflection of her tip their heads to the left at the same angle. On the
right side of the frame, blue sky echoes the blue blanket on the left.

Tourmaline is reflected in the mirror and seemingly doubled by this dou-
ble selfie, but it is her smartphone, in fact, that is actually doubled within the
image. Reflected in the mirror and in Tourmaline's sunglasses, the smart-
phone creates a mise en abyme between her sunglasses and its screen. This
endless exchange of reflections is withheld from us, and yet is tantalizingly
within reach, for to a certain extent our position coincides with the position
of the camera/screen. Captioning the image "new sunglasses to bounce pro-
jections off but let reflections in [sun emoji] #mirrormagic," Tourmaline cel-
ebrates her mirrored lenses and the protection they provide. She revisits this
theme later, in another selfie with the same sunglasses, captioned "when ur
armor is ur glamour."[51] Framed as armor and as glamour, protecting Tourma-
line from others' projections but allowing her still to connect with the power

of reflection ("#mirrormagic"), these sunglasses are a striking feature of her selfies in late 2016 and early 2017.

The wide framing of these mirror selfies deemphasizes the camera's minuscule reflection. However, in other selfies from this period, Tourmaline poses outdoors, with bright sunlight illuminating her mirrored lenses. Without a wall-mounted mirror, these selfies are necessarily framed more tightly, and they offer a larger and clearer reflection of her smartphone. In some cases, the result is a clear yet diminutive image of the apparatus, distorted by the curvature of the lenses and reflected right over her eyes. As Tourmaline's arms reach out toward the viewer, her hands and the smartphone they hold—which is the space that we feel we occupy, with her arms extended around us—is doubled in each of the mirrored lenses. We are caught up in a hall of mirrors between sunglasses and screen that is still not fully visible, yet the effect of a mise en abyme persists. Confronted by her look, embraced by her outstretched arms, and yet evacuated from the position we feel we occupy by a reflection that does not reflect us, we are present yet absent, doubled yet excised from the image.[52] Elsewhere, Tourmaline takes selfies holding her smartphone off to the side, posing so that it is not reflected at all in her mirrored sunglasses. The evacuation of our position is even more complete. Rather than being doubled by a technological tool whose perspective we feel we share, we are confronted with our utter absence from the image. In these cases, Tourmaline both invites viewers into a relationship of doubling and forecloses that relationship. She seems to offer herself as a mirror for the viewer yet refuses our "projections" through the protection of "#mirrormagic."

Knowing Where to Look

Selfies with mirrored sunglasses draw our attention to our own relationship to the image, dramatizing Keegan's description of a face-to-face encounter in which we are "always looping back, never landing." Yet they also block our ability to see exactly where the selfie creator is looking. These images withhold the direct look into the lens, as well as the slightly askance look toward the smartphone screen that is also a recognizable characteristic of many selfies. Encountering this mise en abyme between mirrored lenses and smartphone screen, we are simultaneously hyperaware of our own fractured look and conscious of our inability to know precisely where the figure within the image is looking. In thus blocking our direct access to the look, such selfies leave open multiple possibilities.

As Shraya says about selfies, "A good selfie is one where you know where to look."[53] Taking Shraya's "you" as a plural, inclusive pronoun, I suggest that "knowing where to look" refers both to eye lines within selfies and to the metaphorical question of where we all—selfie creators and selfie viewers—should direct our attention. By emphasizing the importance of knowing where to look, Shraya's language defies solipsistic narcissism and gives our encounters with self-representation a future-oriented temporality. In the solo selfie described earlier, originally captioned "something wicked this way comes" (see figure 1.9), Shraya's look is barred by her sunglasses.[54] Yet the line of her arm, illuminated by sunlight, leads toward the shadowed screen that we know duplicates the image we see. Although it is obscured by shadow within the image, a vision of futurity that "this way comes" emerges in vibrant color in this relay between the selfie, Shraya, her smartphone, and the spectator. Like Kara Keeling's "black femme function," which points to a future "elsewhere," Shraya's selfies point to the potentiality of brown trans feminine futurity.[55] As demonstrated by the play of light and shadow in the image, this is something that is distant and difficult to see but simultaneously vibrantly imminent, as long as she—and we—know where to look.

Within a world that is hostile to queer, Black, and brown trans femininity, Shraya's and Tourmaline's selfies aren't only about self-love in the present. Instead, the circuits of reflection they create among self, screen, spectator, and image open out toward alternative futures. As Dora Silva Santana writes when describing transition as movement through water, "Transitioning is our movement along that space of possibilities that produces embodied knowledge. It is moving across and along the waters, the imposed limits of gender, the secular and the sacred, the expectations of our death, the imaginary that we are not lovable."[56] In selfie aesthetics, the visual rhetoric of doubling is not about static dualities; nor is it a realization of postmodern fantasies about transsexuality and digitality. Instead, in its construction of doubles as future-oriented possibilities that mediate shifting relationships among creators, viewers, and images, doubling makes evident the processes that produce such potentialities. As Drucker and Ernst's work demonstrates, reflection is not merely a passive step toward self-constitution. Rather, it is an active construction of resemblance amid difference. Through queering the mirror stage and substituting the mise en abyme for the mirror scene, doubling's ripple effects can help reveal the seams, the strategies, and the technologies that allow us to experience ourselves as reflections of one another.

Gender Performatives
and Selfie Improvisatives

Like other forms of self-representation, selfies provide a tool through which
the self can be expressed, alongside a (precarious) promise of self-possession
and self-control.[1] After all, selfies can be imagined as fixing, preserving, and
controlling what they represent. In Susan Sontag's words, photography "means
putting oneself into a certain relation to the world that feels like knowledge—
and, therefore, like power."[2] However, Sontag's statement implies that this is
a feeling, an impression—a fantasy. Selfies might seem to establish or main-
tain the sovereign self, but when they travel across online networks and when
they appear in museums, galleries, and magazines, selfies foster unexpected
connections among creators, viewers, situations, and technologies. In addi-
tion to expressing a *self* to an audience of *others*, selfies circulate in intersub-
jective networks in which authorial control recedes in favor of improvisational
collaboration. Selfie viewers aren't just receiving meanings in a kind of uni-
directional, broadcast mode; they actively construct meaning—and even al-
ter the images themselves. Here, juxtaposition, conjunction, and relationality
are unpredictable, disturbing, dynamic, contingent, and playful. These selves
aren't necessarily in dialogue with an audience that represents the power of
the Other (with a capital O). Nor can these images be understood through the
simple binaries of visibility politics, where selfies allow marginalized people
to become visible to the Other. Instead, these selves unfold unpredictably as

Figure 2.1 Selfie by
Zinnia Jones, n.d. Screen
grab by the author.
Used with permission
of Lauren McNamara/
Zinnia Jones.

they present opportunities for resistance that go beyond reiterating or resigni-
fying hegemonic norms. Through these improvisational relationships among
creators, images, and spectator/collaborators, selfie aesthetics allow us to re-
think how performativity theory has shaped queer theory's understanding of
iterative self-constitution, as well as the political possibilities of deconstructing
selfhood.

This chapter begins with a single image, then expands outward to explore
how selfie creators and viewers construct evolving ideas of selfhood through
improvisational exchanges. This image is a single low-resolution selfie by the
trans activist Zinnia Jones that was probably posted on Myspace in the late
2000s (figure 2.1). Since then, it has circulated widely across many different
online platforms. It appears over and over when Jones documents her own
life. It is also regularly featured in narratives about Jones that have been cre-
ated, appropriated, and modified by others. Repeatedly, this photo signals
an origin point that is followed by varying and evolving images of Jones "af-
ter" transition. It is particularly resonant as a "before" photograph because

of Jones's almost wistful look toward the top of the frame, in contrast to the more common look into the lens—or slightly to the side of the lens, into the screen—that selfies often feature. Gazing hopefully upward, the youthful Jones appears to be looking out toward an undefined future, and this future is then defined by whatever follows it. This selfie becomes far more than a record of one particular moment in Jones's life, for as she and her followers revisit, rearticulate, and reimagine this self-portrait, it accumulates a dense set of histories and connotations that it never had originally. Throughout this iterative process, repeated gestures begin to cohere around, and thus create, an origin that is simultaneously reinscribed and reimagined because it keeps being restaged—and not only by Jones for her audience, but by Jones and her followers, dialectically and improvisationally.

Zinnia Jones is an online persona created and maintained by the trans activist and educator Lauren McNamara—in dialogue with her online followers. Across a range of distinct platforms, Jones has emerged as a set of fragmented and distributed selves. The different elements of her persona have multiplied, conflicted, and vanished as Jones and her followers have collaborated over more than a decade. On November 19, 2008, the then teenage Jones uploaded her first video to YouTube, introducing herself as "ZJ" and declaring that she intended to produce videos addressing, among other topics, politics, ethics, philosophy, and "technological progress and its influence on the future of humanity."[3] Over time, Jones became a prominent atheist vlogger, with tens of thousands of views for her videos on religion, atheism, and the Bible, and during this period, her self-presentation noticeably shifted. In response, YouTube commenters started speculating about her gender, persistently and even obsessively, and the comment sections for Jones's videos regularly spiraled wildly off-topic into debates about her gender, sex, and identity. Initially, Jones insisted that she would not answer her followers' questions, and later, she contested her followers' assertions that she was transgender. But several years later, Jones did come out as a trans woman, and she documents her transition through videos and selfies, continuing a process that began unintentionally on YouTube. Currently, Jones appears on many online platforms, including YouTube, Twitter, and Facebook, and she uses selfies in a number of ways. These vary by platform—for example, her Twitter presence emphasizes text and tends to use selfies rhetorically to support her arguments about social and political issues, while her public Facebook page uses selfies to document more banal moments of her life, from the clothes she wears in her college classes to the places she vis-

its. On Tumblr, her sexually explicit selfies generated additional income and drew attention to her adult sex education work.

As a result of all of her online activity, there is extensive documentation of Jones's life, but her digital archives are also precarious and unstable. In part, this is because she has changed her Tumblr URL repeatedly, from her early online handles to zinnia.sexy and then to gender.agency. More significantly, it is because her blog has been restricted by Tumblr since the platform banned all adult content in November 2018. The broken links that result demonstrate the fragility of social media archives and affect my research for this book, since no one, including Jones, is able to access her entire blog and its archives.[4] Instead, I've had to rely on old screenshots, downloaded images, and notes to reconstruct missing material. To some extent, this research problem and my response to it also becomes an aspect of the continuing construction of Zinnia Jones's persona, for it is one more example of how, over many years, Jones's selfies trace a project of staging, restaging, and rearticulating a self that is created through extensive participation from others.

In this chapter I draw on Jones's selfies to explore what improvisation within selfie aesthetics can contribute to our understanding of gender performativity theory. In Jones's case, her selfies facilitate complex relationships among herself, technology, and her online followers, for as Jones documents her life, exteriorizing pieces of her own memory, she is not simply archiving these images. Rather, she is sharing them with a community (including myself) who produce their own accounts of her *through* these images. As the philosopher Bernard Stiegler writes about media, when we exteriorize memory in media objects, they aren't merely an appendage to "natural" memory; instead, these media are constitutive of human life as such.[5] When exteriorized memory is not simply stored and archived but shared, developed, revised, and exchanged through improvisational processes, the self is no longer the individuated, sovereign subject. In this way, selfies reveal that we are interdependent selves in relation to others—humans and machines, as well as nonhuman animals, natural elements, objects, landscapes, and so on. I analyze how Jones's selfies have been appropriated and manipulated by others to explore how these improvisatory interactions produce opportunities for vulnerability and solidarity. Through improvisation, selfie aesthetics can invite viewers to examine the possible limitations of gender performativity theory and think anew about the potential for iterative resistance.

Posting

Gender performativity theory describes how gender is socially constructed and seems to present resistant potential. However, it can also become a false promise of liberation that exploits trans experiences without being responsible to the trans people whose lives are central to the theory's original insights. Gender performativity theory emerges most clearly in Judith Butler's *Gender Trouble: Feminism and the Subversion of Identity*. According to Butler, our genders are not inherent truths but, instead, are continuously constituted through ordinary acts that are performative—language, gestures, expressions that *do things*. Expanding on Simone de Beauvoir's statement that "one is not born, but rather becomes, a woman," Butler demonstrates that gender is a social construct that is stabilized through iterative gestures.[6] From Butler onward, gender performativity theory seems to offer a theory of how we are gendered, as well as a powerful strategy for subverting gendered oppression. If performatives constitute us as women or men, then if we experiment with our gendered performances (perhaps in selfies), it seems that we might change ourselves—and the world.

The way I have chosen to summarize this claim deliberately collapses the distinction between *performatives* and *performances*, because similar summaries of performativity theory are pervasive in both popular and scholarly discussions of this concept. As a result, gender *performance* is often understood as a field of individual choice, even though gender *performativity* encompasses many acts that are sub- or unconscious.[7] This uncertainty about the role of individual agency within gender performativity theory appears in Butler's original writing, with sometimes disturbing implications. Even when Butler describes the violence that trans feminine people face, she suggests that this comes from their own "tragic misreading" of the structures of power.[8] This implies that trans people don't actually understand the sometimes impossible conditions they must navigate, and this shifts accountability for transphobic violence from its perpetrators to its targets. According to Butler, her argument is misread when it is interpreted as a theory of individual agency,[9] but her best-known case study actually does elide the difference between a performative and a performance. Turning to drag culture, Butler bases her gender performativity theory on agential, ritualized, spectacularized *performances* by queer and trans people of color, even though the theory is also supposed to explain the daily, banal gestures that solidify the heterosexist and white supremacist gender binary.[10] There's a logical error here, for drag performance is an exceptional case with its own norms and rules, yet it is tasked with reminding us that *all* gender is performative.[11] As a result, the

ordinariness of performatives is easily missed by people outside of or on the edges of the drag community—including Butler, who implicitly locates herself within an "us" that watches drag performances from the audience.[12] By contrast, those within the community more readily identify how daily, banal gestures work to solidify identity within drag performance and can reinforce subcultural norms that delegitimize trans femininity.[13]

Since *Gender Trouble*, gender performativity theory has been central to debates between queer theory and trans studies.[14] As Jenny Sundén writes, gender transition is celebrated within queer theory because it produces "glitches" in heterocispatriarchy that might "open up a domain of nonhuman agency at heart [*sic*] of how gender operates." Yet these "glitches" are not a mere metaphor, for they are also experienced by human beings for whom "the brokenness of gender hurts."[15] Where queer theory seems interested in playing with concepts abstracted from queer and trans lives, trans studies is often regarded as overly bound to identitarian discourse when it examines trans experience. Yet why should theoretical concepts and material realities be regarded as opposed? Like the recent turn in decolonial studies, the crucial question is: How are queer theory and trans studies part of a "daily praxis of living" that "advances other ways of being, thinking, knowing, theorizing, analyzing, feeling, acting, and living for us all"?[16] In other words, who are queer theory and trans studies *for*?[17]

Responding to this question, we can more critically examine the politics and ethics that are at issue when theories that attempt to analyze gender *in general* are based on *specific* subcultural practices that create and sustain queer and trans communities. As Julia Serano writes, academic theories make demands on trans people that are not similarly imposed on cis people, even though the theories that result are supposed to explain both transgender and cisgender experiences.[18] Jack Halberstam's work illustrates how this operates, for he writes that "trans* bodies, in their fragmented, unfinished, broken-beyond-repair forms, remind all of us that the body is always under construction."[19] Although this proposes a potent challenge to sovereign subjectivity, I find myself asking whether it is actually true that, when we recognize that trans people's bodies are "unfinished," this necessarily teaches us something about cis people's bodies. Conversely, might it reinforce the dominant idea that trans people's bodies are unfinished *because* they are not cisgender bodies?

Since gender performativity theory is perpetually reacting to power, it actually risks stabilizing hegemonic discourses. As Tracy McMullen argues, performativity theory asserts that we continuously struggle to be recognized

by power. The result is that performativity theory demonstrates "the contingency of the subject," but, simultaneously, "the 'Other' is often implicitly credited with great stability and power."[20] According to Mari Ruti, performativity theory imagines social change as always "incremental," based on constant "reperformance, resignification, and reiteration" that "remains remarkably respectful of hegemonic power in the sense that everything, including resistance, must be done *in relation to power* rather than in direct opposition to it."[21] Moreover, since gender performativity is "seamlessly compatible with the spirit of consumer capitalism," we can perform against certain dominant scripts (e.g., by wearing particular clothing) without necessarily attending to how these very performative acts create norms of their own.[22] Performatives are often understood as performances that rupture, but performatives also create new forms of coherence. When these new forms of coherence are affirmed by power, it is particularly difficult to maintain resistance.[23] In place of performatives, McMullen offers an alternative: the improvisative. Freed from the binary of success or failure in relation to the law, the improvisative posits that experience involves events that require responses.[24] Concerned with selves and others rather than self/Other, the improvisative "is responsive, not reactive."[25]

With this theoretical terrain in mind, I trace how Jones and her followers interact, collaborate, and respond improvisationally to each other through her selfies. First, I offer a reading of some of Jones's "not safe for work" selfies, where I examine the trope of the reveal to argue that Jones uses selfies and captions to represent her body as a coherent whole. In these images, Jones stages her own bodily integrity and rejects the demand that *her* body emblematize the idea that *all* bodies are fragmented. Next, I examine how the persona of "Zinnia Jones" has been collaboratively created, particularly through Jones's selfies, as Jones and her followers have gradually produced an open and shifting archive that constitutes "Zinnia Jones." Finally, I unpack an incident in which Jones was confronted by a follower who used Jones's selfies and YouTube videos to construct a dialogue between the two and who insisted that Jones respond to this manipulation of her self-representational media. Across all of these examples, Jones's selfie practice deconstructs the sovereign subject and interrogates how this posthuman move disproportionately affects those who are already marginalized. Through improvisational responsiveness, selfie aesthetics don't merely reiterate power's messages with a difference. Instead, selfie improvisatives happen on possibilities that exceed dialogue with hegemony.

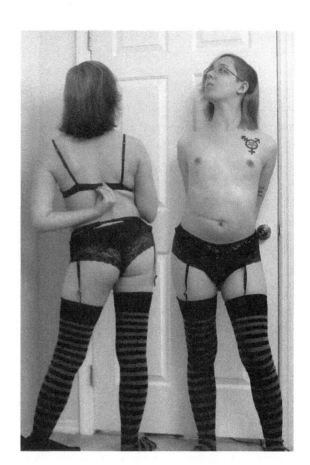

Figure 2.2 Selfie by
Zinnia Jones, ca. 2014.
Used with permission
of Lauren McNamara/
Zinnia Jones.

Deleting

In a doctored double selfie that Jones has shared repeatedly, two doppel-gängers stand side by side, one facing the camera and the other facing away (figure 2.2). Both versions of Jones wear identical lingerie, and the wide framing shows the two bodies from head to toe. On the left, Jones is turned away from the camera, and her hand is bent behind her back to unclasp her bra. On the right, Jones faces the camera, hands locked behind her, topless. A black object on the ground creates a narrative from left to right: Jones has removed the bra and tossed it aside while turning around to face the camera. On January 2, 2014, Jones posted this selfie and asserted her power to reveal and conceal—or post and delete—nude selfies: "reposting deleted nudes cause I feel like it."[26] The selfie and its caption claim that Jones has agency over her self-representation, clarifying that the selfie didn't disappear

because of platform-based censorship; instead, Jones chose to delete and re-post the image. As the striptease narrative progresses across the selfie from left to right, it's paired with this statement about how Jones curates her online persona: publication, deletion, and (re)publication. This narrative moves to-ward visibility (in a number of ways), but it also raises the question of what prompted Jones to delete this selfie in the first place—and subsequently, why she deleted it and its caption yet again.

Visibility is vulnerable, and for trans people the vulnerability of visibility is deeply tied to the trope of the genital reveal. The reveal is not only a media trope; it also punctuates trans people's daily experiences, and it is insepara-ble from violence.[27] At times, the reveal might be recuperated as an agentive act of self-revelation, but within trans representation, the reveal polices (and fetishizes) trans people through coercively exposing their genitals, then de-fines trans people's identities based on their anatomy.[28] Trans celebrities such as Laverne Cox and Carmen Carrera have refused to answer invasive ques-tions about their genitals and have pointed out the troubling assumptions behind interviewers' inquiries.[29] Their refusal is significant, but it produces additional divisions: specifically, between those trans people who are able to be respectably visible—while fully clothed—and those trans people (includ-ing trans sex workers) who have a more contentious relationship to this kind of respectability, since they might be producing images that seem to be the kind of images the reveal demands.

On her social media accounts, Jones occasionally shares selfies tagged #NSFW (not safe for work), but it is under the alternative handle "TS Satana Kennedy" that Jones regularly shares sexually explicit selfies and engages in sex work. Perhaps unsurprisingly, Jones's sexually explicit selfies do not shy away from representing her genitals. As Satana Kennedy's profile on Tum-blr stated, before it was deleted: "Yes, there's girlcock. That's what the 'TS' means. Trans woman. Woman."[30] Even though Jones uses a different name for sex work, she hardly conceals the connection between herself and her porn doppelgänger. Through selfies and social networking, Jones even stages a relationship between herself and Satana Kennedy. In 2014, Jones skewered the solemnity of National Coming Out Day by posting the double selfie de-scribed earlier with the cheeky caption, "oh it's national coming out day? i'm satana kennedy."[31] A few weeks later, Satana Kennedy tweeted "for hal-loween I was notorious atheist personality Zinnia Jones" and shared a dif-ferent selfie.[32]

This isn't just a performance addressed to a passive audience, for Jones's online persona has been improvisationally constructed through a series of

actions and responses that take place in time, in collaboration, and in relation to others. Performatives certainly also involve relationality, but performativity theory tends to deemphasize collaboration in favor of evaluation. Within many accounts of performativity theory, the success or failure of performatives is assessed against a standard established by power. By contrast, improvisatives involve responsive interactions that don't only react to power. Within Jones's work, her #NSFW selfies demonstrate that even though improvisation offers incomplete access to agency, its iterative gestures can construct actual alternatives to hegemonic norms. Through one selfie series, Jones asserts that her body—including her "girl cock"—is a female body. Instead of reiterating womanhood with a difference, these selfies refuse the idea that Jones's body is broken or incomplete (and therefore a reminder that wholeness is illusory for everyone). Then, in a series that I describe as her "point-of-view" selfies, Jones shares her look toward her own body. Amateur photography usually represents the photographer's perspective, but I use the phrase "point-of-view selfie" to stress that, in this case, the image is a perspective *of the self* and, simultaneously, unlike so many other selfies, is *not* produced through reflection—either reflection in a mirror or reflection in a front-facing smartphone camera. In these point-of-view selfies, smartphone technology isn't a transparent conduit for agential self-expression; instead, Jones uses technology to relate to her body in a way that deemphasizes, without denying, her genitals. Presenting her body as a coherent field or landscape, these selfies represent her genitalia as part of the cohesive whole of her embodiment.

Through selfies, Jones envisions new ways of encountering trans embodiment. In a trio of #NSFW selfies with pointed captions, Jones explores the labels "girl cock" and "girl bulge," terms that rhetorically assert that her genitalia are female—and not just "female with a difference" but female, full stop. Here, the fact of Jones's body, including its shape and how it looks in particular outfits, isn't concealed; it also isn't positioned as necessarily transgressive. A bathroom selfie from March of 2014 shows Jones posed in a loose tank top and polka-dot underwear with her left hip popped and her right hand, with brightly painted nails, resting on her right thigh (figure 2.3). Through assonance, the caption points out three elements of visual interest in the photo: "tank tops, polka dots, girl cocks." All three are available possibilities, seemingly common enough (because of the plural form) that none, including Jones's genitalia, is particularly remarkable.

While this selfie shows Jones from head to mid-thigh, two selfies from the end of May 2014 focus on sexualized body parts. Yet rather than staging her

Figure 2.3 Selfie by Zinnia Jones, 2014. Used with permission of Lauren McNamara/ Zinnia Jones.

breasts and penis as disjunctive, the images present Jones's body as (part of) a coherent whole (figures 2.4 and 2.5). Captured with a camera held out at arm's length, these images are intimate, showing Jones from her shoulders to her upper thighs, juxtaposing her hands and her genitals. In the first selfie, Jones wears a tight black camisole and black jeans, and her free hand rests on her hip. Captioned "fashionable girl bulge," the selfie and its caption draw attention to the bulge in Jones's jeans but also ask what it means to call a body part "fashionable." Here, fashion isn't just something layered on top of the body but a material issue of Jones's body's morphology. Captioned "bits," the second selfie also shows her wearing a black camisole. This time, however, she isn't wearing any other clothing. Instead, Jones's hand is positioned directly over her crotch, fingers spread wide, hiding—or substituting for—her

● ● ● ● ● ● ● ●

Figure 2.4 Selfie by Zinnia Jones,
2014. Used with permission of Lauren
McNamara/Zinnia Jones.

● ● ● ● ● ● ● ●

Figure 2.5 Selfie by Zinnia Jones,
2014. Used with permission of Lauren
McNamara/Zinnia Jones.

genitals. Redistributing sexual power to her hands, this pose undermines the reveal by shifting sexual significance to nongendered organs that are almost always available to view.[33] Hands and fingers blur the boundaries between the sexual and the banal, deconstructing the divide between public and private. Jones's selfies challenge normative assumptions about the gendering of genitalia, as well as the logic that divides sex organs from other body parts.[34]

In her "point-of-view selfies," Jones continues visualizing the coherence and continuity of trans feminine bodies such as hers, using technology to relate to her body as part of a broader visual field. Capturing an image of her body from the waist down, Jones shares with her followers *not* her embodied view of herself or a reflection of herself *but* a self-representation created by the intervention of technology into her look toward herself. These point-of-view selfies invite us to explore the everyday experience of using digital, networked technologies to facilitate one's relationship to one's body. Amid banal settings, these selfies offer multiple points of visual interest. Showing Jones's body from the waist down, they include but don't highlight her crotch, and they present her body as ordinary rather than as an extraordinary exemplar of bodily fragmentation. Jones appears to be lying back on her bed, capturing a quick glimpse of her body with a camera that must have been close at hand. In both images, the frame is structured around the long line of Jones's legs stretching from the bottom toward the top of the frame. Jones wears a brown or purple shirt in one image, with blue jeans and bright pink sneakers (figure 2.6); the image also includes a closed laptop beside her and a GameCube, turned off, against the wall. In the other, Jones's stomach is bare, and she wears fishnets over her underwear (figure 2.7). The bed is messy, the Game-Cube is turned on, and a partner's hand rests on Jones's leg. Despite these small differences, both images convey the contingency of the everyday.

These point-of-view selfies present Jones's body as a perspective rather than as an exhibit. We see part of her body that Jones can see without the intervention of the technology, but like Jones, we see it through the technology she uses to mediate her encounter with her body. Moreover, her body is among other objects of visual interest, and it becomes a line that extends from the camera toward another technology of vision in the distant planes of the shots: the GameCube. Where the #NSFW selfies use poses and captions to make a political point, these point-of-view selfies convey the affective qualities of the moments when they were produced—the lazy boredom that Jones might have been experiencing when she grabbed her phone or camera, which was, of course, close at hand, and snapped a picture of herself. Instead of staging her body against cissexist norms, these images ask us to

● ● ● ● ● ● ●

Figure 2.6 Selfie by Zinnia Jones,
2014. Used with permission of
Lauren McNamara/Zinnia Jones.

● ● ● ● ● ● ●

Figure 2.7 Selfie by Zinnia Jones,
2013. Used with permission of
Lauren McNamara/Zinnia Jones.

share not Jones's embodied perspective, but a technologically mediated look toward her body that she created.

Iterative and improvisational, these selfies complicate Jones's agency over her self-representation when they travel beyond her control. Selfies are often associated with autonomy and self-authorship, and many feminist analyses of selfies reclaim them as tools for agentive self-expression.[35] However, selfies generate only limited opportunities for self-agency. For example, my archive of Jones's selfies makes the research in this chapter possible, even in cases where Jones has deleted specific images. In 2019, I corresponded with Jones and secured permission to reproduce these selfies in this book, but in March 2015, many of the selfies I discuss here were deleted by Jones when they were used in a legal action against the family of Jones's then partner.[36] At the time, Jones locked down her social media accounts and deleted a significant number of selfies, including some that I had already downloaded and saved during my research for this project. As a result, my archive itself demonstrates the limits of Jones's agency and control over her image, even though she has now granted me permission to reproduce her selfies here.

Of course, Jones often posts and then deletes selfies, particularly #NSFW selfies. In some cases, she frames this as an agentive act. On December 19, 2013, she responded to an anonymous follower's query, "What happened to your ladycock photo?" by saying, "I took it because I felt like it, then I took it down because I felt like it."[37] Yet as she discusses elsewhere, Jones's sex work, like all labor, is constrained and coerced by economic pressures.[38] Moreover, Jones points out that transmisogyny already denies her the respect that she supposedly risks by posting pornographic selfies. In response to another anonymous questioner who asked, "Do you worry about how posting porn online will affect you personally and professionally, especially regarding your parents, kids, and reputation as a trans activist?" Jones replied bluntly, "Nobody respects trans women in the first place anyway."[39] Jones rejects the idea that she must be "respectable" to do advocacy work, in part because she argues that such an effort would be futile. Ultimately, Jones's selfie practice must be understood beyond the question of her own agency—or lack thereof—in producing and distributing self-representations. Her selfies demonstrate that there is a messy space between agentive respectability and the nonconsensual violence of the reveal where visibility is iteratively chosen, coerced, and negotiated—a space where Jones controls and loses control of her own image.

Constructing

Jones posted a selfie cheekily captioned "cyborg silver nails/perfect for elimi-
nating robo-dysphoria" (figure 2.8) on Tumblr on November 30, 2013. The
image highlights Jones's hand pressed against its own reflection in the mirror,
her fingernails painted silver. Jones's camera peeks through her fingers, a cy-
borg extension of her vision. Constructing an analogy to gender transition,
the selfie and its caption humorously evoke a desire to transcend human em-
bodiment's limitations. In doing so, this robo-dysphoria selfie connects con-
temporary transgender experiences to transhumanist or posthumanist fu-

tures.[40] Perhaps more important, it demonstrates how selfies enable Jones and her followers to collectively and collaboratively construct Jones's online persona. In this case, both before and after the robo-dysphoria selfie post, Jones and her followers used Tumblr's "Ask" feature to blur the lines between Jones's gender transition and cyborg imaginaries. A flexible blogging platform, Tumblr allows bloggers to accept anonymous questions, or "asks," from their followers; bloggers then have the option to answer any of these questions publicly, should they choose to do so. In the early 2010s, Jones would often post that "asks are on" during particular time periods to invite such dialogue with her followers. Shortly before she posted the robo-dysphoria selfie, Jones shared a follower's question that began with the invasive query, "Are you considering having . . . the Surgery?" But subverting the reader's expectations, the questioner then revealed that they weren't referencing gender confirmation surgery and instead described a surreal transmutation: "I really want to but I'm worried having my body replaced with a pillar of eternally screaming fire, wailing constantly into the night, immortal and etenal [*sic*] might make things difficult with my husband." Echoing this ironic stance toward "the Surgery," Jones envisions a cyborg union of human and machine, replying: "I'd rather go for full nanobot swarm conversion."[41] After she posted the robo-dysphoria selfie, Jones shared another follower's question about her transition plans. Once again, this inquiry sidestepped cliché questions about Jones's primary and secondary sex characteristics and asked, "I can't believe no-one's asked this: are you considering getting cybernetic brain implants?" Jones replied, "Probably just P3 and Boss. And . . . maybe Ensemble, if I can get my hands on it." Jones tagged the post with the provocative (and nonfunctional) hashtag, "#it all adds up to normality."[42] Rejecting the demand that she symbolize antinormativity, Jones jokingly claims for herself the position of "normality."

Out of context, Jones's robo-dysphoria selfie might seem to reject human embodiment. Yet the image actually functions quite differently. By imagining how Jones could modify or enhance her physical form, Jones and her followers improvisationally produce a science-fiction future that is posthumanist *and* bound to the material reality of her existence as a trans woman.[43] Although major trends within posthumanism anticipate utopian futures that free consciousness from the body—for example, by uploading our minds to the cloud[44]—scholars such as N. Katherine Hayles and Thomas Foster argue that posthuman potentialities are inextricable from material embodiment. For Hayles and Foster, this kind of posthumanism problematizes the boundaries that separate self and other and offers an opportunity to deconstruct the

autonomy, individuality, and sovereignty of the white, cis, straight, and male sovereign subject. For Foster, this generates possibilities for resistance, and Hayles writes that posthumanism "signals . . . the end of a certain conception of the human, a conception that may have applied, at best, to that fraction of humanity who had the wealth, power, and leisure to conceptualize themselves as autonomous beings."[45] Deconstructing the sovereign subject seems liberatory, and this posthuman possibility is fueled by the way network technologies increasingly interpenetrate our bodies. Of course, since one way that the boundaries of the self are deconstructed is through trauma and interpersonal harm—harm that has disproportionate impacts on those who are already marginalized—this perhaps demands a new humanism, not a posthumanism.[46] However, given Jones's interest in a kind of popular culture version of transhumanism, it's productive to examine how her selfie practice bridges posthuman possibilities and material embodiment. Posted alongside narratives of Jones's life, her selfies circulate amid stories that convey the particularities and messiness of embodied existence. Moreover, her selfies themselves operate as a kind of posthuman extension of the self, given how they are used by Jones and others to construct her digital identity.

Since 2008, Jones's selfies have been downloaded, altered, and recirculated many times, and Jones's material reality is affected when she and her followers narrate and renarrate Jones's life story. Even though her transition timelines might seem to construct a linear, individuated self, Jones is never the only one constructing her history—or a shared, collective history—from her selfies. In one incident, several of Jones's selfie timelines were stolen, watermarked, and reused, bizarrely, in an advertisement for penis enlargement pills. Instead of challenging this appropriation, which might explicitly or implicitly valorize the original, Jones responded by running the advertisement through a meme generator, adding her own commentary: "You didn't build that."[47] In response to a reader's question, she jokes dryly, "These aren't the pills you're looking for." Just as her original self-documentation on YouTube was dogged by feedback, commentary, and questions from her followers, Jones's deliberate attempts to document her transition through selfie timelines are repurposed by others in a continuous process of circulation, modification, and transformation.

Across social media platforms, Jones uses and reuses selfies while her followers grow more fluent in reading and deploying their meanings. Jones's selfies appear and reappear, accumulating significance as they circulate across platforms over time. As a result, "Zinnia Jones" becomes a persona composed of elements that Jones and her followers can use referentially, reflex-

ively, and recursively. For example, in sixteen videos from December 2009 through March 2011, Jones wore a red-and-black feather boa, including in a video where she attended a counterprotest of the far-right Westboro Baptist Church. In that video, she wears the boa over a distinctive red coat and holds a sign referencing Ezekiel 23:20, a Bible verse that discusses the size of donkeys' genitals.[48] This image of Jones has now circulated for years in atheist discussion boards and elsewhere. In 2014, Jones reposted the picture on Twitter, calling it "perhaps the one moment I am most proud of in my life."[49] Correctly, Jones assumed that her followers were familiar with this particular iteration of her persona, even years after the fact. In 2013, one follower wrote to Jones about a dream they had where Jones was wearing the boa and red coat.[50] In August 2014, Jones posted a selfie wearing the red coat, captioning it "New Zinnia Jones, classic Zinnia outfit."[51] A week later she posted, "Guess who's about to cosplay as herself from 2009," with a list of associated accessories. A follower replied, "That was a grand outfit."[52] As these elements of Jones's persona leap from platform to platform—and person to person— over a period of years, the online persona of "Zinnia Jones" emerges as distributed and nonlinear, no longer entirely within anyone's control.

When Jones's selfies are reused and remixed, these open-ended, improvisational engagements include those who ally themselves with Jones, as well as those who use her selfies against her. One story of how Jones is collaboratively constructed begins with a transmisogynistic cartoon suggesting that Jones wants to force cisgender lesbians to have sex with her.[53] In the cartoon, Jones is represented by a strange, alien figure with brilliant teal-colored skin and bright red hair that resembles Jones's style at that time. The figure's pose also resembles Jones's pose in the selfie that she was using at that time as her Twitter profile image. The cartoon is far from the first time that a group of trans-exclusionary radical feminists—or TERFs, as the cartoon describes them—have accused Jones of being a man who wants to rape cisgender lesbians.[54] Jones typically responds to these narratives with selfies that playfully reject their claim that Jones is somehow attacking cisgender women through, for example, using the women's restroom or using women's dressing rooms.[55] Therefore, her followers are familiar with the persistent harassment Jones faces, as well as with her choice to respond to these attacks playfully through selfies.

After a group of TERFs tweeted the cartoon, one of Jones's followers reappropriated and repurposed this image of Jones. The follower seems to have downloaded Jones's original selfie from Twitter, colored in Jones's skin to resemble the striking coloring in the cartoon, then posted it. Jones shared the

tweet on Tumblr.[56] Her followers responded with a set of cartoon drawings, posted both on Tumblr and Twitter, exploring this particular version of the Zinnia Jones persona. As her followers creatively reinterpreted the transmisogynistic cartoon, Jones kept re-blogging the images on Tumblr in a long blog post that chronicles this incident.[57] Throughout this unpredictable, collaborative process—one that crossed platforms and blended photography and cartoon image making—Jones's persona was improvisationally elaborated through both transmisogynistic harassment and creative responses to this event. As Jones and her followers repurpose, redesign, and revisit this version of her persona, her image is transformed over time and across platforms.

In this story, Jones and her followers worked together to repurpose a malicious appropriation of her selfies. However, improvisational processes are unpredictable, and not all such incidents have had positive conclusions. In the summer of 2017, Jones's sexually explicit selfies were appropriated from Tumblr and posted on Twitter by Ray Blanchard, a transmisogynistic sexologist whose work Jones has frequently challenged.[58] Along with J. Michael Bailey, Blanchard promotes the discredited diagnosis of "autogynephilia" to describe lesbian trans women.[59] According to Blanchard and Bailey, trans women who are attracted to women are actually straight men who are so turned on by the idea of themselves as women that they transition as part of a sexual fetish. Attempting to refute Jones's criticisms of his work, Blanchard shared some of Jones's sexually explicit selfies on Twitter and claimed (speciously, absurdly, and offensively) that because he doesn't find Jones's nude body attractive, this demonstrates that her intellectual work challenging his theories should be disregarded.[60] On Twitter and elsewhere, TERFs use Blanchard's theory of autogynephilia to harass queer trans women. In Jones's case, TERFs frequently cite her selfies as evidence that Jones is an autogynephile, asserting that her selfies prove that Jones finds her own body attractive and thus is a male sexual fetishist. Frequently, Jones responds to these attacks, usually by posting more selfies, and she questions why it is framed as fetishistic or pathological for women to find their own bodies attractive. Stripping the charge of its stigmatizing power, Jones embraces the label "autogynephile" and encourages other people—trans and cis—to join her.[61] Though Jones usually manages to have the last word, these incidents dramatize the risk and vulnerability of sharing selfies online, particularly for marginalized people.

Appropriating

Just because there is the option to respond doesn't guarantee that improvisational encounters online will have a clear or comfortable outcome. Another incident in Jones's history reveals the complex ways digital self-representation might be appropriated and manipulated, propelling improvisational contests over power. One of Jones's followers, under the handle "Nebulous Persona," used Jones's selfies to argue that Jones should transition.[62] The story begins early in 2011, when Nebulous Persona sent Jones an email encouraging her to transition. As Nebulous Persona recounts, she never received a direct reply to this email.[63] Shortly thereafter, however, Jones posted a video that opens: "First of all, I'm not transgender."[64] Frustrated by this, Nebulous Persona rephrased and reiterated her message as a video response.[65] In the video, Nebulous Persona used Jones's selfies and other self-representational media to support her claim that Jones should transition—and that, in fact, she had already begun to do so. Drawing on clips from Jones's YouTube videos, screenshots of Jones's tweets, and other media that capture Jones's perspective and voice, Nebulous Persona staged a dialogue between herself and Jones. Though Jones didn't reply directly to Nebulous Persona's email, Nebulous Persona appropriated Jones's image and voice, and, like a ventriloquist, constructed the conversation she wanted to have as this improvisational exchange between Nebulous Persona and Jones unfolded across several years.[66]

The video repeats Nebulous Persona's email message in two different forms: first, as continuously scrolling on-screen text; and second, through a robotic female-coded voice-over generated by an automated text-to-speech program. Behind the scrolling text, Nebulous Persona compiles Jones's selfies, screenshots of Jones's online profiles, and YouTube clips. Since Jones was looking into the lens of her camera as she created these videos and selfies, Nebulous Persona's video shows Jones appearing to address the viewer directly. As Jones seems to speak to us, Nebulous Persona addresses Jones in the second person, both through the on-screen text and through the robotic voice-over that reads the scrolling text aloud. Featuring a remix aesthetic, the video assembles visual evidence while the audio moves between Jones's voice and the synthesized voice. Hard cuts juxtapose Jones's voice—accompanied by ambient sound—with the emptiness surrounding the synthesized voice. Clearly nonhuman, this voice piles up evidence, poses questions that are actually opinions, and never hesitates, never falters, never pauses to breathe. Nebulous Persona's control over Jones's voice and image is palpable.

In Nebulous Persona's video, Jones's selfies and self-representational media become building blocks of a self that can be reshuffled and redeployed

at will. But this isn't a completely clear-cut violation. As Nebulous Persona notes, Jones gave her followers explicit permission to remix her videos, inviting improvisational encounters that might undermine Jones's control over her self-representation and complicate the power relations between Jones and her followers. As "Nebulous Persona," the creator of the video maintains her anonymity, increasing her ability to speak on behalf of a collective. Here, the collective is the loose community that has assembled around Jones's work. Usually, their voices and their questions about Jones's gender are confined to the comment section, but here their voices become the content within the video. As Nebulous Persona's message scrolls continuously across Jones's face, it is as if the comment sections on Jones's videos have taken over the image.

Years later, Jones recalls that she was deeply troubled by the video.[67] Although it might have been intended as a gesture of support and solidarity, it doesn't actually seem to represent one trans woman talking to another. Instead, Nebulous Persona's video dramatizes a very different narrative in which a female-coded artificial intelligence berates Jones—passive-aggressively—to become a woman. In a series of short, punchy statements, the robotic voice tells Jones, "Maybe this *is* it. This is as far as you'll go. And that's fine, there's nothing wrong with that." Clearly, however, the voice has an opinion about what choice Jones should make. Ultimately, the voice concludes by saying prophetically, "And I still doubt that you yourself know just where your Zinnia Jones persona is going. We'll see, I guess. I can wait."

As Jones and Nebulous Persona reflect and echo each other, this unfolding encounter includes Nebulous Persona's initial email, her video, her eventual blog post about the incident, and, finally, Jones's blog posts about their exchange. Doubling text and speech, the video produces a kind of vertiginous relay of echoes, and this impression is furthered by the subsequent blog posts both women publish. Writing in 2013, Jones describes it as an "Argument without End," recalling, "I was seriously shaken by what she said."[68] Jones describes them echoing and reflecting each other, writing, "This person . . . seemed to see me as an echo of herself."[69] Later, Jones comments that the power to predict where someone is headed is "not a power to be used without tact, discretion, and the gentlest approach possible. And when I start to see her reflected in me, that's how I know where to stop." In the end, Jones asserts that this incident did not propel her along the path to self-knowledge. Rather, although it was intended to speed up Jones's journey, it was a frightening twist that did not actually influence her process of self-discovery.[70] Yet despite Jones's discomfort with how her selfies were appropriated, she

collaborates with Nebulous Persona in creating this science-fiction story, a story that intertwines and affects both women's identities. Jones titles her blog post about the incident "Two Years Later: Notes from the Future." Who exactly is writing these notes from the future to Jones's past? How has that version of Jones been transformed by this incident? And Nebulous Persona doesn't only appropriate and manipulate Jones's selfies to support an argument that Jones does not know herself. Nebulous Persona uses Jones's self-representational media to narrate a story that she seemingly regards also as her own. As Jones and Nebulous Persona respond to each other, they echo and reflect each other, for each woman sees in the other a vision of who they once were or who they might become.

Responding to one another, Jones and her followers experiment with who Zinnia Jones is or could become, and these improvisational relations between self and other are made possible by and through technology. As Nebulous Persona compels Jones to speak the things that Nebulous Persona wants to hear, Nebulous Persona also includes clips in which Jones "talks back" and resists the argument that the video attempts to make. The dialogue that results becomes a form of making and building together that is possible only through digital media and online networks that allow Jones to distribute self-representational media that can then be appropriated and repurposed by others. Rather than a dialogue that takes place through the presence of each to the other, this dialogue is dispersed across time and space, constructed by Nebulous Persona out of materials originally created by Jones, materials that were published, shared, and made available for repurposing and response. Here, in place of presence, selfie aesthetics facilitate responsive engagements that destabilize the sovereign subject's coherence. But destroying the subject involves real risks. At its extreme limit, the self ceases to exist when it is deconstructed through intense experiences of pain.[71] As the queer theorist Leo Bersani suggests, we need to question autonomous individuality without embracing annihilation, particularly the annihilation of already marginalized bodies. He advocates that we pursue "self-expansiveness" instead of self-destruction, turning to "something like ego-dissemination rather than ego-annihilation."[72] I suggest that Jones's selfies represent one way to imagine what "ego-dissemination" could actually, literally *look like* in the contemporary digital era.

Improvisation provides opportunities to respond again and again, asking us to consider not just the fact of our intersubjectivity but also the question of how we are going to work with this material reality. As Donna Haraway argues, moving away from autonomous individuality doesn't have to

be about destroying the subject. It can, instead, be about recognizing that our interconnections can make us responsible to and for one another. Haraway demonstrates this through a number of case studies, including tracing how a common prescription—estrogen supplements—creates networks where bodies, industries, and histories are bound together, revealing the sovereign subject's instability.[73] Yet even though Haraway emphasizes that these intimate connections demand "response-ability" from all those linked together by sex hormones extracted from horse urine, she herself omits trans women from the networks she describes; in her account, these biochemical bonds connect cisgender women, horses, dogs, farm laborers, and more, but not trans women, who also often take estrogen supplements. With trans women so easily erased from this story of kin making, it becomes clear that our intimate connections to others don't *necessarily* obligate us to these others in transparent and inescapable ways. Performativity theory provides another crucial example of this problem. Even though the discipline of gender studies is indebted to studying the lived experiences of trans and gender-nonconforming people, especially trans feminine people, this fact has not necessarily obligated gender studies *to* transgender people.[74]

"Response-ability" is about *response*. It is not enough to break down boundaries and make sovereign subjectivity unthinkable. Instead, as Haraway argues, art and cultural production can nurture dialogue, networks, and interdependence that could support us in imagining what building together might become. According to Ariella Azoulay, responsibility is central to the "civil contract of photography," for spectatorship "deterritorializes photography, transforming it . . . into a social, cultural, and political instrument of immense power."[75] Azoulay's account stands in contrast to theories of spectatorship that ask only for judgment, not for the spectator to take on "responsibility for what is seen in the photograph."[76] In this chapter, I have argued not only that selfie aesthetics are concerned with the performance of the self in daily life, but that they are profoundly shaped by improvisational dynamics that emerge among creators and spectators. These selfie improvisatives can propel us into unpredictable encounters that might exceed power rather than just citing its norms. Yet improvisation is, fundamentally, open-ended. As a result, we must ask again and again: What worlds do our responses bring into being?

Visibility Politics
and Selfie Seriality

One of the central issues for selfie aesthetics might seem to be visibility, particularly the accessible visibility that selfies offer to members of marginalized populations.[1] Yet as chapter 2 discusses, visibility politics poses many unique challenges for trans people. Responding to the problems with visibility, the Black trans femme scholar Che Gossett posted a message on Instagram in July 2017 that proposed a shift away from trans visibility and toward other goals, writing: "Trans visibility? What of trans conspiracy? Trans as on the run from gender. Trans as plot, as scheme, as gossip, as undercurrent, as live wire."[2] Appearing amid many selfies and other photos, the post was actually a screenshot of a Facebook status update. Through this manual process of digital reproduction and replication across multiple platforms, Gossett advocates for "trans conspiracy" in poetic language that echoes Stefano Harney and Fred Moten's call to fugitive knowledge production in their collaborative work *The Undercommons: Fugitive Planning and Black Study*.[3] The tensions in Gossett's post are immediately evident, from the corporate products in which this call to subversion appears to the fact that, while Instagram shares photos seamlessly to Facebook, Facebook doesn't share text-based posts to Instagram, since the latter is designed to be an image-sharing app. Amid Gossett's own Instagram posts, the Facebook screenshot stands out, appearing visually distinct among many of Gossett selfies and other self-

representational photographs. Perhaps the most significant tension is that Gossett, who takes and shares many selfies, seems to be advocating a retreat from representation even as they continually produce self-representational media.

Gossett's post—and its context—can be taken as a provocation to ask how selfie aesthetics might sidestep trans visibility and nurture something like trans conspiracy instead. Where visibility involves seeking recognition from those in power, conspiracy suggests working together to undermine power. (While *conspiracy theories* are a dangerous form of false history, a conspiracy—defined broadly—can be understood as merely unlawful and not necessarily harmful.) Visibility is usually oriented toward inclusion within a dominant culture, while conspiracy works to dismantle it. A crucial survival tactic for trans and queer people, conspiratorial community building is emblematized in the legendary legacies of Sylvia Rivera and Marsha "Pay It No Mind" Johnson. Founders of Street Transvestite Action Revolutionaries (STAR) and mothers of the STAR household, Rivera and Johnson worked against the assimilationist drive within the white-dominated gay rights movement. As Ehn Nothing writes, "STAR's politics—'picking up the gun, starting a revolution if necessary' . . . could find no harmony with a movement of white middle-class gays seeking inclusion in white supremacist capitalist patriarchy."[4] From the homophile movement through selfie campaigns on social media, assimilation has routinely relied on visibility politics; given this, Rivera and Johnson's legacy provides a framework for examining how "visibility" and "conspiracy" might be opposed. Of course, as Nothing points out, Rivera and Johnson's revolutionary politics is repeatedly taken up by white, middle-class academics and professional activists in ways that reduce "lived experiences to facts one can repost on the internet to maintain one's image."[5] And as Harney and Moten note, the work of critical academics can reinforce the university's institutional power.[6] In this context—one that implicates my own work—the conspiracy Gossett proposes cannot just be imagined as a conspiracy against the direct agents of state power. Instead, this *plot, scheme, gossip, undercurrent, and live wire* must take the form of knowledge and cultural production by and for trans people of color. In this chapter, I seek out how such conspiracies are supported by selfie seriality as I trace a chain of connections that branches out from selfies to include scholarship, friendships, family relationships, films, and more.

To understand trans conspiracy as an alternative to trans visibility, I draw on the anthology *Trap Door: Trans Cultural Production and the Politics of Visibility*, which calls for "trapdoors" that lead to escape routes beyond vis-

ibility politics.[7] Edited by Che Gossett's sister Tourmaline, along with Eric A. Stanley and Johanna Burton, the collection features work by trans scholars, artists, activists, and cultural critics, including Gossett, micha cárdenas, Miss Major Griffin-Gracy, CeCe McDonald, Dean Spade, Morgan M. Page, Juliana Huxtable, and many more. As Eliza Steinbock notes, the anthology is far from antirepresentational, for it is full of contributions by visual artists whose work represents trans lives; however, it does seek to understand and celebrate trans visuality outside of visibility politics.[8] The anthology's cover image is a film still showing the trans actress Mya Taylor playing Johnson in the independent short film *Happy Birthday, Marsha!* (Tourmaline and Sasha Wortzel, dirs., 2018). Replete with pearls, rhinestones, and flowers, Taylor's look re-creates iconic images of Johnson that have appeared on the promotional material for the controversial Netflix documentary *The Death and Life of Marsha P. Johnson* (David France, dir., 2017) and on dozens of posters, T-shirts, and prints celebrating the Black trans activist's legacy.[9] Yet there is a crucial difference: in the archival photographs of Johnson, and in the derivative works that reproduce or reference them, Johnson has a wide, joyous smile. Taylor, by contrast, does not. Taylor's appearance—her serious expression, with a wry grimness at her lips—does far more than reenact a moment from Johnson's life. Instead, it comments on the tensions and paradoxes of trans visibility. As part of a series of images that explore and stage Johnson's legacy, the film still on the cover of the anthology is able to generate this commentary because of its relationship to other iterations of this image and those like it.

Where visibility politics imagines a binary choice between visibility and invisibility—a selfie is posted or it is not—seriality nuances this dynamic through its improvisational openness. Selfies are part of performative self-constitution, facilitating iterative self-representations that can be shared, circulated, liked, appropriated, and transformed. Thus, a selfie is rarely—if ever—a singular image. Instead, selfies are members of series, from intentional subseries within a particular selfie creator's work to series recognized by viewers based on similarities across a set of images, series curated by hashtags, selfies of a certain type (such as "bathroom selfies"), and the series of the genre more broadly. Through improvisation and seriality, I argue, selfies can be ambivalent toward visibility and its politics of respectability, particularly the demand to be visible only in ways that conform to dominant norms. More than tools for the agential expression of a self, selfies are a site of continuous negotiation among selves, improvisative gestures, and audiences. By constructing or identifying series of selfies, creators and their

audiences move beyond the binary of visible and invisible, generating more complex networks of meaning, nonchronological experiences of time, and new ways of engaging with queer theories of conspiratorial resistance.

In this chapter, I examine how selfie seriality can create "trapdoors" that enable resistant cultural production to slip away from both visibility politics and the unstated whiteness of performativity theory. First, I show how Gossett uses selfies to document conspiratorial knowledge production. In Gossett's selfies, I trace how selfies make community, collectivity, and knowledge creation not just visible, but actual and communicable. Selfies can be used to reproduce white supremacist norms, but they can also challenge how trans people of color are required to assimilate to these norms to become legible. To explore this, I show how the South Asian trans femme performer and fashion designer Alok Vaid-Menon contextualizes and recontextualizes a single selfie in a series of posts that interrogate how white cisnormative femininity is iteratively produced. Across the series, Vaid-Menon uses selfie seriality to demonstrate how trans people of color are affected by the racialized binary choice between hypervisibility and total obscurity. I do not know whether Vaid-Menon and Gossett intended their selfies to be read as I read them. However, visibility politics and performativity theory are fundamentally shaped by the tensions among our internal experiences, intentions, actions, (compromised) choices, and how we are understood by others. As audiences actively construct selfie series through reading connections among disparate images, selfie aesthetics show that the iterative improvisatives that constitute digital selfhood include how audiences read coherence into proliferating and diverse selfie series. Through seriality, visibility can be nuanced, challenged, explored, undone, and transformed into something else entirely: a visuality that doesn't just document *what is* but invites us to participate in conspiratorial knowledge production in the name of *what could be.*

Plot, Scheme, Gossip

Selfies seem to express a static, ephemeral present. As a result, they appear ideally designed for visibility politics, which are primarily concerned with present-day recognition rather than future-oriented transformation. Of course, recognition is meaningful, and visibility politics seems to expand understanding, tolerance, and civil rights.[10] Following years of silence and repression, queer and trans art practices often seek to document queer and trans lives, although David Getsy notes that these art practices also ensure that difference is "open to surveillance."[11] Indeed, many artists, activists, and scholars

don't see trans visibility as an unmitigated good—although this can depend upon what public(s) trans visibility is understood to be addressing. According to Dean Spade, visibility "provides even greater opportunity for harmful systems to claim fairness and equality while continuing to kill us."[12] As Emmanuel David demonstrates, trans visibility, "it turns out, can be highly profitable, a source of yet untapped value that could be put to use to bolster the status quo."[13] The trans filmmaker Sam Feder concurs, noting that "to be visible, we must conform to the demands placed on us by a public that wants to buy a story that affirms their sense of themselves as ethical."[14] As these critiques make clear, visibility politics expands the boundaries of common sense to include some who were previously excluded, but they don't necessarily challenge the underlying logic that includes some through excluding others.[15] As the cinema scholar Kara Keeling argues, visibility politics neglects to imagine alternative futures and actually limits future possibilities; after all, visibility politics focuses on the present, which is inevitably shaped by the past.[16] In other words, visibility politics is caught in the compromises of the moment, producing its own zones of invisibility.[17]

These zones of invisibility are intertwined with classism, white supremacy, and the politics of respectability. As Tourmaline writes, "Visibility uses the lens of respectability to determine who, even in the most vulnerable communities, should be seen and heard," warning that "through the filter of visibility, those of us most at risk to state violence, become even more vulnerable to that violence."[18] First explicated by Evelyn Higginbotham, respectability politics is concerned with individual behavior, and while marginalized groups can use respectability politics strategically, respectability politics often blames those who don't conform to dominant values for the social stigma they face. In the end, respectability politics requires strategic *in*visibility in the service of assimilation. Since racism and cissexism intersect, this can be an impossible demand on trans people of color. As C. Riley Snorton writes, the history of the category of "transgender" is racialized, and "race and gender are inextricably linked yet irreconcilable and irreducible projects."[19] Gossett concurs, expanding on Judith Butler's iconic title when they assert that "blackness is gender trouble and . . . blackness troubles gender."[20] For trans people of color, this produces a racialized double bind that they face as they are compelled to negotiate between hypervisibility and obscurity.[21]

Within scholarship, Blackness also troubles—and demands intellectual rigor and ethical accountability from—gender performativity theory. As I discussed in the previous chapter, gender performativity theory tends to be understood (whether correctly or incorrectly) as a theory of individual

agency, especially because performatives get confused with performances. This creates an imagined divide between the performer and the audience, and gender performativity becomes something certain people contemplate while other people are asked to live it *in order that* the first group may understand it. The divide is racialized. In addition, the divide is shaped by cis-sexism. Fundamentally, however, the divide is created by the dynamics of performance itself: some people perform so that others may watch. Visibility politics is conscripted into this spectacularization. This divide can be restated in stronger language: some people suffer so that others may contemplate the possibility of gender transgression and the potential of queer liminality. Gender performativity theory tends to be created *by* some people *about* others. Meanwhile, visibility politics ensures that certain people remain always hyper-visible, available to be taken up as objects of others' knowledge.

This is a question about the ethics of knowledge production: who gets to produce knowledge, for whom, and at whose expense—as well as what constitutes "knowledge." These power relations are racialized, given that gender performativity theory emerges from the nearly simultaneous release of Butler's *Gender Trouble* and Jennie Livingston's documentary *Paris Is Burning* (1990), along with Butler's subsequent discussion of performativity in *Bodies That Matter: On the Discursive Limits of "Sex."* Since that moment in the early 1990s, trans and queer people of color have been asked to perform and embody the liberatory potential of performativity, even though this doesn't necessarily liberate actual trans people of color. As Jay Prosser argues, ethics are central to discussions about *Gender Trouble, Bodies That Matter,* and *Paris Is Burning* because of how these texts relate to the murder of Venus Xtravaganza. Ethics are at issue when Butler claims that Venus Xtravaganza's story contributes to our knowledge of "subversive bodily acts" precisely because Venus Xtravaganza's death prevented her from living the normative life she desired.[22] Meanwhile, Livingston chose not to pay her documentary subjects for their time, labor, and expertise, and Venus Xtravaganza was killed by a customer while doing survival sex work.[23] As Prosser insists, these works depend on Venus Xtravaganza's death to produce knowledge. Perhaps theory does not need to answer for individual experience; as Jack Halberstam asserts, "trans*" might send us "looking not for trans people . . . but for a politics of transitivity."[24] Yet, as Mari Ruti writes, "Although . . . the task of theory is to reinvent the world rather than to merely describe its existing—impoverished—forms, there is . . . a difference between theorizing that provides alternatives to lives as they are currently lived and theorizing that sounds like futile talk about visions that are entirely untenable as real-life options."[25] When theory

is constructed from the experiences of trans people of color, it seems ethically imperative that this theory should be accountable to—and created to further—trans of color liberation.

For many Black trans women, their actual experiences of embodying the potential of queer liminality can be "a prison," and this is not just a metaphor.[26] Trans people of color are literally imprisoned, assaulted, and killed because they obviously blur the white supremacist gender binary. To be sure, this violent response indicates that blending and crossing gender categories has transgressive power, but it also furthers a necropolitics that produces wealth and power for white people from Black trans death. In this context, it's radical for trans people of color to survive, including through performative acts that imitate dominant ideals. As the artist Juliana Huxtable insists, Black trans beauty traditions are not merely assimilationist but have their own radical potential. Black trans elders, Huxtable says, "are these beacons of beauty and traditional ideas of what beauty is, but in a really intense way. I think their beauty, their insistence on and mastery of it, is radical, especially coming from a Black woman."[27] Here, Black trans beauty practices aren't primarily directed toward assimilation; nor do they deconstruct respectability politics. Instead, they are iterative acts of self-making that are situated and specific, as well as collective and communal.

Discussions of performativity in queer theory often sideline the specific, the subcultural, and the community, conscripting trans people into embodying a kind of ultimate or universal queer subversion. In these cases, trans people of color are positioned as spectacularized representatives of performativity theory's resistant potential—of the idea that choosing performatives that challenge dominant scripts can liberate us. Yet when the power of spectators is preserved, and when spectators are imagined as uninvolved outsiders who represent hegemony, gender performativity theory requires trans people, especially trans people of color, to embody something that is true about all of us but that *does not affect all of us the same way.* The result is a theory of spectacularity instead of solidarity. Blaming "assimilationist" trans people for wanting to live without the "gender trouble" that is foisted on them, therefore, gender performativity theory asks *them* to continuously demonstrate a possibility of free agency and gender choice that is available only for *us.* In place of community building and solidarity, this kind of visibility produces "a scattering of people without any redistribution of power."[28]

Trans visibility is intertwined with anti-trans violence, particularly violence against Black trans women. In the film still of Taylor as Johnson, visi-

bility and violence coexist, for amid her strength and beauty the revolution-
ary activist is depicted with a mottled black eye. This speaks to the daily
harassment she experienced and the police violence that accompanied the
Stonewall Riots she instigated; it also foreshadows her violent death. For
many trans people of color, the binary choice between visibility and invis-
ibility is, in fact, no choice at all. This requires a metaphor more nuanced
than "the closet." Snorton has offered the "glass closet" to conceptualize how
hypervisibility both confines and exposes Black sexuality.[29] Expanding on
Snorton's crucial critique of representational practices, *Trap Door* attempts
to articulate a metaphor that provides a solution. In place of the closet, the
anthology offers "trapdoors," with this portmanteau word conveying several
simultaneous, contradictory meanings. On the one hand, there is the "trap,"
which reconfigures a transmisogynistic slur to highlight how trans women of
color are harmed by visibility politics and the transphobic trope of the gen-
ital reveal.[30] On the other hand, there are "doors": cultural production that
doesn't just represent *what is* (making it visible in the present) but also makes
things possible (by envisioning alternatives). Combined, they become *trap-
doors*, or escape routes into futurity.[31]

These trapdoors are found—and created—within subcultures, commu-
nities, friendships, and chosen family, in striking contrast to visibility poli-
tics, which stages visibility *for* an audience of outsiders with (relatively more)
power. In an interview, the prison abolitionists Miss Major Griffin-Gracy and
CeCe McDonald discuss how their positive experience as documentary sub-
jects was made possible by friendship, collaboration, trust, and community
building among the documentary creators.[32] Trapdoors transform the power
relations that structure representation, something Aymar Jean Christian has
analyzed in his research on how independent cultural production by LGBTQ
artists and artists of color gains value from community.[33] Christian's work is
based on web series that are often freely available online, but *Trap Door* high-
lights trans art and archival work that is generally far less accessible. As Cáel
Keegan notes, the anthology's "attention to the gallery as somehow less of a
'trap' than mass culture is perhaps its most obvious shortcoming."[34] While
I acknowledge Keegan's point, I contend that selfies (and other vernacular
media) can be understood in dialogue with the anthology's argument as cre-
ating trapdoors within popular mass media. Selfies aren't exclusively or pri-
marily addressed to an audience of outsiders with power and privilege, for
selfies also circulate within communities, contributing to the kind of cultural
production that *Trap Door* celebrates. Ultimately, trapdoors take us beyond

the aims and structure of visibility politics. Instead, we find ourselves some-where dynamic and participatory; some place where, as Gossett suggests, "trans conspiracy" takes precedence over trans visibility.

As I mentioned earlier, Gossett's call for solidarity over spectacularity evokes Harney and Moten's descriptions of fugitive enlightenment within the "undercommons." On Instagram, Gossett explores this relationship among knowledge, embodiment, fugitivity, and visuality through a series of point-of-view selfies that show Gossett's hands holding works of cultural theory, trans and queer theory, critical race theory, and media theory. In my read-ing, this motif visualizes a form of resistant "conspiracy"—knowledge cre-ation by and for those who for too long have been the objects rather than the subjects of intellectual inquiry. Posted under the evocative handle @au-totheoryqueen, Gossett's selfies show their brightly painted nails holding one academic title after another, pairing Black femme style with high theory, in-cluding both canonical texts and texts that interrogate the canon. These sel-fies create a visual grammar that unites Gossett's body, their research, and their self-authorship. In image after image, Gossett's left hand appears on the left side of the frame, holding up a book to show its cover to the camera or holding open its pages to some particular passage. On the right side of the frame, Gossett's right hand is, of course, not visible—it's very clear that this is the hand taking the selfie. Appearing over and over on Gossett's Instagram account, this pose unites theory and embodiment and positions Gossett as a Black trans femme *as* the subject of knowledge creation within a social media space that is usually not recognized as a legitimate arena for intel-lectual labor. This recurring gesture is experienced viscerally when scroll-ing through Gossett's posts using the application on a smartphone, but it can also be visualized within a static format, such as this book, by looking at screenshots of Instagram's browser-based layout, which features nine im-ages at a time in a grid. These selfies seem to tell the story, again and again, of what it is to be inside academia as an outsider. Yet they don't just capture the experience of a racialized and non-normatively gendered person coming up against the invisible walls of the academy.[35] Instead, seriality turns this repeated encounter into an improvisative gesture that places canonical work by "dead white men" among radical theory, scholarship, and art. The selfies stage how Gossett and many other thinkers are producing alternative forms of knowledge in dialogue with the canon, against the institution, with intel-lectual ancestors, and with each other—for example, in a selfie where Gos-sett holds Huxtable's book.[36] Books aren't the only nourishing objects that

Figure 3.1 Che Gossett's Instagram timeline via the browser interface, 2020. Screen grab by the author. Used with permission of Che Gossett.

Gossett photographs in this way, for their selfies use the same framing to show them holding flowers and cake (figures 3.1 and 3.2).[37]

Finally, amid Gossett's theory-reading selfies, I also find selfies that intersect with other series that I discuss in this book, tracing the community-building and knowledge-sharing possibilities of selfie aesthetics. On December 11, 2017, Gossett appeared in a double selfie smiling over Alok Vaid-Menon's shoulder.[38] In October 2017, Gossett reposted a selfie of their sister, Tourmaline, who faces the sun with closed eyes (figure 3.3). In the image, Tourmaline's heavy green eyeshadow creates a visual rhyme with some of her selfies I discuss in chapter 1, although here sunglasses don't provide

riticaldarkness
Þqueercruising

arx posited the real differer
btw "male"/"female" but a
n and non human gender."
m as trans/gender/specie$

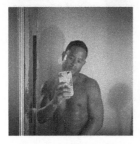

• • • • • •

Figure 3.2 Che Gossett's Instagram timeline via the browser interface, 2020. Screen grab by the author. Used with permission of Che Gossett.

her with "armor." Originally, this selfie accompanied an Instagram post in which Tourmaline described how her research into Marsha Johnson's life had been appropriated by a white director.[39] Uplifting knowledge production by Black trans women, Che Gossett writes: "My brilliant and light giving sister @reinaxgossett authored a heart and soul baring and heart and soul outraging post on her IG [Instagram]. She not only names how her archival and creative work have been appropriated—she also speaks out against the violence of 'trans visibility' in the afterlife of slavery—the commodification of Black trans women's labor and study."[40] In this case, reposting Tourmaline's selfie amid Gossett's own self-representations uses selfie seriality to oppose spectacularization with solidarity, furthering a counter-discourse that works

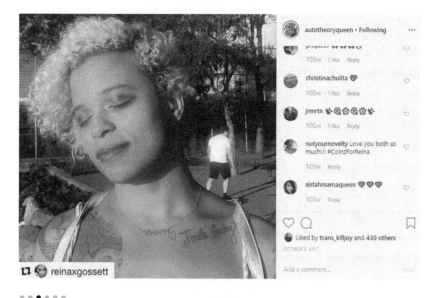

Figure 3.3 Selfie by Tourmaline, reposted by Che Gossett, 2017.
Used with permission by Tourmaline and Che Gossett.

to steal back the Black trans lifework stolen by a white director. Of course, these are only (some of) the connections and associations that emerge when I read these images as members of a series. I offer this reading as a demonstration of how selfie seriality makes such ambivalent explorations of visibility, visuality, and conspiracy possible.

Undercurrent, Live Wire

Unlike conspiracy, which overtly involves deception or, at least, dissimulation, visibility is often intertwined with ideas of authenticity. Meanwhile, although gender performativity theory can be criticized for the problems I described earlier, it simultaneously undermines authenticity claims. After all, gender performativity theory offers a crucial insight: there is no "original" gender, and, as a result, performative parodies of conventional gender norms are always themselves parodies of parodies.[41] As a result, gender performativity theory has a contentious relationship to visibility, because performativity theory reveals that gendered authenticity is a charade, at best, and a violent myth, at worst. Yet it's too simplistic to conclude that gender performativ-

ity theory just jettisons any idea of truth in gendered identity or experience, since gender performativity theory is also intertwined with the ball culture concept of "realness." As José Esteban Muñoz describes it, realness involves glamorous self-presentation that is "mimetic of a certain high-feminine style" and simultaneously stages and deconstructs normative expectations and demands.[42] It is related—but not equivalent—to "passing." Realness is distinct from authenticity and closely tied to camp; it includes an excessive, communal, and profoundly felt love for what dominant society denigrates. Realness, crucially, is not authenticity, but neither is it its precise opposite. In this section, I explore how Alok Vaid-Menon uses selfie seriality and camp sincerity to interrogate how visibility politics relies on authenticity testing to make both authenticity and visibility fraught for trans femmes of color.[43]

A former member of the South Asian poetry and performance duo Dark-Matter, Alok Vaid-Menon is an artist, performer, and fashion designer whose Instagram account pairs captions full of political musings with colorful, stylized selfies. According to Vaid-Menon, image and text interact in ways that are always already political, given that visuality is often dismissed as "the domain of femme" by a patriarchal culture that prioritizes language.[44] As a member of DarkMatter, which they formed in 2012 with Janani Balasubramanian, Vaid-Menon performed spoken word poetry and conducted educational workshops on race and gender on college campuses before pursuing independent projects as a performer and fashion designer.[45] Embracing contradictions like Gossett, they also use selfies to critique visibility politics. Arguing that Trans Day of Visibility emphasizes representation rather than structural change, Vaid-Menon suggests that popular discourse around trans issues exhibits misplaced priorities, posting a selfie to draw attention to a Facebook post that asks, "Can we be more critical of a culture that tells us that we are brave for being ourselves instead of dismantling the structures that made that so impossible to begin with?"[46] Through their selfies and social media posts, Vaid-Menon interrogates visibility's promises and perils, how transgender histories intersect with colonialism, and how femininity is stigmatized.

In one particular series of selfies, Vaid-Menon employs camp sincerity to challenge authenticity, as well as the white supremacist, hetero- and cissexist norms that govern visibility politics and the politics of respectability. For me, this series centers on a selfie Vaid-Menon posted on Instagram in which they pose with pursed, bright red lips, and wear a curly blonde wig in front of a purple background (figure 3.4). In addition to red, yellow, and purple, the selfie features a luminescent baby-blue tank top, creating a hypersaturated

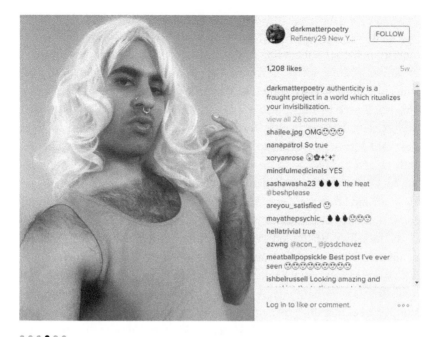

Figure 3.4 Selfie by Alok Vaid-Menon, 2016. Screen grab by the author.
Used with permission by Alok Vaid-Menon.

experience of vibrant, glowing colors. These four brilliant colors compete for
attention with Vaid-Menon's thick, dark body hair that itself contrasts with
the light gold of the blonde wig. The selfie juxtaposes artifice and authentic-
ity, masculinity and femininity, and the caption asserts that "authenticity is
a fraught project in a world that ritualizes your invisibilization." Combining
authenticity, visibility, and ritual, the caption describes the time-based pro-
cesses stilled by the photographic instant—ritual, the project of authenticity,
and the process of invisibilization.

 Visibility politics tends to assume that an authentic self can transpar-
ently be made visible. As Snorton writes, it reiterates the "popular, long-held
myth—that both the truth of race and the truth of sex are obvious, trans-
parent, and written on the body."[47] Furthering this myth, visibility politics
relies on the visual to legitimate authenticity and employs authenticity test-
ing humorlessly.[48] As a result, identities become a question of truth or deceit,
and they are imagined as static and unchanging rather than iterative, expe-
riential, partial, compromised, and negotiated. Against this, Vaid-Menon's
selfie series asserts that transparent authenticity is an impossible demand,

particularly for trans femmes of color. Wearing the blonde wig and the baby-blue tank top in all four of these posts, Vaid-Menon employs a variety of humorous modes—including camp, puns, and parody—to show how cis-sexism and racism affect minoritized subjects. The series begins with a silent, slow-motion video loop that stages the sensuous pleasure of the wig. This is followed by the selfie described here and, finally, by two videos that explore stereotypes of blondes through a parodic monologue. Across the series, Vaid-Menon uses makeup, jewelry, movement, sound, stillness, silence, and time to produce tensions and contradictions that cannot be fully resolved. Ultimately, the series demonstrates that visibility—what is made visible, how, and for whom—is never straightforwardly transparent but requires continuous, and often exhausting, renegotiation.

As the selfie's caption indicates, "authenticity is a fraught project" that depends on visibility and that can be undermined by what is invisible. However, it would be a mistake to regard that which is not visible as authenticity's opposite: as inauthenticity. As I have discussed elsewhere, John L. Jackson Jr. argues that this threatening, murky realm outside the visible is where sincerity disturbs authenticity.[49] Sincerity sidesteps the authenticity testing of identities and instead describes "how people think and feel their identities into palpable everyday existence."[50] As two interrelated but distinct modes of expressing and embodying identity, authenticity and sincerity have different relationships to visibility—and to the possibility of change over time. Jackson writes that "authenticity fools itself into scopic certainty" while "sincerity can't help but recognize its gaze as the feeblest attempt to visualize the invisible: the dark insides of the subjective, intentional, and willful social other."[51] Thus, authenticity relies on what is visible to assess identity while sincerity leaves open other possibilities. For Johnson, sincerity is critical to understanding racialized identities since racialized subjects will always fail racist authenticity tests. In Vaid-Menon's selfie, the hypersaturated colors highlight the wealth of information made available within the visual field, but the image itself cannot tell us what visible markers, if any, are signs that communicate the truth of Vaid-Menon's identity. For example, one reading of the blonde wig might see the long, curly hair as a truthful expression of Vaid-Menon's femme identity, but another reading might interpret the wig as a sign of artificiality, contrasting as it does with Vaid-Menon's own naturally dark hair, which in turn might be framed as communicating the truth of Vaid-Menon's South Asian heritage. Amid its references to processes that take time, the caption warns us that identity isn't stable. In the selfie, authenticity testing falters because the instant captured by the image is full of con-

tradictions. Furthermore, the selfie is part of a series that uses time—in the three videos and in the time of serial production and reception—to interrogate the politics of visibility.

The series analyzes how race and gender intersect, both through the image of a brown trans femme wearing a blonde wig and through the captions that accompany each post. Exploring the politics of hair, the series demonstrates how hair visibly marks gendered and racialized identities without ever being able to authenticate Vaid-Menon's identity within the context of white supremacist heterocispatriarchy. Opening with the slow-motion video, the series immediately highlights the wig, both through Vaid-Menon's performance and through the caption.[52] Brightly painted lips parted, Vaid-Menon gazes almost directly into the camera lens, but their look is slightly aslant, suggesting that they are most likely looking at their image reproduced on the screen of the smartphone. As they slowly move their head back and forth, swinging the blonde curls, their look remains constant, steady, fixed on (presumably) their own image. The blonde curls have a sensuous quality, for the slow-motion emphasizes how each lock of hair moves as Vaid-Menon twirls the curls around their fingers and they contrast with Vaid-Menon's dark body hair. This contrast between the wig and Vaid-Menon's dark body hair does not merely deconstruct gender or disturb hegemonic ideals. It explores how gender and race inflect each other.

Stating "gender is a racial construct: blondes have more funding," the caption on the looping video focuses on how gender and race intersect through the politics of hair. Combining an intersectional revision of the gender studies dogma "gender is a social construct" with the popular culture slogan "blondes have more fun," the caption asserts that when body hair is gendered masculine, femininity is overdetermined as whiteness while white (cis) femininity is privileged within capitalism. This is a topic that frequently appears in Vaid-Menon's social media posts, as they use this nonacademic platform to contribute to a broader discourse about how body hair is layered with racialized and gendered meaning. Black feminist scholars have studied how racism and sexism combine to negate Black women's femininity and womanhood.[53] Some scholarly literature has addressed the gendered significance of head hair and facial hair within South Asian contexts.[54] And online, bloggers have explored the significance of body hair for South Asian women and femmes. Writing "body hair on South Asian women is an axiomatically ignored and underrepresented issue in Western third-wave feminism," the blogger Duriba Khan says that her thick, dark body hair is an inheritance from her father that makes her racial identity visible and caused her

embarrassment and shame as a child.[55] Interviewing other women of color about body hair, Tasnim Ahmed describes her body hair as an inheritance from her father that aligns her with his masculinity. Responding to Ahmed, an Indian woman named Medha describes hair removal as an attempt to appear simultaneously more feminine and less Desi.[56] Finally, Nish Israni describes how her body hair makes her race "hyper visible," and all three bloggers concur not only that visible body hair is a racial marker, but that it also tends to delegitimize their femininity.[57] On Instagram, Vaid-Menon regularly posts selfies that highlight their body hair and captions these posts with the hashtag #TGIF.[58] Although they post these selfies on Fridays, Vaid-Menon asserts that the popular hashtag means "thank goddess I'm femme" rather than "thank god it's Friday," appropriating the popular hashtag to insert their selfies into this mainstream digital media space. In one #TGIF post, Vaid-Menon describes the compounding pressures they face around body hair removal, which are shaped by both racism and cissexism and seem to require "invisibilization."[59]

Through selfies, Vaid-Menon proudly claims visible, dark body hair as feminine and beautiful. Beyond the #TGIF posts, Vaid-Menon has produced a scattered series of other posts that similarly display their body hair, with captions that state that they are "another hairy brown girl against the patriarchy." These posts emphasize their seriality through the arbitrary episode numbers that Vaid-Menon assigns to them.[60] Implicitly, then, Vaid-Menon's captions disrupt the #TGIF hashtag not only to increase their own brand, but also in the name of a collective of "hairy brown girls against the patriarchy." Rather than striving for authenticity, Vaid-Menon stages their sincere commitment to an identity that might not be readily recognized within dominant discourses. And through the series featuring the blonde wig, Vaid-Menon extends this work by exploring the pressures (and possibilities) of embodying (or attempting to embody) an idealized femininity—which is, of course, over-determined as cisgender and white. The series stages these pressures, possibilities, and complex desires through a performance of the failure of passing.

Passing is usually understood as a unidirectional move from a stigmatized identity into a more privileged identity.[61] However, Vaid-Menon does not simply fail to pass into white femininity; they *perform* this failure—and thus perform their own resistance to white femininity. As a result, the selfie series troubles the assumption that passing moves in only one direction. Within the framework of authenticity, of course, passing can be understood only as concealing a fundamental (and testable) truth about the self through per-

forming a false self.[62] However, in contrast to authenticity's claim that identities are stable and unalterable, identities are relational, and that means identity is always in flux, never actually solidifying into "an ontological given."[63] If identities are relational practices rather than ontological givens, then passing must be understood as multidirectional. Capturing this multidirectionality, Jen Cross writes in the anthology *Nobody Passes: Rejecting the Rules of Gender and Conformity* that "it all depends on which direction you're talking: passing 'in' to visibly marked identity, or passing 'out' of awareness, moving stealthily."[64] In Cross's example, the visibly marked identity into which a social actor passes may or may not be "authentic"—and, indeed, elsewhere in the anthology, the editor Mattilda Bernstein Sycamore describes authenticity as a "dead end."[65] From this perspective, passing not only involves *passing out* of a stigmatized identity but includes *passing into* recognition.

Using the blonde wig, Vaid-Menon performs the codes of different identities simultaneously, passing into and out of seemingly stable identity categories and destabilizing each through its relationship to the others. Passing usually reinforces the signifying power of particular cultural markers, but this series demonstrates their contingency because the signs that point to distinct identities emerge from the same aspects of clothing, makeup, and performance.[66] For example, gesturing simultaneously to femininity and to whiteness, the wig appears to make Vaid-Menon's "true" gender identity visible (passing into recognition), on the one hand, while on the other hand, the wig has a complex relationship to Vaid-Menon's race (passing out of awareness). In both cases, however, the blonde wig cannot stabilize into any certain meaning. Instead of tracing a clear trajectory between truth and falsehood, the image and the accompanying text collide to produce unresolvable tensions. Sycamore writes that passing into identity is a "pass/fail" endeavor, and in the series of posts with the blonde wig, Vaid-Menon never succeeds in passing seamlessly into any single identity category.[67] Staging blonde, white womanhood and captioning it "gender is a racial construct/blondes have more funding," Vaid-Menon doesn't clarify whether this brown femme in the blonde wig is constructing themselves to access institutional support or is being marginalized by a society whose standards will always remain just out of reach.

This is the central question in Vaid-Menon's selfie series with the blonde wig. Looping back on itself, this series makes palpable the repetitive, circular trap of striving for authentic visibility. Rather than the instant of the single selfie, the series produces several different temporalities simultaneously: the time of playback, the circular time of the loop, and the time of the series.

Formally, each post has a distinct relationship to time—from the first video's looping slow-motion to the selfie's static instant and the final two videos' teleological drive—a relationship that then inflects the other posts through serial structure. Continuously looping, the slow-motion video focuses our attention on time and tactility, as Vaid-Menon's fingers play with the wig over and over. In the selfie, by contrast, the wig is on display, and the selfie's pose points to the wig—literally, in fact, as Vaid-Menon's index finger, accentuated with pink nail polish, points directly back toward their head. Since it follows the looping, slow-motion video, the circularity and self-referentiality of Vaid-Menon's pose in the selfie are more apparent, for their gesture points back to the wig as it appears in the image and to the wig as it appeared in the previous post.

While the looping, slow-motion video and the selfie with its circular, reflexive pose point toward an ever-repeating past, the final, parodic pair of videos move urgently forward, toward a critique of how white women uphold carceral logic. In the two videos (figures 3.5 and 3.6), Vaid-Menon describes, in the first person, a typical day for a stereotypical upper-class white woman, a "Becky":

> Hi everyone, it's Becky. Just getting ready for today. I've got a full schedule. Um, yoga appointment at ten am, then at twelve I've got tennis lessons with Fred, he's so cute, then at two I'm eating salad, and then at five [end of part 1; start of part 2] um, getting ready for drinks, and then at seven, still getting ready! Come over and take selfies [giggle]. And then at nine we're going out for drinks and it's going to be amazing, it's this amazing place that my friend knows, and I'm going to get really drunk, but it's OK, because the police state is going to protect me![68]

Despite their teleological drive toward political clarity, these final two posts in the series also have a complicated relationship to time, contingency, and serial structure. In the Becky videos, Vaid-Menon's voice is pitched artificially high, with a studied inflection that evokes Valley Girl or airhead blonde stereotypes, and it never wavers from this heavy pastiche. The camera is unstable and Vaid-Menon's gesture feels rushed, almost fidgety, rather than languorous. The high-pitched voice that Vaid-Menon employs combines with the shaky camera movement and the hurried gesture to create a sense of urgency, insistence, and even agitation that the first video, with its slow sensuousness, lacked. Performance, composition, and text combine to produce a very different viewing experience from the slow-motion video, which invites us to dwell in the moment and its contradictions.

At the same time, since all three videos were published on Instagram, they are all actually looping videos, but these temporal loops create different effects. In 2016, Instagram automatically looped videos posted to the platform, producing a jump cut effect as the end of each video perpetually returned to its beginning. Within the slow-motion video, this jump cut is slightly jarring, but the viewer can quickly settle back in the video's flow. In the first of the Becky videos, however, this looping effect feels like a problem to be corrected through "moving on" as quickly as possible to part 2. The end of part 2 not only leaves the viewer with nowhere to go as the video loops back on itself, but it adds an odd and unnerving new character: a white, blonde-wigged woman who stares intensely at the camera as she contributes to the video's playfulness through this ludic, yet disquieting, performance of "photobombing."[69] Rather than investing in the instant (in the selfie) or the looping moment (in the slow-motion video), the Becky videos create a teleological drive toward meaning, a drive that is then satisfied by the move from vapid, and not particularly pointed, stereotypes to ultimately reference white women's complicity in the criminal punishment system.[70]

Yet as the narrative ends abruptly, the video restarts at five o'clock, and we never learn what happened afterward. A plurality of the comments refer to the final line of the monologue, making it clear that the entire performance is understood by many viewers to be directed toward Vaid-Menon's critique of the white supremacist carceral system at the video's close.[71] But the Becky videos do not simply end with this final line. Instead, part 2 loops back to the beginning, abruptly splicing together "protect me" and "um, getting ready for drinks," producing an endless spiral in which Becky repeats and repeats the structure of that evening. Moreover, the loop also suddenly cuts the white woman with the curly wig and duckface lips out of the video, only to allow her to emerge again and again as a specter hovering behind Vaid-Menon's shoulder. This white woman haunts the video as she is abruptly eliminated from it.

Serial structure creates a new history—it doesn't preclude the viewer from referring to hegemonic common sense, but it begins the process of producing alternative possibilities of seeing. In this series, the selfie (which does not invoke race explicitly in its caption, although Vaid-Menon's race is made hypervisible within the image) is re-contextualized by the three videos. This clarifies that the authenticity and visibility it explores are gendered and racialized. The selfie could be understood as part of the larger series of Vaid-Menon's Instagram account, an account full of images that celebrate visible femininity as brave, true, and authentic, but when it is read as referring back

to the slow-motion video and serving as a reference for the Becky videos, the series ends up challenging any simplistically affirming reading. The series collapses the positions of the threatened white woman and the brown person she regards as threatening while pushing the actual white woman off-screen. Through serial structure and the formal technique of looping video, the series reverses the logic of visibility politics, a logic that would reproduce the ideology of the present by centering gender-conforming whiteness while consigning people of color, and gender-nonconforming people, to spaces beyond the edges of the frame. Of course, Vaid-Menon displaces "Becky" by enacting her, so the video doesn't produce uncomplicated visibility for Vaid-Menon's identity as a brown trans femme. Despite Vaid-Menon's critique of the criminal punishment system, Becky keeps going out for drinks. Undermining the assumption that selfies offer direct access to legibility, the series troubles the demand for authenticity that visibility politics makes of selfies.

Throughout this book, I describe many selfie series. They are all series that I identified after the fact, using the concept of serial structure to understand the connections that I make among selfies, as a viewer, that may not necessarily have been intended by their creators. And after all, selfies are rarely, if ever, singular or individual productions; particularly in the work I consider here, each selfie appears as a possible member of a plethora of potential series—from the series of all selfies to the series of all selfies by a particular creator and the many subseries that I (or other viewers) identify by noticing visual rhymes, compositional patterns, and other similarities, including repetition in the accompanying captions and hashtags. Furthermore, the boundaries of these series are expanded by network technologies, with creators relinquishing complete control over their self-representation when they post selfies online. As discussed in chapter 2, selfies can easily be repurposed and reimagined by others. This has consequences for our understanding of the boundaries of subjectivity, but it also produces additional, proliferating series. Finally, social media platforms produce and incentivize serial production and reception of selfies through platform-specific network structures such as tags and hashtags. Serial structure cannot foreclose readings that depend on dominant logics, but it makes available other possibilities. Seriality also offers the potentiality of escape even as images that were formerly outside of recognition become recuperated by dominant structures of vision. Through seriality—whether produced intentionally by the author or in the process of reception by a viewer—the seemingly static, instantaneous, individual selfie is mobilized across platforms, across media, across communities, and across time.

Selfie Time(lines)

On the internet, time can be strange, paradoxical, and nonlinear. Social media amplify these effects, crafting so-called timelines that display posts out of order, with images, news, and text organized based on algorithms rather than chronology. These dynamic, ever-changing timelines aren't concerned with temporal fidelity but are instead shaped by complex relationships among number of likes, number of comments, number of social media connections, the presence of hashtags in the captions, and many other factors. Given this, it seems all too easy to understand online temporality as potentially—or even automatically—a form of "queer time."

When it comes to selfies, this possibility can feel exciting, since typically selfies are used to track and dramatize the passage of time linearly. We see this in "before and after" pairings, in timelines that highlight privileged moments of an individual's history, and in videos that animate such transformations. In *Becoming* (2010), the trans artist Yishay Garbasz turned her transition selfies into proto-cinematic toys, including a flip-book and a zoetrope, creating physical, stable, and linear records of her transition.[1] By contrast, social media timelines might be understood to be queering the presumed linearity of selfie temporality, shaking up those tediously familiar "before and after" pairings, especially when it comes to transition timelines. However, these algorithmically nonlinear timelines aren't designed to question the

teleological trajectories of conventional or "straight" time; rather, they are geared toward maximizing profits. Simultaneously, Garbasz's proto-cinema experiments aren't actually a pure example of stable linearity, since they ask us to see twentieth- and twenty-first century trans ways of being through nineteenth-century technology. Instead, this example points to something else entirely: the complex process of working with time, including the intentional labor that creators and spectators do to explore the multivalent effects and queer potential of *both* linearity and nonlinearity.

When linear time is framed as normative, binary, and fundamentally opposed to nonlinear time (which is overdetermined as nonnormative and queer), this poses particular problems for representations of transition and trans lives. Often, gender transition is regarded as conservative *because* it is imagined to be linear. Of course, this is a reductive understanding of linear temporality; as Laura Horak notes, transition timelines can also be seen as "appropriat[ing] the 'straight' temporality of progress for radical ends—proving that trans self-determination is not only possible but viable and even joyful."[2] Nonetheless, transition is sometimes criticized for being too rigidly directed toward a goal, and, as a result, trans people are spuriously derided for enforcing the gender binary.[3] For trans creators, this is just one half of a double bind, since trans people have long been *required* to tell their histories teleologically to access health care and other resources. Such pressures extend into media criticism. For example, B. Ruby Rich criticizes trans self-representation as "almost purposefully ahistorical," at least when trans self-representation represses "past bodies and names."[4] For Rich, trans media makers deny history when they refuse to depict themselves prior to transition, when they decline to share their former or legal names, or when they do not otherwise indicate that they understand themselves as having once been the opposite gender.[5] Thus, trans representation faces a paradox: trans people are expected to defy linearity by existing forever in motion between stable states, cut off from the past and forbidden from imagining a future, and they are simultaneously required to admit their history in response to demands that recognize only certain trajectories of transition as authentic or true.

Before turning to my case studies and argument about how selfie aesthetics facilitate the intentional exploration of temporality, I want to acknowledge that nonlinear time can indeed create new ways of being and relating outside of conventional trajectories. Understandably, this is the major reason nonlinearity has been embraced by theories of queer time.[6] Yet if we unquestioningly embrace nonlinearity as queer—and overdetermine queerness as resistant—we falsely assume that "asynchrony, multitemporality, and non-

linearity . . . [are] automatically in the service of queer political projects and aspirations."[7] On social media, all subjects—queer, straight, and otherwise—relate to one another in modes that are nonlinear and asynchronous. Rather than being always and necessarily liberatory, these nonlinear temporalities are often ordinary or even traumatic. As micha cárdenas writes about the experience of scrolling through social media feeds: "These days, I am splintered—shattered by sadness, shock, and fear—from news of events that come in an irregular, but inexorable, rhythm."[8] Nonlinear experiences of time are not unique to queer subjects but "the universal condition of the subject caught up in structural repetition."[9] The fact that social media generates nonchronological user experiences is hardly a foundation for trans or queer liberation. In fact, as social media increasingly fragment time, they produce nonchronological temporalities that generate impossible fantasies of flexibility and fluidity, the very fantasies that support the structures of late capitalism.[10] As C. Riley Snorton points out, however, this fantastical flexibility is available only to white subjects and depends on the *fungibility* of racialized gender.[11] In recent years, theories of queer time have tried to grapple with how capital mobilizes nonchronological time and queerness to its own ends. However, theories about queer temporality still often conflate queerness and resistance, further entrenching the "binary oppositions" that (ironically) have structured the poststructuralist field of queer theory.[12] Selfie temporality—linear and nonlinear—can't be understood outside of these conditions.

Indeed, the resistant potential of selfie aesthetics is always tempered by social media's profound connections to capitalism, though selfies certainly aren't unique in being deeply intertwined with capital. After all, self-representation has a long historical connection to self-marketing.[13] Contemporaneously, selfies are critical to establishing and maintaining personal brands, a form of self-fashioning in which individual subjectivity is inseparable from—and constituted by—capitalist impulses. While Kim Kardashian's selfies are perhaps one of the most recognizable examples of personal branding through self-representation, this practice extends to the art world, where self-representation produces recognizable media objects that enhance the familiarity, popularity, and prestige of the selves thus represented. Cindy Sherman's selfies may be celebrated as an artistic practice distinct from vernacular selfie practices, but simultaneously her selfies contribute to her artistic reputation by demonstrating her continued relevance in this new media era.[14] Clearly, selfies are deeply imbricated in capitalist networks, and the nonlinear organization of

selfies and other content on social media doesn't automatically disrupt or deconstruct capital. Technology isn't deterministic; resistance is produced by interactions between communities and technologies. If selfie aesthetics and selfie temporality have resistant potential, that possibility emerges out of the collaboration between creators and their audiences.

One example of how selfies can do resistant political and theoretical work appears in the social media scholar Minh-Hà T. Phạm's monograph *Asians Wear Clothes on the Internet: Race, Gender, and the Work of Personal Style Blogging*. As Pham writes, selfies by Asian fashion bloggers are dismissed as cheap, fake, and narcissistic in a discursive gesture that actually functions to affirm the authority of white European fashion magazine editors.[15] But as Pham shows, these selfies employ racial signifiers both to maintain the fashion bloggers' personal brands *and* to reframe race beyond "the physical and social body to the sites of aesthetic sartorial choice."[16] As a result, Pham's analysis reveals that these fashion bloggers demonstrate how race is socially constructed, producing images that are available for and encourage critical analysis. The images don't automatically produce this effect, and many viewers probably don't engage with the selfies Pham studies in this way. However, close readings of the images and captions bring out and amplify these possibilities.

In this chapter, I explore how creators and their audiences mobilize the theoretical and political possibilities of nonlinear time by revisiting, revising, and renarrating their self-representations. These versions of nonlinear temporality are produced through laborious work rather than being an automatic or transparent effect of any particular medium or identity. The case studies I examine appear wholly or partly on YouTube, and the self-representations include still photographs as well as moving images. First, I return to a case study from chapter 2 to explore in more detail how Zinnia Jones's selfies were used in a YouTube video by an anonymous follower who created a "transition timeline" for Jones well before Jones herself had decided to transition. Second, I look at how the leftist YouTube vlogger Natalie Wynn, under the handle ContraPoints, has revisited and revised her videos as her own self-understanding has evolved. In my reading, YouTube is not only a site of self-authorship and community building, as Horak and Tobias Raun have shown, but also a platform that fosters in-depth hermeneutical and argumentative exchanges.[17] While this kind of engagement can become harmful, as the first case demonstrates, it also opens up space for active modes of spectatorship.

In the examples I discuss in this chapter, viewers are invited into a mode of spectatorship that actively explores time and the potential of nonlinear-

ity. Without positioning nonlinearity as more desirable or more radical than linear time, this chapter shows how digital media's nonlinearity allows creators to make evident the material labor of reimagining and reenvisioning the self. I argue that self-representational art can use social media's nonlinear temporalities to explore time while not reinforcing fantasies of trans fluidity. Through the specificity of their interventions, and the material traces these interventions produce, selfie aesthetics reveal political uses for nonlinear time that exceed assumptions about transgender ontology, as well as the technologically determined possibilities produced by social media platforms.

Predicting the Future

Transition timelines typically use selfies retrospectively to document a life in chronological order, but they can also be mobilized to much more complicated ends. Usually static composite images, transition timelines tend to produce a teleological sense of the temporality of transition. After all, they accumulate frozen moments that must be read in the correct chronological order. According to Maggie Nelson, gender transition selfies are a "genre" in and of themselves.[18] Indeed, there are certain typical features of transition selfies. Often representing a clear journey from "before" to "after," a contrast that usually emerges in the selfie creator's gender presentation/expression and secondary sex characteristics, transition selfies typically tell an apparently straightforward story.[19] Yet not all transition timelines are linearly binary. For example, Zinnia Jones toyed with the transition timeline format when she posted a selfie timeline in August 2014, challenging her followers to put the images in chronological order from left to right. On the left, Jones appears conventionally feminine, with long hair and red lipstick, while on the right, half her head is shaved and she wears no makeup. The implication is that the images toward the left must be more recent, since they are more conventionally feminine. Only later in the blog post does Jones reveal that the images already were in chronological order from left to right, documenting a transition that does not, in fact, aim at realizing normative femininity.[20] This transition timeline does not actually defy the conventional linearity of transition timelines: the images, after all, are already in chronological order from left to right. Instead, it undermines and exposes assumptions about what visual markers track the trajectory of transition. These assumptions are not only those held by Jones's followers; indeed, like all of us, Jones herself cannot fully anticipate how her future will unfold.

This selfie timeline is only one of many that Jones has created over the years. Yet although they might seem to be straightforward examples of the linear construction of a coherent, individuated self, Jones's selfie timelines in fact articulate a self that is not simply self-made. As I described in chapter 2, the first transition timeline that intentionally used Jones's selfies to trace her shifting gender presentation was not actually created by Jones. Instead, it was a video created by one of her followers. The trans woman behind the video, who used the pseudonym Nebulous Persona, arranged Jones's selfies in chronological order and paired them with an unsettling, computer-generated robotic voice that argues that Jones should transition—and claims that, in fact, the constructed timeline presented in the video proves that Jones has already begun to do so. In this section, I examine how this seemingly linear transition timeline video attempts to predict and change the future. As it delves into the past for signs that indicate possible outcomes, this transition timeline video has a conflicted relationship to how historical time unfolds. On the one hand, it assumes that by turning to the past it is possible to uncover signs that predict an inevitable future. Yet on the other hand, it also assumes that these discoveries must be shared to influence which future possibilities will come to pass. Caught between these two positions, where the future is simultaneously inevitable and mutable, the case study demonstrates how self-documentation is not merely a passive record of what has happened but also an active construction of what might be.

Uploaded to YouTube in early 2011, the video narrates a story of gender transition and illustrates the tale with selfies of and by an individual who, at the time, had a very different narrative of her own life. Instead of merely documenting Jones's life chronologically, her selfies also make nonlinear temporalities possible, as Jones's life path becomes a topic of dialogic contestation. Nebulous Persona's video appears to offer a normatively chronological account of Jones's life, but it is in fact an imaginative construction that opens up potential futures—some of which are realized and some of which are not. Earlier in 2011, Nebulous Persona had emailed Jones and encouraged her to transition. When Jones didn't reply, Nebulous Persona rephrased her argument as a video response, adding a voice that is likely the "Samantha" voice from the Apple operating system's text-to-speech program.[21] Although portions of the video are chronological and linear, the video moves backward and forward in time based on the argument's requirements.

Moving rapidly through a selection of selfies, as well as clips from Jones's videos, Nebulous Persona talks at Jones and then compels Jones to deliver

evidence that supports Nebulous Persona's argument. About two minutes into the video, Nebulous Persona pauses a clip from Jones's YouTube channel and, over a frozen head-and-shoulders shot of Jones, uses voice-over and scrolling text to ask Jones, disingenuously: "Well, at least you never think of yourself as a woman, right?" A jump cut propels the image of Jones back into motion, almost as if Nebulous Persona had tugged on a puppet string, and Jones says, emphatically, "It seems like any time a woman dares to be outspoken about, well, anything, there's always someone there to call her a bitch." Jones continues talking about her experiences with misogyny, and the video again abruptly pauses, cutting Jones off in mid-sentence. Then Nebulous Persona points out that Jones's words prove that Nebulous Persona is right: long before she came out, Jones at times indicated that she considered herself a woman.

The video's temporality is both linear and circular, as it loops back on itself to assemble the clues that predict the future. The video's circular temporality and collage aesthetic extend into the nuances of the robotic voice itself. Drawing on synthesized sounds, the robotic voice-over delivers particular words with the same pitch and inflection every time, so that when a single word is repeated multiple times in proximity, it starts to feel like an echo or a copy of each iteration of the same word. In this way, the robotic voice loops back on itself while advancing a necessarily linear argument, blending both teleological argumentation and formal circularity.

Portentously foretelling the future, Nebulous Persona says she wants to help Jones, writing on her blog: "If you . . . could help someone see their path of self discovery a little better, it could help, and maybe someday they'd thank you for it."[22] However, Nebulous Persona is also clearly motivated by her desire to claim (fore)knowledge of Jones's journey based on a belief that Jones is destined to follow the same path that Nebulous Persona has traveled. As I note in chapter 2, the video ends with the ominous statement, "We'll see, I guess. I can wait." Reflecting back on this incident two years later, Nebulous Persona anticipates that Jones will follow her example in more ways than one: "She says she wouldn't do what I did, but it's hard to know. Probably there won't be another high-profile personality on YouTube doing quite what she did any time soon. But I do know that she likes calling people out when they're putting stuff out there on the 'Net that's blatantly wrong—will she be able to resist? Now perhaps, but in ten or twenty years? We'll see, I guess. I can wait." Echoing her video's foreboding ending, this blog post asserts that Jones still doesn't know herself or what she might end up doing.[23] The post implies that Jones is stumbling toward a future she can't predict, while Nebu-

lous Persona foresees what is to come. Similarly, the video suggests that Nebulous Persona is waiting, patiently and even menacingly, at the end of Jones's journey, a journey Nebulous Persona alone can recognize and foretell.

According to Jones, this incident did not propel her along the path to self-knowledge.[24] Yet simultaneously, the Jones who reflects on this incident is someone who has been transformed by her life experiences, including this one. In her video and blog posts, Nebulous Persona claims that she is awaiting Jones's arrival at a destination that Nebulous Persona has already reached. Of course, despite her attempt to predict and control the future, the transition timeline video fails to fully imagine what actually comes to pass, demonstrating, as Mari Ruti writes, that "there is always a future in the future."[25] And in her own way, Jones also speaks to her past self about what may come, titling her blog post about the incident, "Two Years Later: Notes from the Future."[26] Far from a straightforward, chronological record of Jones's shifting gender presentation, the video and its subsequent paratexts represent time as cyclical: within the video, elements loop back on themselves, and both within and beyond the video, the two women keep asking how, whether, and in what ways Jones's path might retrace Nebulous Persona's experience. Even though Jones claims she ended up somewhere else, the fact remains that Jones does, of course, end up in *a* future, even if it is not the precise future Nebulous Persona had predicted. Rather than providing stable clues that anticipate a predictable future, Jones's selfies—and the selfie transition timelines she and her followers construct—open up possibilities, demonstrating that what is on the horizon is shaped but never wholly determined by what lies behind us.

Reimagining the Past

Digital technologies make it easier than ever to revise and renarrate the past. However, altering how we represent personal histories involves not only replacing one representation of the past with another, erasing history and writing it anew. Rather, revisiting and revising digital self-representation can be a dialogic practice in which time is not simply fluid but almost viscous. In such cases, history isn't wiped clean, but it can be worked with and worked on. Through reflexive videos, the vlogger Natalie Wynn, also known as ContraPoints, reedits and renarrates her history, creating a timeline of self-documentation that loops back on itself rather than moving linearly from the past to the future. On YouTube, Wynn uses camp, performance, and humor to challenge far-right conservatives on a platform that has become in-

famous for nurturing white supremacy. A former philosophy graduate student, Wynn left the academy and ended up finding a wider audience for her intellectual work online. On Instagram, she uses selfies to showcase elaborate makeup designs for her videos paired with captions that explicate the political implications of her costuming and performance. Combining style and substance, she's been described as "the Oscar Wilde of YouTube."[27] She appeals to people who are flirting with white supremacist ideology and, by using a platform that has become dominated by the so-called alt-right, she manages to move some of them to the left.[28] Rather than seeking "authentic" self-expression, her heavily stylized work explores the political power of drag performance, for, as she says in one video: "Why don't we fight the pageantry of fascism with a pageantry of our own?"[29]

Incidentally at first, Wynn has also documented her transition on You-Tube. As she revises her old videos, and as she references old videos within new productions, Wynn produces nonlinear temporalities that are nonetheless dialectical, for the digital moving image allows her to intervene in her personal history. Through her work, transition timelines are revealed to be more than chronological accumulations of self-documentation. They are also the grounds for active encounters with history, demonstrating how nonlinear time allows the present to engage the past as it builds toward unknown futures.

Wynn's efforts to manipulate time are visible, but they do not always take the form of revising her past. For example, within individual videos Wynn often stages dialogues among multiple characters that she herself plays. Her YouTube channel is saturated with such moments, as she uses split-screen techniques and shot reverse-shot sequences to play multiple, often recurring characters. For example, in "TERFs," Wynn plays three characters in conversation, and in "Debating the Alt-Right," she plays four different roles (figures 4.1 and 4.2).[30] Across her videos, these characters and others interact with one another primarily through carefully staged continuity editing and, occasionally, through wide shots created using basic special effects. Although it's obvious that she has manipulated the digital image, the *work* of collapsing these distinct moments is concealed. Elsewhere, however, Wynn makes her manipulations of time more overt, using superimposition and other obvious editing techniques to show how distinct temporal instants can converge, be juxtaposed, and be revised.

Wynn frequently references old videos and even reedits them—this is a recognizable element of her style—manipulating time and showing the work that is required to produce the self as multiple and, to a certain ex-

Figure 4.1 ContraPoints, "Debating the Alt-Right," video, 2017. Screen grab by the author. The video playback bar is included for comparison with figure 4.3 and to indicate the temporal relation to other figures from the video.

Figure 4.2 ContraPoints, "Debating the Alt-Right," video, 2017. Screen grab by the author. The video playback bar is included for comparison with figure 4.3 and to indicate the temporal relation to other figures from the video.

tent, as mutable. The detailed effects of these formal choices are particularly powerful across one series of videos: "Alpha Males," "Commentary on 'Alpha Males,'" "Degeneracy," and "Why the Alt-Right Is Wrong." In the series, Wynn keeps revisiting her previous work, commenting on and talking to her past selves as she interrogates the formal decisions that shape the series. As she revises, reedits, and restages previous work, she demonstrates how digital self-representation can be opened up to interventions that allow history to be retold. Yet simultaneously, these marked revisions show that the result of this digital alteration is not the unmoored fluidity and flexibility that constitutes the postmodern fantasy about gender transition, in which trans lives serve merely as a metaphor for all forms of transformation.[31] Instead, the visible traces of Wynn's interventions into her personal archive mark the materiality of transition and make apparent the work of self-exploration and the effort of engaging with one's past. Alternative futures become possible, but only through the material labor of revisiting and engaging with the past.

Beginning with "Alpha Males," Wynn uses this series of videos to debate another vlogger, a white supremacist who calls himself The Golden One.[32] The series is structured around her attempts to respond both critically and campily to the larger issues that are raised by his mode of white nationalist racism. The masculinist, heterosexist, and cissexist logic of The Golden One's politics provides a rich text against which Wynn explores gender, at times through artificially constructed dialogue with The Golden One himself but even more so through dialogue with her current and former selves. In "Alpha Males," which was released before she publicly came out as a trans woman, Wynn creates a dialogue between herself and The Golden One by selecting clips from his videos and arranging them as answers to her questions about how one achieves "alpha" (rather than "beta") masculinity. By appearing to take his hypermasculinity seriously, she unpacks the campy homoeroticism implicit in The Golden One's work, particularly in a scene in which she prepares "an Alpha Bath" and invites The Golden One to "awaken our masculinity by bathing nude together in the purifying waters." Throughout the video, the audio track alternates between sync sound and voice-over, with the voice-over narrating and mediating her on-screen actions, laying the groundwork for yet further layering of audio as she talks back to herself in subsequent videos. Later, in "Commentary on 'Alpha Males,'" Wynn rewatches and comments on "Alpha Males" after coming out as a trans woman.[33] Here, the bathtub scene becomes a critical moment in which she engages her past self, primarily by pausing the original video and talking back to her history through a picture-in-picture framing that juxtaposes past and present.

"Degeneracy" sees her turning once again to The Golden One as a source of knowledge, pretending that she seeks his guidance to understand the eugenicist, homophobic, and transphobic comments about her "degeneracy" that she receives from his political kindred on YouTube.[34] In the video, she again revisits the bathtub scenes from "Alpha Males," using superimposition and other strategies to comment on the time that has elapsed. Finally, in "Why the Alt-Right Is Wrong," Wynn takes a video that she had originally posted as a follow-up to "Alpha Males" and reedits it, nearly a year later, after it was blocked in most countries as a result of a targeted harassment campaign by white nationalists.[35] In modifying some elements of the video and voice-over, she juxtaposes her past and present selves visually and aurally. In all three of the videos that follow "Alpha Males," Wynn makes her interventions into her previous video(s) apparent, showing how these digital personal archives produce the possibility of revising—and reenvisioning—history.

Through digital effects, Wynn obviously alters her self-documentation, revealing the digital image's openness to transformation while simultaneously exposing the techniques that allow her to modify the past. These techniques include superimposition, picture-in-picture reframing, insert shots of new material, and censorship through pixelization. For example, in revisiting the bathtub scene in "Commentary on 'Alpha Males,'" Wynn combines superimposition and picture-in-picture framing with a gesture that functions like an insert shot of new material. As Wynn pauses the original video to allow herself more time for commentary, she opens up fissures within the original timeline that then overflow with the added context that she provides. In one such instance, most of the screen shows Wynn from 2016 sitting in a bathtub. Her eyeliner runs down her cheeks as she stares out at the viewer, frozen in time. Across the bottom of the screen, jagged text repeats the last words she said before this video clip was paused—not *by* the viewer but for (or, rather, *before*) the viewer. Static and trapped, Wynn's past stares out of the screen, confronting an audience that is also not in control of the video's playback. The frame shows Wynn twice: once in the center of the screen and once in the upper left corner of the screen, where she appears in a small picture-in-picture inset suffused with purple light. She looks at her computer screen—a screen we can't see but that we know duplicates the image we ourselves are seeing—while she controls the previous video's playback and reflects on her prior self. At the base of the YouTube video player, time collapses on itself as the run time of the paused video from 2016 is overlaid with the runtime of the remediation from 2017, generating a series of minutes and seconds separated by slashes: 7:07 / 28:51 15 / 13:42 (figure 4.3). Although it is still

Figure 4.3 ContraPoints, "Commentary on 'Alpha Males,'" video, 2017.
Screen grab by the author.

possible to read the numbers correctly, and to prioritize the clearer, more recent runtime indicators over the gray numbers beneath them, superimposition begins to blur the precise mathematical means through which time is measured.

Superimposition operates as a shorthand for the passage of time, but superimposition's temporality is less straightforwardly linear than it might seem. In the third video in the series, "Degeneracy," Wynn restages the bathtub scene from "Alpha Males." She uses superimposition to alter the original scene, but in doing so, she layers the superimposed clips and effects to produce a more complex vision of time than a simple move from "before" to "after." The video's opening mirrors the opening to "Alpha Males": Wynn intercuts between The Golden One's videos and her own responses, describes herself as ready begin "the training," and invites The Golden One to join her in "purifying ourselves in a bath of Swedish lake water and pure absinthe." After repeating the line that originally introduced the bathtub scene in "Alpha Males"—"It's time"—Wynn cuts to a shot from "Alpha Males" that shows her standing in the bathroom, removing a black robe in slow motion to reveal a pair of tight gold shorts. In "Degeneracy," however, this image is overlaid with a new one, and instead of the black robe and gold shorts, Wynn drops a lacy shawl from her shoulders as she strips down to a black one-piece bathing

Figure 4.4 ContraPoints, "Degeneracy," video, 2017. Screen grab by the author. The video playback bar is included for comparison with figure 4.3.

suit (figure 4.4). Superimposition compresses the year that separates these images into a few seconds. As Wynn steps forward, her past coincides with and then becomes a new iteration of herself through superimposition. On the one hand, superimposition generates a linear (albeit compressed) narrative of transition. Later in the same video, Wynn uses a brief clip of this moment of superimposition to represent "being trans" when she pairs a number of "degenerate" practices with their visual referents. However, through reimagining that year as an instantaneous transformation, one in which she can step from October 2016 into October 2017 in a moment, Wynn marks this extreme representation of gender's fluidity *as a fantastical construct*.

In the video, Wynn's gendered embodiment can become radically flexible only because of obvious special effects. As a result, the transformation retains a kind of material tactility. Moreover, the graphic flowers that rain down across the screen as Wynn poses in 2017 are actually retained from the original 2016 video, revealing that this moment of transformation is not a simple cross-dissolve from 2016 to 2017 but a digitally generated conjunction of the two time periods (figures 4.5 and 4.6). Rather than a before-and-after structure that envisions the temporality of transition as teleological, this scene layers Wynn's image from 2017 between elements from the 2016 video. The feminine flowers from 2016 aren't a sign or symptom of a truth that will

Figure 4.5 ContraPoints, "Degeneracy," video, 2017. Screen grab by the author. The video playback bar is included for comparison with figure 4.3 and to indicate the temporal relation to other figures the video.

Figure 4.6 ContraPoints, "Degeneracy," video, 2017. Screen grab by the author. The video playback bar is included for comparison with figure 4.3 and to indicate the temporal relation to other figures from the video.

be realized in 2017. Instead, these digital effects are a foreground flourish or filter that persists across Wynn's documentation of her experience. Here, the past is not simply "in the past." Instead, it surrounds the present to create the conditions of possibility for the future.

In "Why the Alt-Right Is Wrong," superimposition and insert shots of new footage mark the passage of time and make apparent Wynn's interventions into her previous work, even though the video opens with Wynn denying that she has altered the video. Through this tension, the video explores and refuses the idea that revising the past means erasing all traces of history. After white nationalists flagged Wynn's original video, "Why Wh!te N@tionali$m is Wrong," and strategically used the fact that it included Nazi symbols to assert that it promulgated—rather than critiqued—white nationalist views, Wynn reedited and rereleased the video without any of these images, retitling it, "Why the Alt-Right Is Wrong." She not only removed or censored any visuals that could result in the video being reported and, once again, banned; she also rerecorded sections of the voice-over, replacing terms such as *white nationalist* with euphemistic phrases such as *alt-right identitarians*.

Yet Wynn's self-censorship extends beyond these strategic decisions, for she also reedits the video for another reason. As she says in the video's opening, she would have preferred never to return to the original video; after all, "It's a year-old video. I'm the wrong gender in it." To address this, she uses a variety of techniques to alter her self-representation, including pixelization effects superimposed over her seminude body and digital masks that change the lighting to connect older images to new footage where she is bathed in purple light. As a result, the new video overtly, and even playfully, juxtaposes Wynn's past and present, moving abruptly back and forth between January and December 2017, often within the same image. For example, images from January that show her standing before a bookcase discussing white nationalism and wearing a pseudo-Nordic costume are digitally altered in December, with pixelization effects blurring out her breasts as a violet haze surrounds her (figure 4.7). After this shot, Wynn cuts to a series of stills, including a picture in which she pixelates a white nationalist symbol using the same effect that she used to censor her bare breasts. The result is not the implication that her image from January 2017 should be repressed as a bad object that is somehow equivalent to Nazi propaganda. Rather, the parallelism suggests that Wynn's efforts to obscure the past emerge out of necessity. The video makes these strategic compromises evident, so that as Wynn concedes to others' demands—to make her critique of white nationalism gentler, to participate in the "wrong body" discourse that medical and social structures

Figure 4.7 ContraPoints, "Why the Alt-Right Is Wrong," video, 2017.
Screen grab by the author. The video playback bar is included to compare
with figure 4.3.

require of trans people—she simultaneously makes the labor of this conces-
sional work apparent. Required to obscure elements of her previous video,
Wynn ostentatiously performs these revisions of her history.

Although these edits are obvious, Wynn denies making them, generat-
ing a provocative tension between historical engagement and historical revi-
sionism. In the new video's opening, Wynn explains her editorial decisions
and outlines how she has chosen to respond to the white nationalists' ha-
rassment campaign. Then, staring intently into the lens, she asserts "Other-
wise, I've left the video unchanged." A brief, black-and-white photograph of
Stalin and other party members flashes on-screen for a moment, before the
video returns to the violet light suffusing Wynn's image in the present. As a
digital zoom moves in on Wynn's face, she continues: "My name has always
been Natalie." Another version of the photograph again appears for a few
frames, this time with several of the figures beside Stalin erased, as Wynn
asks us insistently, "Don't you remember?" As she blinks dramatically and
stares into the lens, the digital zoom moves closer and closer to her face as
the soundtrack from the original video rises underneath this footage from
December. Then, a slow cross-dissolve takes us backward in time from her
room in December to a snowy woodland scene in January, and the older
footage begins to play.

By falsely asserting that the video has been left "otherwise unchanged," Wynn prompts us to seek out her alterations. Evidence of Wynn's edits is jarringly obvious not only in the image track but also in the video's audio, for when she rerecords sections of voice-over, Wynn's voice is noticeably higher in register than in the original video. This is a technologically enhanced and material special effect, for Wynn has used voice-training techniques to alter her voice's pitch and timbre.[36] By cutting to the photographs of Stalin as she denies modifying the original video, Wynn juxtaposes her own discomfort with this video of herself as "the wrong gender" with an image that gestures to the politics of historical erasure. Bringing together these disparate images, Wynn exposes the labor of being stealth and critiques how trans people are disciplined to discuss personal history. Erasure becomes necessary because of the medical, legal, social, and even psychological risks of engaging in other forms of self-narration, and Wynn resists this discipline by ensuring that her revisions to her self-representation are clearly marked.

Just as digital self-representation must be *made* resistant, trans and queer people are not automatically radical because of the very fact of our existence. Instead, radicality—where it exists—is produced through critique, negotiation, debate, decisions, and dialogic transformation. This process is fraught, painful, and imperfect, like the visible traces of Wynn's edits that revise but do not entirely rewrite her history. As she revisits and restages moments that have become recognizable to her fans, Wynn further establishes a persona that has become her full-time job. Her fans support her work directly through Patreon donations and indirectly through merchandise purchases and other means. Repeatedly, Wynn's fans have criticized her for voicing what some see as politically problematic views, and she reflects and responds to these critiques, extending her dialogic practice to her relationship with her fans. One example of this occurred in November 2017, when Wynn agreed to participate in an event that would put her in conversation with a trans woman who has deeply conservative views.[37] Wynn quickly found herself in the middle of a Twitter storm of outrage and lost a significant number of her Patreon supporters.[38] The emotional effects were perhaps even more intense. Losing fans, she said, left her "crying in bed, unable to think about anything else." Reflecting on the experience, she added: "This is the best piece of advice I can give to aspiring YouTubers. . . . [Y]our audience are not your friends. They are spectators. Their love is highly contingent. The moment you fuck up you're dead to them. They do not love you. They love an idea of you."[39]

Wynn's complex relationship to her fans parallels the complicated relationship between trans studies and queer theory. For too long, queer the-

ory has positioned trans figures—and, by implication, trans people—as the ultimate symbols of gender flexibility, ambiguity, and resistance. Yet all too often, queer theory does this in ways that do not further trans liberation. To echo Wynn's comments on the contingent love of her fans and apply her remarks to the relationship between some queer theorists and the trans people they study: "They do not love you. They love an idea of you." Yet when trans creators refuse the demand to serve as symbols of fluidity and flexibility, it does not necessarily refute queer theory. Instead, their work can help make queer theory, including theories of queer temporality, more precise, more nuanced, and more meaningful.

In the transition timeline videos I've examined here, digital self-representation challenges fantasies about both gender flexibility and nonlinear temporalities by revealing the material labor that makes it possible for history to be revised. Rather than an escape from late capitalist fantasies, however, these practices of self-representation are dialogic processes. As Jasbir K. Puar points out, "lines of flight" can always be reterritorialized, and, she writes, their revolutionary potential "resides in the interstitial shuttling . . . between intensive multiplicity and its most likely recapture."[40] Indeed, within a capitalist system, it would be unreasonable to demand that technological tools produce visions of the self entirely beyond capitalism. As Donna Haraway writes about cyborgs, "The illegitimate offspring of militarism and patriarchal capitalism, not to mention state socialism. . . . are often exceedingly unfaithful to their origins."[41] They do not become so because of their inheritance—or, in other words, their inherent programming. Instead of technological determinism, in which algorithmic time and the structures of social media platforms might be assumed to automatically ensure that selfie aesthetics can radicalize time and produce alternative futures—these possibilities emerge from specific interventions, facilitated by digital media and network technologies, that reveal the materiality, power, and potentiality of rethinking, reimagining, and retelling personal histories through self-representational art.

Trans Feminist Futures

How we understand trans self-representation is inextricable from postmodern anxieties and fantasies about both trans figures and digital archives. As I have discussed, trans figures represent both the possibility and the threat of unlimited flexibility. Simultaneously, digital technologies make self-representation easier, faster, and more flexible and thus appear to make anything and everything possible, a condition that Fred Ritchin describes as a digital revolution in which "history becomes fluid."[1] As Susan Stryker and Paisley Currah write, postmodernism seizes on both trans figures and digital records to express "anxieties regarding the collapse of time and place," with trans figures functioning as a metaphor for postmodern dislocations, as "an elastic, recategorizable body . . . and a dematerializable and reconstitutable embodiment simultaneously everywhere and nowhere at once, like the Internet." The fluidity that is projected onto transgender bodies and trans experiences points both to our anxieties and to our desires, but, as Stryker and Currah note, this fluidity exists only "in theory, of course, or perhaps in fantasy . . . never in actual practice." Instead, "Transgender bodies are always somewhere. They are never 'the body,' always particular bodies. Knowledges of them are likewise partial, situated, and concrete."[2] Selfies make the body particular and concrete, and selfie aesthetics can produce situated speculative archives that make specific alternative futures possible.

Theorized by Allyson Nadia Field, speculative archives are created by marginalized and minoritized artists to supply the images and narratives that are missing from official histories. As Field describes, films such as Julie Dash's *Illusions* (1982) and Cheryl Dunye's *The Watermelon Woman* (1996) create fictional characters that nonetheless represent the lives and experiences of Black media makers, inserting these fictional creations into cinema history.[3] Along similar lines, transgender filmmakers have reimagined trans history by reanimating stories that have been hidden or lost. In Chase Joynt and Kristen Schilt's *Framing Agnes* (2018), trans media producers such as Zackary Drucker, Angelica Ross, Silas Howard, and Max Valerio reenact recently rediscovered sociological case histories of transgender patients from decades ago and share their own experiences. This generates a web of connections across time that creates a new genealogy of trans history.[4] Similarly, Tourmaline's *Happy Birthday, Marsha!* (2018) re-creates a minor historical moment from the life of Marsha P. Johnson, one of the trans activists who instigated the Stonewall Riots; in other work, Tourmaline has continued to explore the possibilities of speculative archives, as in her film *Salacia* (2020). As a producer for the Amazon.com television series *Transparent* (2014–17), Zackary Drucker was involved in research for a backstory set in Berlin in 1933 that brings to life Magnus Hirschfeld's Institute of Sex Research through the eyes of the central family's ancestors.[5] Instead of a relationship to history characterized by "a fetish for the perhaps nostalgic notion of a specific and locatable past," speculative archives are dynamic, developing, and unpredictable.[6] They produce new histories that become the conditions of possibility for liberatory futures.

Speculative archives explore temporality as a space of resistance to make a future possible; in other words, speculative archives reject the nihilistic move to reject futurity that has been embraced by some queer theorists. "Distilling the past," as José Esteban Muñoz writes, allows us to imagine queer and trans futurity.[7] For Muñoz, "queer futurity" is brought into being through action; it is an act of world making by collectives who come together from a shared desire for liberation.[8] In Muñoz's work, queer time is no longer equated with nonlinear, nonchronological, or nonreproductive temporalities; thus, it isn't linked to the death drive. He responds to Lee Edelman's monograph *No Future: Queer Theory and the Death Drive* and argues that Edelman's assumption that queerness is nonreproductive is directly tied to whiteness and, arguably, to sexist and cissexist assumptions about queer possibilities.[9] On the one hand, transformation depends on no longer reproducing the past; on the other hand, queer theory's anxiety about reproduction manifests its

lingering misogyny.[10] In *Time Binds: Queer Temporalities and Queer Histories*, Elizabeth Freeman presents rich case studies of queer nonlinearity, but since she contends that these cases are united by their opposition to "chrononormativity," she also conflates queerness with nonreproductivity.[11] While Jasbir K. Puar describes hegemonic time as "regenerative" rather than reproductive, she still imagines queerness as having "no future," perhaps most disturbingly when she describes suicide bombers as key figures of queerness.[12] By contrast, Kara Keeling describes hegemonic temporality without defining it through reproductivity and then offers an account of oppositional temporalities that sidestep death and destruction. For Keeling, the present is constrained by the past, specifically through the politics of visibility. Because this produces a temporal loop, hegemonic time can be resisted only when we examine the act of seeing and the politics of recognition.[13] Following Keeling and Muñoz, I contend that the resistant temporal possibilities of selfie aesthetics depend on intentional, critical activity rather than any essential aspect of trans identity or any inherent technical property of digital media.

Close analysis allows us to excavate the formal choices that shape how selfie creators engage in the critical and creative work of "distilling the past"—and the present—to "imagine a future." Shea Couleé's *Lipstick City* (2016), a fictional tale of sisterhood and antipatriarchal revenge, conveys the experience of algorithmic time on social media and the forms of community building that it makes possible. As the characters move abruptly back and forth in time, the short film documents the community networks that are facilitated by social media platforms and preserves the experience of networked, nonlinear community building online. Rooting its fiction in Chicago's queer of color drag culture, the film celebrates queer and trans potentiality. While *Lipstick City* captures a contemporary experience and uses it to create the conditions for queer of color futures, the trans artist Vivek Shraya uses portraits, videos, personal essays, and selfies to re-create her family's history. Restaging her own and her mother's lives, Shraya does not reveal a queer or trans ancestor in her family tree but instead archives an alternative family history. Through revisiting and reimagining the past, Shraya's speculative archive makes new futures possible for herself and her family.

A kind of linearity is implicit in the idea of distilling the past or the present and using that to imagine a future. Ultimately, trans experience—not unlike cis experience—is often directed toward an anticipated future. However, the fact that they are attached to history and invested in the future does not make these self-representative speculative archives conservative, regressive, or normative. Following Muñoz, who describes the aesthetic possibilities of

a "critical deployment of the past for the purpose of engaging the present and imagining the future," I argue that selfies and self-representational art can anticipate a utopian futurity that "is not yet here but [that] . . . approaches like a crashing wave of potentiality."[14] Rather than escaping from the late capitalist structures of social media platforms, these projects exist and move through, alongside, and against the compromises that social media platforms make necessary. Mobilizing future-oriented temporalities to support trans of color liberation, these speculative archives reject both the postmodern desire that trans temporality defy linearity *and* the conservative assertion that trans temporality must begin from a stable and "factual" origin. Here, the instantaneity of digital snapshot photography doesn't consign trans temporality to being permanently suspended between stable states. Instead, these speculative archives work to connect the moment (the instant, the snapshot, the selfie) to futurity.

Meanwhile, Later, a Little Earlier

Music pulses as performers dance on a stage where the proscenium looks like a giant open mouth, its curved lips painted a deep, vibrant red. Bathed in red light, the dancers twirl, manipulate feathered fans, and engage with their adoring audience (figure 5.1). Rapid editing matches each cut to the beat of the dance music and conveys the rhythm of the nightclub—but the editing does something more. Extremely brief medium close-ups of each performer are intercut with black, and the image pulses in sync with the music as each dancer is isolated for a few seconds before the screen goes dark again. In this way, the sequence mimics and inverts an earlier moment in the film. During a photo shoot, similarly brief close-ups were punctuated by solid white—the effect of flash photography. Both sequences capture the temporality of photography, as instants are separated out from the continuity of time. Yet instead of a fleeting instant frozen forever by the camera, here the moment of recording is swallowed up by pure black or white. As viewers, we imagine the documentary image that results while feeling the rhythm of a photographic practice that is never fully depicted. Rather than contemplating the preserved, properly historical moment, our experience is continually and rhythmically interrupted as instants are seized out of the flow of time to become shareable and exchangeable.

Social media temporality isn't an explicit part of *Lipstick City*'s content, although it is the film's context and is central to its spectatorial experience. Glamorous, glossy, and gloriously high-definition, *Lipstick City* was critical to

Figure 5.1 *Lipstick City*, directed by Shea Couleé, 2016. Screen grab by the author.

Couleé's successful bid to compete on the ninth season of *RuPaul's Drag Race*, in 2017. Couleé, a Columbia College graduate and drag performer, musician, and host based in Chicago, comes from an art school background; Couleé's self-representative art includes casual selfies, nightclub performance, music videos, and high-concept film. Couleé's is one of only a few Black drag queens in Chicago.[15] Her Instagram posts combine vernacular selfies with photographic and graphic art based on her characters, using social media to connect with fans and develop her drag persona. Couleé's investment in the highly stylized surface—whether through the high production value and glittery glamour of *Lipstick City* or the carefully curated images that build her personal brand or her foray into music video—embraces femininity, superficiality, and style. In doing so, Couleé uses camp strategies to explore the feminine and the superficial in self-representation. Produced by the Couleé Collective and distributed by Aymar Jean Christian's Open TV–Beta, *Lipstick City* follows Couleé as she plays opposite herself in roles based on the two halves of her drag persona: the "bougie" Miss Couleé and the "banji" Shea.[16] Doubling herself through split screens and parallel editing, Couleé as her two selves pursues and punishes Miss Couleé's cheating paramour. In doing so, they take a rapid-fire, nonlinear tour through Chicago, meeting and performing with a set of Chicago drag queens on their way.

The film documents Chicago's drag culture at a particular historical moment and emphasizes the role that queens of color play in the city's perfor-

mance circuit while also capturing a specific experience of time.[17] Within the narrative, the characters' divergent pathways bring them together at a nightclub that is readily recognizable as Smartbar and Metro, where Couleé regularly hosted the Sunday night party *Queen!*[18] At the nightclub, Couleé and other dancers perform, watched by a crowd of extras from Chicago's queer community. The sequence cuts rapidly among close-ups of the performers; wide shots of the stage; and canted, handheld shots from within the audience. As the audience dances along to the music, silhouetted between the camera and the stage, the realism of the sequence authenticates the documentary value of the recording. Out of the nine minutes and sixteen seconds of the film, this minute and fifteen seconds emerges as a record of Chicago's queer of color community in 2015. Of course, Couleé's performances are rarely, if ever, unrecorded; on a number of social media platforms, records of her and her community are preserved through photos, videos, and other media. But far beyond this single performance, the film's nonlinear chronology documents the phenomenological *experience* of time on social media platforms. Title cards move us backward and forward through time with dizzying speed as the film explores how nonchronological time organized algorithmically alters the phenomenological experience of history. The film archives the *feeling* of a community that moves fluidly between online networks and the networks of the city's performance spaces.

In *Lipstick City*, markers of time and space are never absolute but are, rather, relative, which evokes how many social media platforms mark time. Unlike absolute time stamps, which indicate not just the day, month, and year of a post but also the precise minute it was posted, relative time stamps display the number of minutes, hours, days, or weeks that have passed *since* an image was posted. On many platforms, absolute timestamps appear only when the viewer takes additional steps—for example, hovering the mouse over the relative timestamp. Relative timestamps convey an immediate sense of time passing, but always in relation to the embodied user in a particular, contingent moment. On Instagram, time markers were wholly relative in 2015 and early 2016, with posts time stamped using the following format: "66w" for "66 weeks ago." In *Lipstick City*, time and space are indicated elliptically and relationally: "the night before," "later that night; at the discotheque," "meanwhile at Maison Couleé," "across town," and "not too long after." The film captures how social media temporalities are often relational and situational rather than chronological.

Blending the digital and the material, *Lipstick City* also connects embodied time to social media temporalities through analog motifs: landline

Figure 5.2 *Lipstick City*, directed by Shea Couleé, 2016. Screen grab by the author.

telephones and automobiles. Throughout the film, decorative landline telephones create webs of social connections as the characters call one another up to commiserate, share gossip, and make plans (figure 5.2). The characters are linked through conventional editing techniques, including split screens and shot reverse-shot sequences in which they appear to face one another across the distances that divide them. The community's tight social networks are conveyed through the rapid pace of the editing, which propels each telephone conversation into action. As the characters move toward one another in response to news or decisions communicated via telephone, they consistently move from screen left to screen right. Walking or driving toward their goals, their trajectories converge. However, the consistent screen direction is interrupted by sudden cuts backward or forward in time, by cuts to action taking place simultaneously in other spaces, or by hard cuts to black. Editing generates tension between the film's propulsive forward movement and its recursive, nonlinear structure, and this tension is accelerated when telephones and automobiles converge. Phone calls initiate drives, and characters pose dramatically beside or on expensive cars, cell phones in hand. Thus, the nonlinear networks represented by telephones intersect with the directed movement of automobiles.

Though it might seem counterintuitive, there's a history that can contextualize *Lipstick City*'s use of nondigital technologies to visualize the network aesthetics of social media culture.[19] As Scott Bukatman writes, automobiles exemplify cyborgs and cyberspace, for, while driving a car, "the driver is already a cyborg, wedded to the technology which defines him."[20] Cars and phones express the networked sense of online sociality through technologies that predate the internet, reminding us that humans have always used tools as cyborg prosthetics. In *Lipstick City*, a metonymic chain ties together communication, movement, and social bonds as the film explores the nonchro-

nological, nonlinear web of accelerating connections that characterize social media spaces. Social media is no longer tied to specific platforms and their digital codes; instead, it becomes a virtual space where time is relational, networked, and never fixed, but always potential.

Evoking social media through analog technologies, *Lipstick City* reveals that virtuality is a question of desire and potentiality rather than something technologically determined by the digital. According to the media scholar Homay King, digital logics depend on the idea that the moment is separate from the past and the future, "as if the universe were beginning again with a blank slate at each passing instant."[21] In *Lipstick City*, black slugs divide the continuity of the shot into instants and create the feeling of a world in which recorded moments are selected out of continuous time, with everything that is not recorded "going dark." Yet through relative time markers and network aesthetics, *Lipstick City* also envisions social media time as virtual time. As King describes it, virtual time can be recognized as "a continuous stream of images that forks, loops, and doubles back on itself."[22] In this way, the film conveys how social media mediates our experience of space, time, and history, producing a record that functions as an experience rather than as an object. More than its staged performances, what *Lipstick City* offers is a record that can produce (again and again) a sense of social media's temporality.

In *Lipstick City*, social media temporality is not only virtual but also *potential*, deeply linked to the temporal experiences produced by queer performance spaces. The film connects the feeling of social media temporalities to the affective charge of queer performance spaces and examines how the boundaries of queer performance spaces are exponentially expanded online. Extending across space and time, social media makes the experience of queer performance spaces shareable and exchangeable. This generates yet more forms of nonlinear—and unproductive, as opposed to nonreproductive—time. As Muñoz writes, "queer dance spaces attempt to spatialize utopia."[23] However, queer performance spaces are not only literal spaces, but also the experience of time as potential. Exploring how space and time converge, Muñoz takes literally the familiar, dismissive statement that queerness is a phase or "a stage," and he describes stages at gay bars as spaces of potentiality, spaces that make possible "that moment of hope and potential transformation that is also the temporality of performance."[24] As these performances exceed the dance floor, crossing over to social media platforms, they create additional nonlinear and nonchronological temporalities. On Instagram, for example, algorithms interweave promotional images for queer dance parties alongside selfies and other photographs taken at those parties. Images

posted three days ago might follow images posted more recently, juxtaposing event promotion with its subsequent documentation. Here, advertisements for queer parties futilely promote a future scene of pleasure and community that is, in fact, forever past and foreclosed. Yet these missed opportunities are not only negative; instead, they create additional imagined communal possibilities. Social media temporalities extend the potentiality of queer time beyond one performance space and into another—neither of which are spaces separate from capital. Instead, both the commercial venue of the gay bar and the consumerist digital spaces of social media make possible performances that open up communal futures.

As *Lipstick City* demonstrates, social media temporality accumulates instants, but rarely in chronological order. Instead, as people connect, take selfies together, tag one another in posts, and otherwise add continuously to the networked connections among them, these records are aleatory and quotidian, customized for each user, and always situated and relational. Fundamentally ephemeral, social media timelines, dashboards, and news feeds display certain posts again and again, their persistence almost inescapable, while others are never recoverable or difficult or impossible to track down after being glimpsed in passing. On social media, selfies produce records of lives, experiences, and relationships that are thus also ephemeral, situated, and relational. Although selfies can be corralled into representing chronological time—as in many transition timelines—they can also document, explore, and perform time as potential. Their algorithmic, nonlinear temporalities are created by companies seeking to harvest data for commercial purposes, but social media communal spaces simultaneously offer distinct benefits to marginalized communities. Like so-called IRL (in real life) queer performance spaces, social media provides opportunities for relationship building that might not be available elsewhere, generating new possibilities for imagining what has not yet come to pass. In *Lipstick City*, a networked experience of community building and queer performance creates the conditions of possibility for queer world making.

Distilling the Past to Imagine a Future

Queer futurity is not only built from communities in the present. It also deals with family, genealogy, and how our histories seem to shape our destinies. Undoing the ties that bind the present to the past and constrain the future, the trans artist Vivek Shraya uses self-portraiture to open her family's diasporic South Asian history to other narratives, other trajectories, and even

other family members. In *Trisha* (2016), one of many projects that are part of Shraya's long-term exploration of identity, family, and inheritance, Shraya pairs photographs with a reflective personal essay in which she addresses her mother: "You had also prayed for me to look like Dad, but you forgot to pray for the rest of me. It is strange that you would overlook this, as you have always said 'Be careful what you pray for.' When I take off my clothes and look in the mirror, I see Dad's body, as you wished. But the rest of me has always wished to be you."[25] Here, Shraya describes her desire to become a parent whose present and past model a future that is just on the horizon of becoming. A reality that is not yet here, the wish to become another—especially a parent—is the classic linear story of subjectivation, a teleological drive toward an obvious, and clearly reproductive, goal. Queer of color critique challenges the idea that queer time must be necessarily nonreproductive, yet nevertheless Shraya's wish to become her mother might appear eminently "straight."[26] However, as Shraya intervenes in her family's history, her work bends straight time as she produces new, speculative archives. Through reflexive strategies, including re-creating old photographs, Shraya's speculative archives transform the past retroactively while simultaneously producing the conditions that make alternative futures—and Shraya's present—possible. Here, time is unpredictable and open to potentiality while still being profoundly tied to history, both "real" and imagined. As Muñoz writes, the act of invoking a past—including an improperly remembered or historically inaccurate past—can be a powerful tool in imagining queer futurity.[27] When Shraya turns to her family's history, she does not uncover a recognizably and demonstrably queer ancestry. Instead, she queers her ancestry by opening up possibilities that were, at one time, *im*possibilities, both for her family and for herself.

Through dialogue with her mother across multiple projects, Shraya asks questions about the parent-child connection, questions that foreshadow—and trace—Shraya's gender transition. In her short film *Holy Mother, My Mother* (2014 [figure 5.3]), Shraya documents her trip to India with her mother to celebrate the Navaratri Festival, a nine-day festival dedicated to the Goddess, to the Divine Mother, and to feminine energy. For Shraya, the trip allowed her to connect her queerness to her spirituality while honoring her mother through her art and exploring how her mother's example draws her toward femininity.[28] The film was produced and released two years before Shraya came out as a trans woman. In the film, Shraya captures the lights, sounds, colors, and different spaces of the festival as they coalesce around the figure of her mother, who looks directly into the lens as she si-

Figure 5.3 *Holy Mother, My Mother*, directed by Vivek Shraya, 2014.
Used with permission of Vivek Shraya.

lently holds—or endures—the look of Shraya's camera. Until the very end of the film, there is no sync sound. Instead, as Shraya's mother silently moves through the celebrations, and patiently bears with her child's determination to record her image, her nondiegetic and nonsynchronous voice-over blends with the festival's music as she reflects on motherhood. Initially calm, and even delighted, describing how children can be so easily cheered and soothed, Shraya's mother's voice gradually begins breaking as she starts to cry. She talks about motherhood's unpredictability and the unexpected turns life takes, and by the film's end, her words are frequently interrupted by sniffs and sobs.

Despite the intimacy of this emotionally open voice-over, the film also feels distant. Though it is a documentary by a daughter about her mother, it is difficult to detect the mother-daughter relationship within the film itself. Throughout her voice-over, Shraya's mother describes her children in the third-person plural, referring to "they," "them," or "the children." She uses second-person pronouns only once, when she says, "Only when you become a mother you know how it is . . . what your parents have gone through for you." Here, though she is presumably speaking to her filmmaker child, "you" substitutes for "I." Meanwhile, Shraya does not appear in the film, although title cards position her as the film's author. Speaking in the first-person, a title

card states: "As we took part in the festivities . . . my mother and I discussed her own relationship to motherhood." While framed by this opening title card, nothing about the film's visuals or audio actually realizes the promised "discussion."

Instead, all dialogue between Shraya and her mother is relegated to the film's "teaser," a trailer that introduces the film without anticipating its imagery or style.[29] Opening with Shraya's voice from behind a handheld camera, the teaser puts the two in conversation. "So, mom," Shraya says, her voice distorted by the on-board microphone, "how are you?" On camera, standing in front of an arch in a shot that never appears in the finished film, Shraya's mother replies, "I am fine, thank you, by God's grace." Shraya asks again, "How do you feel?" and her mother replies, bowing her head to her hands, "Good, thank you." A hard cut replaces this handheld shot with a stable shot, presumably on a tripod, as Shraya substitutes for her mother before the same arch. Tipping her head down as she adjusts her glasses, in a gesture that rhymes with her mother's bow, she answers the question that she had just put, twice, to her mother: "I'm excited and I'm nervous." This pattern repeats a second time, as Shraya poses a question to her mother from behind the camera, records her mother's response, and then substitutes for her mother to answer the question herself. Finally, Shraya asks, "What else?" and the teaser cuts to an image of a female goddess and the title of the film, before concluding with an old black-and-white photograph of Shraya's mother in her youth.

In the teaser for *Holy Mother, My Mother*, Shraya explores her relationship to her mother through substitution, seeking to close the distance between mother and child, other and self. Yet their differences are highlighted in the teaser, as Shraya's head reaches the top of the arch that dwarfs her mother (figures 5.4 and 5.5), and as her voice registers lower than her mother's. As they appear on-screen one after the other, their differences overshadow any parent-child resemblance. *Holy Mother, My Mother* appears to freeze the mother-daughter relationship before Shraya came out as a trans woman, concluding with family photographs of Shraya's mother flanked by the tall, bearded figures of her "two sons," the children of whom, she says wistfully, "sometimes along their path . . . might realize what we have taught them."

However, when watched by viewers who now know that Shraya is a trans woman, the film is full of portents that point to Shraya's transition, proving how accurate Shraya's mother was when she described motherhood as unpredictable. In hindsight, the film seems to ask whether Shraya's transition might be understood as one of the parental lessons that "the children" would learn along their journeys. Again, the only time Shraya's mother uses second-

Figure 5.4 Vivek Shraya's teaser to *Holy Mother, My Mother*, 2014. Screen grab by the author. Used with permission of Vivek Shraya.

Figure 5.5 Vivek Shraya's teaser to *Holy Mother, My Mother*, 2014. Screen grab by the author. Used with permission of Vivek Shraya.

person pronouns is when she says: "Only when *you* become a mother *you* know how it is." Later, after coming out publicly, Shraya describes her mother as one of her "earliest supporters."[30]

Shraya reflects that "art, in its ability to reveal, can be ahead of the artist."[31] As she was touring with the film, Shraya began to see that she might substitute for her mother in ways that went far beyond the film's teaser. During the tour, "my presentation always included a photo of my mom," she writes, "at which I would point and say, 'It's strange to see how much I resemble her now.'"[32] Inspired by the resemblance that *Holy Mother, My Mother* brought to her attention, Shraya created *Trisha*, a speculative archive that became a form of "evidence" of this family resemblance.[33] These side-by-side photographs do not passively record Shraya's family history. Instead, they stage Shraya's deliberate intervention into her family's past.

Restaging and re-creating photographs of Shraya's mother from the 1970s, *Trisha* explores their resemblances, their differences, and the unexpected alternative futures that the unpredictability of life makes possible. In the series, nine photographs of Shraya's mother are paired with nine re-creations in which pose, composition, props, costumes, and sets bring together Shraya's mother's past and Shraya's present. Working with collaborators, the re-creations reflect but do not quite duplicate the original photographs, which were taken when Shraya's mother was newly married and had recently immigrated to Alberta, Canada. As Shraya notes, there are many anachronisms, subtle alterations, and distinctions between the images, and these were intentional rather than accidental or regrettable: "I worried that if the goal was to re-create every detail in my mother's photos, any small difference would become exaggerated and viewed as a flaw. We realized that letting go of precise duplication created room to include both contemporary props and my own personality and humour."[34] In the photographs, tensions between past and present are palpable, along with the disjunctions that characterize many family resemblances—close, but never identical.[35]

In *Trisha*, self and other and past and present never coincide. Instead, each makes the other possible. Shraya explores a genealogy that not only passes from parent to child but includes those possibilities the child creates for the parent, beyond even what the parent might have imagined could be. Rather than moving only from past to present, the series bends linear temporality formally and through its production process. One set of paired portraits shows each woman standing nearly at the center of the frame, in the corner of a wood-paneled room, leaning against a wall while talking on the phone (figures 5.6 and 5.7). Although their hairstyles are similar, and each is

Figure 5.6 *Trisha*, by Vivek Shraya, 2016. Used with permission of Vivek Shraya.

Figure 5.7 *Trisha*, by Vivek Shraya, 2016. Used with permission of Vivek Shraya.

wearing a blue, gold, and white print dress, many small distinctions invite an interactive form of spectatorship. Like "spot the difference" games, the photographs are similar enough that they draw attention to their dissimilarities, from the differently sized lamps to the telephones and clocks that betray the decades that divide one image from the other. In dressing like her mother, Shraya reveals the tattoos on her bare left arm, including a red outline of the map of India.

Another crucial difference isn't visible but instead comes from the spectator's knowledge of each image's likely production context. In figure 5.6, Shraya's mother could be posed naturally, by happenstance, actually speaking with someone on the telephone. She might also be posing for the photographer, Shraya's father, who does appear to have "directed" some of the original images in the series.[36] However, the photograph's status as the original marks it as distinct from—and less self-consciously constructed than—the image of Shraya that accompanies it (see figure 5.7). Meanwhile, the portrait of Shraya is not naturalistic and almost certainly does not record one side of an actual telephone conversation. We might not know who is on the other end of the line as Shraya's mother speaks across the distances in this image that propels this contingent moment across time. Yet we assume this was an instant of communication, of contact. Shraya's portrait features forms of communication and contact that are more complex and also more obscure. Likely talking to no one, Shraya holds her cell phone to her ear and poses carefully, based on instructions from the crew of collaborators who helped her re-create her mother's photographs. During the production process, Shraya did not look at the photographs, posing only based on instructions from her collaborators.[37] This portrait records *that* interpersonal exchange, and although *Trisha* seems to connect Shraya and her mother, Shraya indicates that her mother may never actually have seen the images or read Shraya's accompanying essay.[38] Here, self-representation is not teleologically directed toward one mother-daughter connection but is deeply collaborative. Shraya's portraits come from a circuit or network of relations—for example, the hair extensions that Shraya wears were lent to her by one of her collaborators, the hairstylist Fabio Persico, and were originally Persico's mother's hair extensions.[39]

Recalling Cindy Sherman's collaboratively produced self-portraits, *Trisha* generates new forms of self-knowledge through the speculative archive.[40] Instead of uncovering a family history that merely explains or contextualizes the family's present, *Trisha* changes that history through accumulating additional records. The portraits document Shraya's family history and trans-

form the present through dialogue with the past, opening up new and unpredictable futures. Through *Trisha*, Shraya does not simply learn about her mother. Instead, Shraya says, "Placing myself in her shoes, I don't feel like I understand her more or better. But I do feel like I see myself differently."[41] Her mother's truth remains as unknowable as ever, but Shraya's embodied investigation of her mother's experience—an investigation shepherded or midwifed by her collaborators—generates other truths about that history. These truths appear in the photographs and in Shraya's accompanying essay.

Though seeming to move from left to right, from the 1970s to the 2010s, *Trisha* moves not only from the past to the present but also from the present to the past. As these two trajectories converge, they create new futures. In one set of photographs, a frame-within-a-frame makes this dynamic especially clear. In each image, Shraya's mother or Shraya herself stands on the far right of the frame, looking across the empty space in the center of the image toward the frame within a frame: Shraya's parents' wedding photograph on the far left (figures 5.8 and 5.9). Drawing the eye from right to left, these photographs move from divergent presents to a past whose meaning is altered by the distinct vantage points from which it is viewed. Our eyes move not only from the figure on the right to the photograph on the left but also from the lower corner of the frame to the upper corner of the frame, maximizing the blank space across which each woman's look directs our eyes. The pair of portraits asks us to contemplate the unknowable depths of another's thought: What does this wedding photograph mean to the newly married bride, and what does it mean to her adult daughter nearly four decades later?

Though these questions may be unanswerable, Shraya's essay tells us something about her own thoughts, as well as what she hypothesizes her mother's thoughts might have been—along with the lacunas that perhaps neither woman can ever know. Invoking ambiguity through Shraya's repeated use of the word *maybe*, the essay's present addresses the past, posing questions that Shraya's mother might not have been able to answer—or might not even have been able to imagine at all. In the layout featured on Shraya's website, the frame-within-a-frame photographs are immediately preceded by the following reflection:

> My story has always been bound to your prayer to have two boys. Maybe it was because of the ways you felt weighed down as a young girl, or the ways you felt you weighed down your mother by being a girl. Maybe it was because of the ways being a wife changed you. Maybe it was all the above, and also just being a girl in a world that is

intent on crushing women. So you prayed to a god you can't remember for two sons and you got me. I was your first and I was soft. Did this ever disappoint you?[42]

As Shraya speculates about what her mother might have been thinking as she looked across the white wall toward her recent past, Shraya's words also lay the foundation for alternative futures, including the future in which her mother's desire for sons—founded on her own experience of the difficulties of womanhood—conceals a deeper wish for a daughter. This is a wish that, as it turns out, can in fact come true in a future Shraya's mother might never have predicted but that is represented here. As Shraya says, *Trisha* honors not only her mother "but also . . . the daughter she never wanted, or rather, the daughter she wasn't allowed to want."[43] Excavating and producing these desires through articulating and staging them, *Trisha* doesn't discover a previously hidden history but creates a new, speculative past. In *Trisha*, Shraya imagines the history she desires, a history that runs parallel to the official history of her family and that makes her present and future possible.

Although reviews usually say that Shraya takes on her mother's identity, the project's title indicates that the dynamic is yet more complicated. Concluding the essay, Shraya writes, "You used to say that if you had a girl, you would have named her Trisha." In this sentence, the past reaches out to the future, as the past tense ("used to say") yields to the conditional past ("would have named"), in a series of statements about speech acts that culminate, ultimately, in Shraya's decision to call the project *Trisha*. At the end of this series of speech acts, we cannot untangle whether Shraya is playing the role of her mother, or the role of herself, or the role of "Trisha," the daughter her mother wasn't allowed to want and the daughter Shraya wasn't supposed to be. Transforming her mother's wishes to have only sons, Shraya describes "Trisha" as "a ghost," adding, "I persevere despite [my mother's] prayer."[44]

As Shraya intervenes in her family's history, her speculative archive generates additional paratextual material, including a selfie of the collaborators who worked on the project. These paratexts are involved in—or, at least, adjacent to—Shraya's family history. While *Trisha* explores Shraya's relationship to her mother, the selfie documents the relationships that made that exploration possible. As Shraya tells it, "After a dozen shots Karen called it—'I think we have it.' We all hugged and selfied."[45] By way of this selfie—a paratextual behind-the-scenes photo from the setting of the project's final portrait—new members are introduced into the family, linking Shraya's biological/legal family to something that looks more like chosen family. Pressed to-

Figure 5.10 Selfie by Alanna Chelmick, 2016. Used with permission of Alanna Chelmick.

gether in the cold, the five collaborators pose while the person in the center of the first row snaps the selfie, an outstretched arm reflected in Shraya's sunglasses (figure 5.10). "We selfied," Shraya says, stressing the collective act behind this photograph, a collective effort that is largely concealed within the *Trisha* portraits. Through *Trisha*, and through this selfie that expands the *Trisha* project beyond its eighteen paired photographs, Shraya and her collaborators create an alternative genealogy of cause and effect, origin and destination. Motherhood is not the source but, rather, the question toward which Shraya's efforts—and the efforts of the community that came together around this project—are directed.

If selfies have a relationship to temporality that is queer, the queer time that selfies produce may be best understood as time marked by brevity, disposability, and unrecorded lacunas. Like all snapshot photography, selfies are moments seized out of the flow of time. Yet rather than preserving or "mummifying" time, elevating these moments to a privileged status within personal and historical records, selfies are ephemeral and disposable.[46] As in *Lipstick City*, the moment itself might disappear amid the virtual flow of time. Thus,

selfies can be read as a metaphor of queer life's brevity and disposability, emblematizing both the external forces that threaten and damage queer lives and forms of disposability that emerge within queer communities.[47] In this way, selfie temporality might seem to be not just nonreproductive but actually wholly committed to Edelman's ethical demand that queerness stand against futurity.[48] However, in disrupting the flow of time, in seizing moments out of continuity and propelling them into unexpected juxtapositions through the algorithmic time of social media platforms, selfie aesthetics also open up opportunities to revisit and reconceive these moments to imagine liberatory futures. Shraya's speculative archive binds together herself, her mother, and the daughter her mother once imagined and thought she would never have. Looking at the portrait series, we are prompted to trace or to track changes from one image to another. Drawing attention to what has been altered or added, *Trisha* solicits active spectatorship that is attentive to change and encourages us to seek out the transformations that speculative archives produce. Rather than merely accumulating instants in order, selfie aesthetics produce moments of darkness, of the unseen, and of the unrecorded. Like all photography, these interstitial gaps in the historical record make it possible for speculative archivists to distill the past to imagine a future.

Coda

I began this project in 2014, as civil rights for queer and trans people seemed to be expanding. To some extent, that expansion was the short-term result of visibility politics fueled by the ubiquity of selfies, a process that affected my life significantly. Being introduced to Zinnia Jones's work in 2010 helped me understand a loved one's transition; later, seeing Alok Vaid-Menon's selfies was part of my own decision to come out as genderqueer and use they/them pronouns. This book explores how both of these creators (and many others) use selfies for self-expression and political advocacy. However, it contends that the impact of these images isn't only about the creators' intentions. Instead, the meaning of a selfie emerges in the spectatorial encounter—and beyond. In my case, the fact that I read trans feminist futures from self-representational art is inextricable from my own desire—and need—to work toward such futures in community and collaboration. It may seem perverse to spend so much time with ephemeral images whose creators probably didn't intend them to be so closely analyzed. However, given the ubiquity of selfies, I came to believe that it's crucial to examine how they produce meaning when they are read, interpreted, and seen by viewers.

During the early stages of this project, I was constantly on Tumblr looking at selfies, and I came to realize that the aesthetics of selfies are creative, varied, and open to rich interpretation. Meanwhile, cisgender people were becoming more aware of trans existence, sometimes through selfies, and it seemed that life might become less precarious for our communities. Before Caitlyn Jenner came out, I read a study that said that only 9 percent of United States residents knew a trans person—or, perhaps more accurately, were aware that they knew a trans person. At the time, I looked around my community and realized that much of that 9 percent, like me, probably knew dozens of trans people. The lines between one world and the other seemed very clear. Then, between 2014 and 2015, Laverne Cox was on the cover of *Time* magazine, Janet Mock published *Redefining Realness*, and Caitlyn Jenner starred in her

reality television show *I Am Cait*. Hashtags such as #WeJustNeedToPee and #GirlsLikeUs organized selfie visibility campaigns.[1] It felt like everyone was talking about trans people—especially trans women.

Yet this awareness—this visibility—was far from an unmitigated good. Between legislation that sought to limit trans people's ability to participate in public life and targeted attacks that overwhelmingly killed trans women of color, the dark side of visibility politics was quickly becoming apparent even to those who had been most optimistic about its potential. In many ways, this was nothing new; anti-trans violence has repeatedly arisen in response to greater awareness and visibility. What seemed new was the ability trans people had to control—to some extent—trans representation. As a result, selfies have been central to this era of trans self-representation, even as they are increasingly complemented by expanding trans representation in film, television, and electoral politics. Amid violence and repression, visibility is clearly not a simple solution to the complex oppression trans people face.

I wrote this book to analyze the experience of looking at selfies, and I found that selfies by trans creators can do critical, political, and theoretical work through—in part—how they are seen and read. But as I worked on this project, I kept confronting two interrelated forms of determinism or essentialism that limit our ability to understand selfies by transgender people. Repeatedly, I was asked whether I was proposing that all transgender people take selfies in a particular way or arguing that selfies automatically produce pro-social relationships. At first, these interpretations of my work simply frustrated me; then they made me anxious that my work wasn't sufficiently clear. (It probably wasn't.) Over time, however, I realized that these questions actually point to the significance of the work I have been studying, since the work itself challenges the underlying assumptions that prompt such queries. Technological determinism and identity-based essentialism are common frames through which we understand contemporary society. It's easy to slip into these intellectual habits without realizing it because they seem to provide certainty amid rapid change and transformation.

Yet they are inadequate ways to approach the complexity of both contemporary technology and identity politics. They deny the possibility of material political change because they assume that the present and future are determined by the past. Through studying selfies and self-representational art by trans feminine creators, I show how the works themselves can be read in ways that deconstruct these generalizations about digital media and transgender identity. By rejecting these twin assumptions that technology is deterministic and identity is essentialist, I hope that my readings of these works

can play a small part in interrupting the process by which the past constrains the present to reproduce the status quo of the past again and again. What emerge instead are particular, specific, material, and relational readings of these works that can provide insight into larger questions of identity, collaborative ways of being, and liberatory futures.

As I am finalizing the manuscript of this book, Donald Trump's time as president has come to an end, along with a year, 2020, that marked the highest number of recorded murders of transgender people, especially trans women of color. The world has been grappling with a deadly pandemic amid natural hazards-turned-human disasters, as well as increasingly powerful demands for racial, economic, and gender justice. In this context, it has sometimes seemed futile or self-indulgent to continue researching selfie aesthetics, but I believe that it's crucial to disentangle digital self-representation from some of the myths that still shape how we understand it. In the United States, many people have responded to an openly fascist administration by continuing to rely on representation and visibility, despite its risks and failures. My students often imagine that awareness always produces progress, as if ignorance is the only problem we are facing.

Mere visibility is not enough; instead, we're seeing that it's actually dangerous to trust that visibility will somehow protect those who are made visible and, hence, more vulnerable. Public institutions are increasingly observing Trans Day of Visibility, and Hollywood capitalizes on a feverish fascination with trans people. Meanwhile, the devastating murders of trans people continue, and the rate is rising either because more people are aware of and violently antagonistic toward trans existence or because these murders are more visible and reported on more often—or both. For many reasons outlined in this book, I'm not ready to advocate a retreat from representation, but it is crucial that activists, artists, and trans feminists see more in self-representational art than mere visibility. Selfies are everywhere. Visibility is ensured. What we must attend to is how we are looking and what we are seeing.

Notes

Prologue

1. For example, Joan Acocella's review of Lunbeck, *The Americanization of Narcissism* (which, in turn, is a book-length response to Lasch, *The Culture of Narcissism*), opens with an extended discussion of selfies, emphasizing the strength of the popular association between selfies and narcissism: Acocella, "Selfie." In *Selfie*, Will Storr presents a distorted view of how selfies typically function, highlighting only a single case of a young selfie creator who is pathologically isolated. While he acknowledges the exceptionality of his case, Storr's overriding investment in Laschian cultural critique prompts him to consider such an "outlier" a better model through which to understand selfies than a more typical case: Storr, *Selfie*, 295. Ilan Stavans's *I Love My Selfie* not only positions selfies as a symptom of cultural narcissism but also seems torn between two contradictory threads: understanding selfies as purely a contemporary concern and, alternatively, positioning selfies as a transhistorical phenomenon, such that every instance of self-representation becomes "a selfie." See Morse, "Review of Ilan Stavans' 'I Love My Selfie.'"

2. Shelley, *Frankenstein*, chap. 12, para. 13.

3. Tiidenberg, *Selfies*, 6.

4. There are promising signs of a shift toward more nuanced accounts of selfies, from Eckel et al., *Exploring the Selfie*, a recent anthology that examines selfies as images and as practices, to Tiidenberg's *Selfies*, the first monograph to approach selfies as something more than a symptom of cultural narcissism. Anne Burns analyzes how discourse about selfies is used to discipline and police the social behavior of young women, highlighting how distaste for selfies is linked to misogyny (Burns, "Self[ie]-Discipline").

5. Goldberg, "Through the Looking Glass."

6. Tiidenberg, *Selfies*, 79.

7. Tiidenberg, *Selfies*, 87.

8. See, e.g., Ehlin, "The Subversive Selfie"; Murray, "Notes to Self"; Nicholson, "Tumblr Femme"; Pham, "I Click and Post and Breathe, Waiting for Others to See What I See"; Tiidenberg, "Bringing Sexy Back."

9. Azoulay, *The Civil Contract of Photography*, 127.

10. Heyes, "Feminist Solidarity after Queer Theory."

11. Stryker, "My Words to Victor Frankenstein," 238.

12. She also rejects the role that queer theory often foists on trans people, in which trans people embody gender-nonconformity and thus make cisgender gay and lesbian sexualities legible as "same sex" desire: Stryker, "More Words about 'My Words to Victor Frankenstein,'" 40.

13. Stryker, "My Words to Victor Frankenstein," 238.

14. Stryker, "My Words to Victor Frankenstein," 239.

15. Haraway, *Simians, Cyborgs and Women*, 149–81.

16. Bergo, "Emmanuel Levinas."

17. Kenaan, "Facing Images," 157.

18. Campt, *Listening to Images*, 17.

19. Stryker, "My Words to Victor Frankenstein," 247.

20. After Globalism Writing Group, "Water as Protagonist," 15.

21. After Globalism Writing Group, "Water as Protagonist," 16.

22. Santana, "Transitionings and Returnings," 181–90.

23. Santana, "Transitionings and Returnings," 183.

24. Stryker, "My Words to Victor Frankenstein," 250.

25. Stryker, "My Words to Victor Frankenstein," 251.

Introduction

1. Steinbock, "Catties and T-selfies," 175.

2. Tiidenberg, *Selfies*, 95.

3. Azoulay, *The Civil Contract of Photography*; Campt, *Listening to Images*.

4. Serano, *Whipping Girl*.

5. Azoulay, *The Civil Contract of Photography*, 113.

6. Serano, "Reclaiming Femininity," 170; Koyama, "The Transfeminist Manifesto," 246.

7. Enke, *Transfeminist Perspectives in and beyond Transgender and Gender Studies*, 8–9.

8. Bettcher, "Intersexuality, Transsexuality, Transgender," 419–20.

9. Koyama, "The Transfeminist Manifesto," 245.

10. Heaney, *The New Woman*, 276–77.

11. Chen, *Trans Exploits*, 5.

12. According to Nicholas Mirzoeff, selfies existed prior to 2010 but were particularly enabled by the front-facing camera on the iPhone 4. As a result, Mirzoeff asserts that a set of normative aesthetic values attach to selfies. "A set visual vocabulary for the standard selfie has emerged. A selfie looks better taken from above with the subject looking up at the camera. The picture usually concentrates on the face, with the risk of making a duck face, which involves a prominent pout of the lips": Mirzoeff, *How to See the World*, 63.

13. Tiidenberg, *Selfies*, 106.

14. Senft and Baym, "What Does the Selfie Say?" 1588; Bellinger, "Bae Caught Me Tweetin.'"

15. Warfield, "Making Selfies/Making Self."

16. Tiidenberg, *Selfies*, 7.

17. While Nicolas Bourriaud's theory of relational aesthetics offers some useful frameworks for analyzing selfies, his emphasis on exhibition prioritizes a kind of institutional art practice that is unable to fully account for selfies as vernacular works: see Bourriaud, *Relational Aesthetics*.

18. Bellinger, "Bae Caught Me Tweetin.'"

19. As Emma Heaney argues, although trans feminism can be embraced by anyone, it is a political praxis that "grows out of the collective experience of trans women and feminine gender-nonconforming people": Heaney, *The New Woman*, xiv.

20. Senft and Baym, "What Does the Selfie Say?," 1589.

21. Quoted in Shaw, *Reading Claude Cahun's Disavowals*, 44.

22. Quoted in Shaw, *Reading Claude Cahun's Disavowals*, 1.

23. As Jordy Jones writes about this photograph and its reversal, "Cahun sometimes took photographs of Moore that mirrored the photographs that Moore took of her. Here, both women make eye contact through the dual self-visualizing technologies of the mirror and the camera. Cahun looks towards the camera, away from the mirror, and makes eye contact through the lens. Moore looks towards the mirror, away from the camera, and makes eye contact through the reflection. Both ultimately make 'eye contact' with the viewer. But before they make contact with us they initially connect with each other. Cahun at the mirror photographed by Moore followed Moore at the mirror photographed by Cahun. Or vice versa. In either case, this was a case of lovers at play, and the position of the viewer in relation to the subject is that of the love object. Neither is technically a self-portrait, but both are self-representative": Jones, "The Ambiguous I," 90–91.

24. Quoted in Downie, *Don't Kiss Me*, 59–60.

25. Latimer, "Acting Out," 56.

26. In discussing her own work with collaborators, Cindy Sherman notes that, even though other people served as her assistants and at times contributed their own ideas and suggestions to her photographic practice, she considers the works her own creations because she subsequently cropped the images carefully: *Cindy Sherman*, 15. See also Solomon-Godeau, "The Equivocal 'I,'" 117.

27. Fried, *The Moment of Caravaggio*, 18.

28. Koerner, *The Moment of Self-Portraiture in German Renaissance Art*, 142.

29. Hall, *The Self-Portrait*, 9.

30. Bond, *Self Portrait*, 12.

31. Clark, "The Look of Self-Portraiture," 110.

32. Koerner, "Self-Portraiture Direct and Oblique," 67.

33. Berger, *Ways of Seeing*, 51.

34. Bond, *Self Portrait*, 12.

35. See, e.g., "Let Us See You See You," *Discover: The DIS Blog*, December 3, 2012, http://dismagazine.com/blog/38139/let-us-see-you-see-you; DIS *Magazine*, #artselfie; Jeff Landa, "A Museum Dedicated to the History and Art of 'Selfies' Is Coming to Glendale," *Los Angeles Times*, December 8, 2017, http://www.latimes.com/socal /glendale-news-press/news/tn-gnp-me-selfie-museum-20171207-story.html; Abigail

Jones, "The Selfie as Art? One Gallery Thinks So," *Newsweek*, October 17, 2013, http://www.newsweek.com/selfie-art-one-gallery-thinks-so-445.

36. "Cindy Sherman: Clowning Around and Socialite Selfies—in Pictures," *The Guardian*, May 30, 2016, https://www.theguardian.com/artanddesign/gallery/2016/may/30/cindy-sherman-clowning-around-and-socialite-selfies-in-pictures. Similar statements appear throughout popular criticism about Sherman, Cahun, and Goldin.

37. Sherman herself does not like selfies and has expressed that she disagrees with the persistent association between her work and selfies: see Andrew Russeth, "Facetime with Cindy Sherman: The Artist on Her 'Selfie' Project for *W*, and What's behind Her Celebrated Instagram," *W Magazine*, November 6, 2017, https://www.wmagazine.com/story/cindy-sherman-instagram-selfie. Noah Becker writes that while Instagram is usually a "dumping ground," Sherman's work turns it into an "exhibition space": Noah Becker, "How Cindy Sherman's Instagram Selfies Are Changing the Face of Photography," *The Guardian*, August 9, 2017, https://www.theguardian.com/artanddesign/2017/aug/09/cindy-sherman-instagram-selfies-filtering-life.

38. See Benjamin Barron, "Richard Prince, Audrey Wollen, and the Sad Girl Theory," *i-D*, November 12, 2014, https://i-d.vice.com/en_us/article/richard-prince-audrey-wollen-and-the-sad-girl-theory; Capricious, "Anti-selfies and Bondage Furniture," *Dazed*, August 1, 2014, http://www.dazeddigital.com/photography/article/21087/1/anti-selfies-and-bondage-furniture.

39. For example, Lev Manovich's SelfieCity.net explores compositional trends across hundreds of selfies, while Aaron Hess uses individual images as illustrations of broader categories or subgenres of selfies: see Hess, "The Selfie Assemblage."

40. See, e.g., Bruno et al., "'Selfies' Reveal Systematic Deviations from Known Principles of Photographic Composition"; Chua and Chang, "Follow Me and Like My Beautiful Selfies"; Döring et al., "How Gender-Stereotypical Are Selfies?"; Lobinger and Brantner, "In the Eye of the Beholder"; Nemer and Freeman, "Empowering the Marginalized"; Wang et al., "Let Me Take a Selfie."

41. Bourdieu, *Photography: A Middle-Brow Art*, 77–94. Two key texts examine the history of the photo booth and the artistic use of the medium. Although both volumes capture a wide breadth of the diverse possibilities of photo booth photography, both assume that artistic uses of photo booth imagery require artistic intention: Goranin, *American Photobooth*; Pellicer, *Photobooth*.

42. Julia Hirsch identifies trends in the gendering of the direct look in family portraits, demonstrating the importance of pose, gesture, and directionality of the gaze to self-presentation within vernacular portraiture: Hirsch, *Family Photographs*. As Roland Barthes discusses the affective charge of a photograph of his mother as a child, he also pays close attention to the work of the pose, both in our relationship to the photographs we witness and in our relationship to ourselves as photographic subjects: Barthes, *Camera Lucida*. By contrast, Catherine Zuromskis's work on analog snapshots includes other formal techniques in her analysis of analog photography: Zuromskis, *Snapshot Photography*. See also Bellinger, "Bae Caught Me Tweetin," 1809; Frosh, "The Gestural Image."

43. Ahmed, *Queer Phenomenology*, 80.

44. Despite repeated critiques over the years, this abstraction remains "persistent": Benavente and Gill-Peterson, "The Promise of Trans Critique," 25.

45. Chaudhry, "Centering the 'Evil Twin,'" 47.

46. Halberstam, *In a Queer Time and Place*, 18–19; Puar, *The Right to Main*, 46; Serano, *Whipping Girl*, 195–212.

47. Chu and Drager, "After Trans Studies," 110.

48. Halberstam, TRANS*, xiii. As Lauren Herold pointed out to me, Halberstam appears to borrow this term from Snorton, *Black on Both Sides*, without crediting Snorton and without engaging with Snorton's examination of how transitivity provides a grammar for Black trans experience.

49. Tompkins, "Asterisk."

50. Ruti, *The Ethics of Opting Out*, 32.

51. Benavente and Gill-Peterson, "The Promise of Trans Critique," 24.

52. Keegan et al., "Cinematic/Trans*/Bodies Now (and Then, and to Come)," 1; Steinbock, *Shimmering Images*, 6.

53. Keegan, *Lana and Lilly Wachowski*, 1–4.

54. Baron, *The Archive Effect*, 7–9.

55. Rodowick, *The Virtual Life of Film*, 169.

56. Alexander, "Rage against the Machine," 3.

57. Barthes, *The Rustle of Language*, 148.

58. Hansen, "Introduction," xxxv.

59. Heaney, *The New Woman*.

60. See, e.g., Slavoj Žižek, "The Sexual Is Political," Philosophical Salon, August 1, 2016, https://thephilosophicalsalon.com/the-sexual-is-political.

61. I thank Cassiopeia Mulholland, who introduced me to this text.

62. Hale, "Leatherdyke Boys and Their Daddies," 229.

63. Hale, "Leatherdyke Boys and Their Daddies," 230.

64. Kuntsman, *Selfie Citizenship*, 109–60; Giroux, "Selfie Culture in the Age of Corporate and State Surveillance." While these accounts of the surveillant power of selfies are not incorrect, they err in describing this surveillance as a contemporary phenomenon that is coincident with "selfie culture" and selfies themselves. Decades before the selfie was invented, for instance, Susan Sontag described photography as a practice of "self-surveillance": quoted in Lasch, *The Culture of Narcissism*, 48. See also Bay-Cheng, "'When This You See,'" 49.

65. See, e.g., Zach Blas, "Escaping the Face: Biometric Facial Recognition and the Facial Weaponization Suite," *Media-N*, 2013, http://median.newmediacaucus.org/caa -conference-edition-2013/escaping-the-face-biometric-facial-recognition-and-the -facial-weaponization-suite; Steyerl, *The Wretched of the Screen*, 160–75; Hito Steyerl, dir., *How Not to Be Seen: A Fucking Didactic Educational .MOV File*, 2013, https://www .artforum.com/video/hito-steyerl-how-not-to-be-seen-a-fucking-didactic-educational -mov-file-2013-51651.

66. Kornstein, "Under Her Eye."

67. Serano, *Whipping Girl*, 120.

68. Kafer and Grinberg, "Editorial," 595.

69. Moten and Harney, *A Poetics of the Undercommons*.

70. Steyerl, *The Wretched of the Screen*, 31–45.

71. Vivek Shraya, personal communication, October 7, 2018.

72. Google, "Google Pixel 3: Group Selfie Cam," YouTube video, October 9, 2018, https://youtu.be/gJtJFEH1Cis. I thank Noemi Marin for pointing out this advertisement to me.

73. Morse, "The Transfeminine Futurity in Knowing Where to Look."

74. McMullen, "The Improvisative," 123.

75. Freeman, "The Queer Temporalities of *Queer Temporalities*," 93.

76. Field, "The Archive of Absence."

77. Morse and Herold, "Beyond the Gaze."

1. Doubling

1. Intentionally or not, the video's title evokes the pseudonymous lover(s) and object(s) of longing, desire, and loss from Roland Barthes's *A Lover's Discourse*, a figure (or figures) never named but instead masked beneath the capital letter *X*.

2. As Amanda du Preez writes, selfies function as doppelgängers because "the selfie stands in the tradition of doubling, imitation, twinning, cloning, alter egos, mirroring, masks, and shadows": du Preez, "When Selfies Turn into Online Doppelgängers," 6.

3. Drucker and Ernst, *Relationship*, 96–97.

4. Barthes, *Camera Lucida*; Bazin, *What Is Cinema? I*, 9–16; Prosser, *Light in the Dark Room*.

5. Barthes, *Camera Lucida*, 77.

6. van Dijck, "Digital Photography"; Gunning, "What's the Point of an Index?"

7. Barthes, *Camera Lucida*, 115.

8. du Preez, "When Selfies Turn into Online Doppelgängers."

9. Thanks to Jane Caputi for this reminder in a book release event hosted by the Center for Women, Gender, and Sexuality Studies at Florida Atlantic University held on Zoom on September 2, 2020.

10. Stiles, "Kicking Holes in the Darkness"; Meredith Talusan, "This Former Couple Documented Their Gender Transitions in Gorgeous Photos," Buzzfeed.com, July 16, 2016, https://www.buzzfeed.com/meredithtalusan/before-breaking-up-this-trans-couple-took-gorgeous-photos-of. Drucker herself states that it is possible that the work is in dialogue with the mirror stage, but only, of course, because she had read the article in the course of her education: Zackary Drucker, personal communication, University of Chicago, May 8, 2015.

11. Keegan, *Lana and Lilly Wachowski*, 35.

12. Lavery, "Trans Realism, Psychoanalytic Practice, and the Rhetoric of Technique," 723, 725–26.

13. Sullivan and Murray, *Somatechnics*, 3.

14. Stryker and Sullivan, "King's Member, Queen's Body," 50.

15. Danielle Owens-Reid, "Girl, It's Your Time: Trans Artist Vivek Shraya on Finding Freedom and Wholeness," *Autostraddle*, May 19, 2016, https://www.autostraddle

.com/girl-its-your-time-trans-artist-vivek-shraya-on-finding-freedom-and-wholeness
-336300.

16. Owens-Reid, "Girl, It's Your Time."

17. Drucker, "April Dawn Alison," n.p.

18. For more on the film, see Tourmaline and Thomas J. Lax, "Anything We Want to
Be: Tourmaline's *Salacia*," *MoMA Magazine*, June 25, 2020, https://www.moma.org
/magazine/articles/360.

19. Benavente and Gill-Peterson, "The Promise of Trans Critique," 26.

20. Marina Merlo, "Selfietopia: Looking at Images in the Digital Age," paper pre-
sented at the annual conference of the Society for Cinema and Media Studies, Chicago,
March 26, 2017.

21. John Hutt, "Interview with Zackary Drucker and Rhys Ernst: Six Years," *Musée*,
April 15, 2014, http://museemagazine.com/culture/art-2/features/interview-with
-zackary-drucker-and-rhys-ernst-six-years.

22. Talusan, "This Former Couple Documented Their Gender Transitions in Gor-
geous Photos."

23. See, e.g., Stiles, "Kicking Holes in the Darkness," 61.

24. Drucker, personal communication.

25. Nelson, "Notes on a Visual Diary, Co-Authored," 149.

26. Drucker, "ThestoryofZackaRhys," 15.

27. Hutt, "Interview with Zackary Drucker and Rhys Ernst."

28. Plato, *Symposium*.

29. Lacan, "The Mirror-Phase as Formative of the Function of the I."

30. Ruti, *The Ethics of Opting Out*, 137.

31. I thank Noa Merkin for pointing out to me that, for Emmanuel Levinas, the *face*
is fundamentally a question of sound rather than sight, for the face "speaks." She also
pointed out that in a child's development, a key developmental stage is when they
reach out to *touch* their own reflection in the mirror, a moment omitted from Lacan's
account of the child before the looking glass.

32. Talusan, "This Former Couple Documented Their Gender Transitions in Gor-
geous Photos." In interviewing Drucker and Ernst, Talusan describes the artists dis-
cussing their relationship through the metaphor of mirroring as well, quoting Drucker:
"There was this strong sense of mirroring, and this frustration with ourselves that we
had just projected and laminated onto the other person." Talusan adds, "For [Drucker],
the way they were so similar became a source of tension. Ernst, on the other hand,
found comfort in the mirroring of their lives."

33. Tulsa Kinney, "Trading Places: Zackary Drucker and Rhys Ernst at the Whitney
Biennial," *Artillery Magazine*, March 4, 2014, http://artillerymag.com/zackary-drucker
-and-rhys-ernst.

34. GLAAD *Media Reference Guide*, 8th ed., Gay and Lesbian Alliance against Defa-
mation, 2010, 8–11.

35. Jacob Bernstein, "In Their Own Terms: The Growing Transgender Presence in
Pop Culture," *New York Times*, March 12, 2014, https://www.nytimes.com/2014/03/13
/fashion/the-growing-transgender-presence-in-pop-culture.html. Elsewhere, in Julian

Carter's description of transition, he writes that "transition is thousands of little gestures of protest and presence, adding up and getting some momentum behind them so that you can finally achieve escape velocity from the category you were stuck in all those years ago": Carter, "Transition."

36. Dick, "On Repetition."

37. "X-TRA Fall Launch: Leslie Dick and Zackary Drucker in Conversation," Facebook event hosted by X-TRA, November 1, 2014, Facebook.com, https://www.facebook.com/events/1575020499384296.

38. Steyerl, *The Wretched of the Screen*, 31–45.

39. Roland Barthes writes of moments in which "the image of the other—to which I was glued, on which I lived—no longer exists . . . severed or united, dissolved or discrete, I am nowhere *gathered together*; opposite, neither you nor me, nor death, nor anything else *to talk to*": Barthes, *A Lover's Discourse*, 11.

40. Hansen, "Media Theory," 300.

41. Keegan, "Moving Bodies."

42. Prosser, *Second Skins*, 100.

43. Bea Cordelia, "The T with Bea Cordelia and Daniel Kyri," Q&A at the Film Studies Center, University of Chicago, January 18, 2019.

44. Keegan, "Revisitation," 38.

45. Keegan, "Revisitation," 38.

46. Keegan, *Lana and Lilly Wachowski*, 34.

47. For more, see Morse, "Trans* Cinematic Embodiment."

48. Foucault, *The Order of Things*, 3–16.

49. See, e.g., Nolan Feeney, "Why Selfies Sometimes Look Weird to Their Subjects," *The Atlantic*, March 27, 2014, https://www.theatlantic.com/health/archive/2014/03/why-selfies-sometimes-look-weird-to-their-subjects/359567; John Herrman, "Giz Explains: Why You Look Different in Photos than You Do in the Mirror," Gizmodo.com, October 12, 2010, http://gizmodo.com/5661253/giz-explains-why-you-look-different-in-photos-than-you-do-in-the-mirror.

50. Tourmaline's Instagram account at one point attributed joint authorship of her selfies to herself and her cat, Jean, who frequently appeared in double selfies with Tourmaline. Tourmaline's double selfies with Jean are not merely incidental to exploring the aesthetics of doubling. Eliza Steinbock writes that the cats who proliferate across social media "are not mirrors of our human selves, they are not self-same": Steinbock, "Catties and T-selfies," 162. Yet Steinbock argues that the cute aesthetics of "catties" are doubled in the cute aesthetics of selfies, identifying an additional form of doubling that extends to relationships between human and nonhuman animals: Steinbock, "Catties and T-selfies," 166.

51. tourmaliiine, Instagram post, April 11, 2017, https://www.instagram.com/p/BSwuqgAgy9S.

52. In some ways, the fascination of these selfies is similar to the fascination that Joel Snyder identifies viewers experiencing before Velázquez's *Las Meninas* (1656). Even though Snyder dismisses the accuracy of viewers' fascination with the impression that we are reflected by the mirror in the depths of the painting, he cannot disregard that

this spectatorial experience is common: Snyder, "'Las Meninas' and the Mirror of the Prince," 551.

53. Quoted in Morse, "The Transfeminine Futurity in Knowing Where to Look."

54. Vivekshraya, "Something Wicked This Way Comes," Instagram photo, August 13, 2018, https://www.instagram.com/p/BmcZyM4g1Hl.

55. Keeling, *The Witch's Flight*, 137.

56. Santana, "Transitionings and Returnings," 183.

2. Selfie Improvisatives

1. The "improvisative" is an alternative to performative self-constitution proposed by Tracy McMullen, who writes that performativity too often preserves the power with which it is in dialogue. By contrast, within improvisation, McMullen argues, "agency is not located in a re-iteration or an address to the (great, symbolic) Other but in a response to the immediate, singular other," making actual alternatives possible. McMullen, "The Improvisative," 123.

2. Sontag, *On Photography*, 4.

3. Zinnia Jones, "Introduction," YouTube video, November 19, 2008, https://youtu.be/p4wZF5JLrHM.

4. Zinnia Jones, personal communication, November 7, 2019.

5. Stiegler, "Memory," 73.

6. Butler, *Gender Trouble*, 151.

7. Kendall Gerdes writes that the "rhetoric of performativity . . . turns it into a tool for defending the power of the subject, through the conscious presence of agential intention, to intervene in the discourse of gender and so to free that discourse of its injurious potential. . . . In a sense, it reduces performativity to *performance*." Gerdes, "Performativity," 148.

8. Butler, *Bodies That Matter*, 131.

9. Butler, *Bodies That Matter*, 125.

10. Butler, *Gender Trouble*, 187.

11. As Julia Serano points out, the more challenging test case for the argument that gender isn't natural or inherent might be cisgender experiences in which gender feels and appears unremarkable and natural. Serano, *Whipping Girl*, 206. Along similar lines, David Getsy has used queer and trans modes of critique to examine straight, cisgender artists, arguing that "all artists and all art need to be approached with the understanding that gender/sexuality and unforeclosed multiplicities are already inextricable. It's myopic to assume that it's only women artists who need (or benefit from) feminist critique, only non-heterosexual artists who require queer critique, or only transgender artists who are the topics of transgender studies." Jones and Getsy, "Abstract Bodies and Otherwise."

12. Butler does not directly state whether her understanding of drag comes primarily from participating in or watching drag performances, but her language indicates that she imagines herself and her readers as audience members. "Part of the pleasure, the giddiness of the performance is in the *recognition* of a radical contingency in the rela-

tion between sex and gender in the face of cultural configurations of causal unities that are regularly assumed to be natural and necessary," she writes. "In the place of the Law of heterosexual coherence, we *see* sex and gender denaturalized by means of a performance which avows their distinctness and dramatizes the cultural mechanism of their fabricated unity." Butler, *Gender Trouble*, 187–88, emphasis added.

13. Namaste, "'Tragic Misreadings,'" 186.

14. Prosser, *Second Skins*, 24.

15. Sundén, "On Trans-, Glitch, and Gender as Machinery of Failure."

16. Mignolo and Walsh, *On Decoloniality*, 7, 10.

17. I thank Michael Horswell, who suggested this way of framing this issue.

18. Serano, *Whipping Girl*, 209.

19. Halberstam, *Trans**, 135.

20. McMullen, "The Improvisative," 118.

21. Ruti, *The Ethics of Opting Out*, 40.

22. Ruti, *The Ethics of Opting Out*, 41.

23. Ruti, *The Ethics of Opting Out*, 18.

24. McMullen, "The Improvisative," 122.

25. McMullen, "The Improvisative," 123.

26. The post has been subsequently deleted, along with several other instances in which Jones posted this selfie on Tumblr.

27. Seid, "Reveal," 176. Until 2014, every state in the United States of America permitted defendants to argue for lighter sentences based on the assumption that the revelation of someone's transgender identity, often through a genital reveal, partially justified a violent response. Parker Marie Malloy, "California Becomes First State to Ban Gay, Trans 'Panic' Defenses," *The Advocate*, September 29, 2014, http://www.advocate .com/crime/2014/09/29/california-becomes-first-state-ban-gay-trans-panic-defenses.

28. Morse, "Seeing Double." Neil Jordan's *The Crying Game* (1992) is perhaps the best-known example of the reveal in popular culture, with a reveal scene in which the main character vomits when he realizes that the woman he has been dating has a penis. Reveal scenes appear throughout media about trans characters, including in Kimberly Peirce's *Boys Don't Cry* (1999), in which the reveal leads to the rape and eventual murder of Brandon Teena. The reveal also functions as a punchline in *Ace Ventura: Pet Detective* (1994) and as a schlocky final shock in *Sleepaway Camp* (1983).

29. Following an interview in which Piers Morgan framed Janet Mock's story around gender confirmation surgery, Mock criticized Morgan's focus on her genitals, including through a selfie that shows Mock and Laverne Cox looking skeptically into the lens. Chris Geidner, "Transgender Advocate Janet Mock: Piers Morgan 'Sensationalized' My Story," Buzzfeed.com, February 4, 2014, https://www.buzzfeed.com/chrisgeidner /transgender-advocate-janet-mock-piers-morgan-sensationalized?utm_term =.dwqAXjaMe#.qy16rwOR4.

30. Satana Kennedy, "About," n.d., http://satanakennedy.com, accessed March 29, 2017.

31. Zinnia Jones, Tumblr post, October 11, 2014, 2:20 p.m., http://zjemptv.tumblr .com/post/99744229095/oh-its-national-coming-out-day-im-satana.

32. Satana Kennedy, Twitter post, October 31, 2014, 7:24 p.m., https://twitter.com /satanakennedy/status/528371998678712320.

33. Cáel Keegan and Tobais Raun discuss how hands work to simultaneously produce genital visibility and invisibility in an article about a self-portrait by the trans activist Aydian Dowling, but in this case the hand that substitutes for Dowling's genitals are the hands of Dowling's partner, creating a different effect that is more concerned with issues of desirability than purely the substitution of one body part for another: Keegan and Raun, "Nothing to Hide."

34. Georgia Warnke writes that, by categorizing people based on binary sex categories that are mapped onto morphological genital differences, we "take certain aspects of the body . . . to be indicative of who the person is . . . exclud[ing] other physical and biological features of bodies, such as knobby knees and muscle types." Warnke, "Transsexuality and Contextual Identities," 35.

35. Anirban Kapil Bashiya describes the role that selfies played in the 2014 Indian election, arguing that Narendra Modi's selfie practice constructed him as a man of action because of the agentive self-making that his selfies expressed: Bashiya, "#NaMo." On selfies as tools for agentive self-expression, see, e.g., Ehlin, "The Subversive Selfie"; Murray, "Notes to Self"; Nicholson, "Tumblr Femme"; Pham, "'I Click and Post and Breathe, Waiting for Others to See What I See'"; Tiidenberg, "Bringing Sexy Back." However, Sarah Neely argues that, for women, visibility online is available only through sexualization and objectification, particularly self-objectification. She is deeply critical of the idea that any agency whatsoever is available to women who post sexualized images of themselves online. Neely, "Making Bodies Visible," 104–5.

36. Zinnia Jones, Tumblr post, March 28, 2015, 11:38 p.m., http://zjemptv.tumblr.com /post/114901499925/are-you-okay-z-your-account-has-been-quite-quiet.

37. Zinnia Jones, Tumblr post, December 19, 2013, 12:47 a.m., http://zjemptv.tumblr .com/post/70465951007/what-happened-to-your-ladycock-photo.

38. Zinnia Jones, Tumblr post, July 22, 2014, 11:43 a.m., http://zjemptv.tumblr.com /post/92539075630/would-you-ever-consider-doing-porn-or-similar; Zinnia Jones, Tumblr post, August 9, 2014, 3:23 p.m., http://zjemptv.tumblr.com/post /94269151915/i-really-hope-you-dont-regret-posting-your-nudes.

39. Zinnia Jones, Tumblr post, August 18, 2014, 8:27 p.m., http://zjemptv.tumblr.com /post/94202228085/do-you-worry-about-how-posting-porn-online-will.

40. Gender transition is a specific experience, currently structured by a variety of social, legal, medical, and other power regimes, and a variety of problems arise when trans people's experiences are loosely analogized to more general experiences of transformation and change. Serano, *Whipping Girl*, 199. However, here I am discussing the specific conjunction of references to transgender experiences and transhumanism within Zinnia Jones's blog.

41. Zinnia Jones, Tumblr post, November 30, 2013, http://zjemptv.tumblr.com/post /68581651898/are-you-considering-having-the-surgery-i.

42. Zinnia Jones, Tumblr Post, December 1, 2013, http://zjemptv.tumblr.com/post /68725153768/i-cant-believe-no-ones-asked-this-are-you.

43. Trans studies was significantly shaped by Donna Haraway's "A Cyborg Mani-

festo" (1984) and by "The Empire Strikes Back: A Posttranssexual Manifesto" (1987) by Sandy Stone, who was then Haraway's graduate student. Stryker and Whittle, *The Transgender Studies Reader*, 103; Stryker and Currah, "Introduction," 3. Subsequently, Susan Stryker's "My Words to Victor Frankenstein" also celebrates the unnatural, constructed transsexual subject, opening with the words: "The transsexual body is an unnatural body. It is the product of medical science. It is a technological construction," 238. More recently, Stryker and Currah write that "transgender studies offers fertile ground for conversations about what the posthuman might practically entail (as well as what, historically, it has already been)." Stryker and Currah, "Introduction," 9.

44. See, e.g., the trans woman and transhumanist Martine Aliana Rothblatt's *Virtually Human*.

45. Foster, *The Souls of Cyberfolk*, 7; Hayles, *How We Became Posthuman*, 286.

46. Discussing Sylvia Wynter's work, Katherine McKittrick says that Wynter shows the necessity of an active, praxis-based humanism, writing, "Under our current epistemological regime, those cast out as impoverished and colonized and undesirable and lacking reason—can, and do, provide a way to think about being human anew. Being human, in this context, signals not a noun but a verb." McKittrick, *Sylvia Wynter*, 3.

47. Zinnia Jones, Tumblr post, June 2, 2013, http://zjemptv.tumblr.com/post /51991286504/dont-fucking-watermark-my-photos-i-put-a-lot-of.

48. In the New International Version, the verse reads: "There she lusted after her lovers, whose genitals were like those of donkeys and whose emission was like that of horses."

49. Zinnia Jones, Twitter post, February 18, 2014, https://twitter.com/zjemptv/status /435950496432398336.

50. Zinnia Jones, Tumblr post, May 17, 2013, http://zjemptv.tumblr.com/post /50660821901/i-once-dreamt-i-met-you-in-the-car-park-outside-my.

51. Zinnia Jones, Tumblr post, August 5, 2014, http://zjemptv.tumblr.com/post /93850830520/new-zinnia-jones-classic-zinnia-outfit.

52. Zinnia Jones, Tumblr post, August 14, 2014, http://zjemptv.tumblr.com/post /94785786260/red-leather-coat-black-and-red-feather-boa.

53. Zinnia Jones, Tumblr post, June 13, 2016, http://zjemptv.tumblr.com/post /145843214590/terfs-made-some-kind-of-meme-of-me-and-now-were.

54. As Andrea Long Chu notes, *trans-exclusionary radical feminist* (TERF) is a term that is usually rejected by those to whom it is applied. "Their beliefs, while varied, mostly boil down to a rejection of the idea that transgender women are, in fact, women," she writes. "They also don't much like the name TERF, which they take to be a slur—a grievance that would be beneath contempt if it weren't also true, in the sense that all bywords for bigots are intended to be defamatory." Chu, "On Liking Women." Highlighting that anti-trans strands of feminism are almost always far most hostile toward trans women than toward trans men, some have started using "TWEF" rather than "TERF." A "TWEF" can be defined as a "trans women exclusionary feminist," a "trans woman excluding feminist," or even a "trans woman eliminationist/extermination's feminist," given that many such individuals do indeed advocate for the cultural or legal abolition of trans women.

55. Zinnia Jones, Tumblr post, February 17, 2014, http://zjemptv.tumblr.com/post /77015491453/the-latest-controversial-incident-of-a-trans-woman.

56. Zinnia Jones, Tumblr post, June 13, 2016, http://zjemptv.tumblr.com/post /145843214590/terfs-made-some-kind-of-meme-of-me-and-now-were.

57. Zinnia Jones, Tumblr post, June 14, 2016, http://zjemptv.tumblr.com/post /145912522140/zjemptv-zjemptv-nuggetemily-zjemptv.

58. See, e.g., Zinnia Jones, "Alice Dreger, Autogynephilia, and the Misrepresentation of Trans Sexualities (Book Review: *Galileo's Middle Finger*)," *Gender Analysis* (blog), April 1, 2016, https://genderanalysis.net/2016/04/alice-dreger-autogynephilia-and -the-misrepresentation-of-trans-sexualities-book-review-galileos-middle-finger; Zinnia Jones, Tumblr post, June 14, 2014, http://zjemptv.tumblr.com/post/88808574985 /a-lot-of-that-autogynophilia-stuff-is-things-i; Zinnia Jones, Tumblr post, June 11, 2014, http://zjemptv.tumblr.com/post/88527274205/to-be-honest-i-was-as-cute-a-lady -as-you-id-be.

59. There are profound problems with Blanchard's and Bailey's research. Charles Moser has demonstrated that Blanchard's work suffers from terminological and conceptual imprecisions and errors. Moser, "Blanchard's Autogynephilia Theory." Julia Serano has shown the inadequacies of Blanchard's and Bailey's research in a number of popular and peer-reviewed publications, including an article that demonstrates the inaccuracies and stigmatizing effects of the theory of autogynephilia. Serano, "The Case against Autogynephilia." In his research, Bailey tests the accuracy of people's stated sexual orientations and gender identities by measuring their genital responses to pornographic stimuli. This is the method he and his collaborators used to supposedly prove that lesbian trans women are autogynephiles. However, not only did this study include only one self-identified lesbian trans woman, but the way that Bailey and his collaborators use pornographic media displays a deep misunderstanding of how pornography—and desire—operate. Morse, "Pornography in Sex Research."

60. Zinnia Jones, Twitter post, July 12, 2017, https://twitter.com/ZJemptv/status /885247537057280002.

61. For more on the harm that "autogynephilia" causes queer trans women, see Imogen Binnie, *Nevada*. J. Jennifer Espinoza writes in a poem titled "Autopainophile," a reference to autogynephilia, "I wish I loved my body the / way you say I love my body." Espinoza, *There Should Be Flowers*, 10.

62. Paratextually, Nebulous Persona self-identifies as a trans woman on her blog *Sugar and Slugs*; as a result, I am using she/her/hers pronouns to describe her. However, that cannot be independently verified, and, in fact, Jones tends to use they/them /theirs pronouns to describe Nebulous Persona.

63. Nebulous Persona, "The Time I Outed Someone to Herself," *Sugar and Slugs* (blog), January 14, 2013, https://sugarandslugs.wordpress.com/2013/01/14/the-time-i -outed-someone-to-herself.

64. Zinnia Jones, "Clearing Up a Few Misconceptions . . . ," YouTube video, January 11, 2011, https://www.youtube.com/watch?v=czIyk9jLELo.

65. Nebulous Persona, "Re: Clearing Up a Few Misconceptions . . . (Zinnia/ZJ vs.

Transgender)," YouTube video, January 13, 2011, https://www.youtube.com/watch?v=iNCLuRbBX-A.

66. In his review of Stephen Connor's *Dumbstruck: A Cultural History of Ventriloquism*, Jonathan Rée describes ventriloquists as having "fissiparous personalities" that they "scatter" among objects and "silly voices," indicating the extent to which borrowing, throwing, and manipulating the voice has a long history of generating distributed selves. Rée, "Tummy-Talkers," https://www.lrb.co.uk/the-paper/v23/n09/jonathan-ree/tummy-talkers.

67. Zinnia Jones, "Two Years Later: Notes from the Future," *The-Orbit.net/Zinnia-Jones* (blog), January 12, 2013, https://the-orbit.net/zinniajones/2013/01/two-years-later-notes-from-the-future.

68. Zinnia Jones, "From the Other Side," *The-Orbit.net/ZinniaJones* (blog), January 16, 2013, https://the-orbit.net/zinniajones/2013/01/from-the-other-side.

69. Jones, "Two Years Later."

70. Jones, "Two Years Later."

71. Scarry, *The Body in Pain*, 29–30.

72. Bersani and Phillips, *Intimacies*, 55–56.

73. Haraway, "Awash in Urine," 104–16.

74. Serano, *Whipping Girl*, 195–214. As A. Finn Enke writes, gender studies and women's studies draw on transgender people and experiences to explore "the meanings of gender, bodies, and embodiment" while simultaneously marginalizing transgender studies so that "'women's studies' will position transgender as something outside or other than itself." Enke, *Transfeminist Perspectives in and beyond Transgender and Gender Studies*, 1–2.

75. Azoulay, *The Civil Contract of Photography*, 129.

76. Azoulay, *The Civil Contract of Photography*, 130.

3. Selfie Seriality

1. For example, in the anthology *Selfie Citizenship*, a section dedicated to "Selfies and the Politics of In/visibility" addresses selfies that make visible citizenship, death, rape, and trauma, while also exploring how the hyper-visibility produced by selfies increases surveillance: Kuntsman, *Selfie Citizenship*, 109–60. The opportunities for visibility that selfies offer LGBTQ people have been a particular focus of scholarship on selfies and visibility, including Stefanie Duguay's "Lesbian, Gay, Bisexual, Trans, and Queer Visibility through Selfies." Yet LGBTQ selfie visibility is not always regarded positively in scholarship, and Kay Siebler argues that the visibility of trans youth that selfies and YouTube make possible is harmful to young LGBTQ people: Siebler, "Transgender Transitions." In February 2017, women posted selfies tagged #DressLikeAWoman to contest President Donald Trump's comment that White House employees should dress "appropriately": Trilby Beresford, "So Many Women Are Posting #DressLikeAWoman Selfies, and Here's Why," *Yahoo! Style*, February 3, 2017, https://www.yahoo.com/style/many-women-posting-dresslikeawoman-selfies-190108885.html. The #DisabledAnd Cute campaign used selfies to show that "disabled folks were here, owning our

bodies and looks rather than trying to cover up, slink away": Carrie, "'I Want to Be Visible': A Queer #DisabledAndCute Photo Gallery," Autostraddle.com, February 20, 2017, https://www.autostraddle.com/i-want-to-be-visible-a-queer-disabledandcute -photo-gallery-369532.

2. Che Gossett, Instagram post, July 7, 2017, https://www.instagram.com/p /BWOFFJSAXgbADRI2Ri6HBE3c_mtvWpLV34WVGw0.

3. Harney and Moten, *The Undercommons*.

4. Ehn Nothing, "Queens against Society," in *Street Transvestite Action Revolutionaries: Survival, Revolt, and Queer Antagonist Struggle*, zine published by Untorelli Press, March 12, 2013, https://untorellipress.noblogs.org/post/2013/03/12/street -transvestite-action-revolutionaries-survival-revolt-and-queer-antagonist-struggle, 8.

5. Nothing, "Queens against Society," 5.

6. They elaborate, writing, "To distance oneself professionally through critique, is this not the most active consent to privatize the social individual? The undercommons might by contrast be understood as wary of critique, weary of it, and at the same time dedicated to the collectivity of its future, the collectivity that may come to be its future": Harney and Moten, *The Undercommons*, 38.

7. Gossett et al., *Trap Door*.

8. Steinbock, "The Wavering Line of Foreground and Background."

9. France has been accused of appropriating Tourmaline's research to make this feature film, forcing Tourmaline to make a short film instead of the documentary she originally planned to create: see, e.g., Tre'vell Anderson, "Trans Filmmaker Reina Gossett accuses 'The Death and Life of Marsha P. Johnson' Creator of Stealing Work," *Los Angeles Times*, October 9, 2017, http://www.latimes.com/entertainment/movies/la-et -mn-marsha-p-johnson-doc-reina-gossett-david-france-20171009-htmlstory.html; Reina Gossett, "Reina Gossett on Transgender Storytelling, David France, and the Netflix Marsha P. Johnson Documentary," *Teen Vogue*, October 11, 2017, https://www.teen vogue.com/story/reina-gossett-marsha-p-johnson-op-ed; Jenna Marotta, "Netflix Doc 'The Death and Life of Marsha P. Johnson': Did Director David France Steal a Filmmaker's Research?" *IndieWire*, October 7, 2017, http://www.indiewire.com/2017/10 /netflix-director-david-france-accused-stealing-reina-gossett-research-1201884876.

10. The importance of visibility to contemporary trans activism is encapsulated in Trans Day of Visibility, observed annually on March 31. Created in 2010 by the trans activist Rachel Crandall, Trans Day of Visibility is usually described through positive language that speaks to a desire to increase awareness and tolerance: see Monica Roberts, "What's the Transgender Day of Visibility?" *TransGriot*, February 15, 2010, http:// transgriot.blogspot.com/2010/02/whats-transgender-day-of-visibility.html. For example, one frequently cited resource from 2016 says that Trans Day of Visibility "aims to bring attention to the accomplishments of trans people around the globe" and describes it as a day designed "to celebrate the trans community in a positive light": "Transgender Day of Visibility," *Trans Student Educational Resources*, n.d., accessed March 28, 2017, http://www.transstudent.org/tdov.

Meanwhile, Roberts writes that Trans Day of Visibility is an event that "celebrates who we are." In describing the founder's effort to provide a counterpoint to the mourn-

ful Transgender Day of Remembrance, Roberts elaborates that "Rachel's vision for the Trans Day of Visibility is to focus on all the good things in the trans community, instead of just remembering those who were lost": Roberts, "What's the Transgender Day of Visibility?" Although "who we are" technically seems to include trans sex workers, trans prisoners, and others, the emphasis on "the accomplishments" of the transgender community and the description of the day presenting the community "in a positive light" suggests that there is a certain assimilationist logic to Trans Day of Visibility, as well as a bracketing of vulnerability.

11. Getsy and Simmons, "Appearing Differently," 39.

12. Spade, "What's Wrong with Trans Rights?," 191.

13. David, "Capital T," 30.

14. Feder and Juhasz, "Does Visibility Equal Progress?"

15. Morse, "Authenticity, Captioned."

16. Keeling, *The Witch's Flight*, 23.

17. Rancière, *Dissensus*. Elsewhere, Louis Althusser writes that "the invisible is not therefore simply what is outside the visible . . . the outer darkness of exclusion—but *the inner darkness of exclusion*, inside the visible itself because defined by its structure": Althusser, *Reading Capital*, 28–29.

18. Reina Gossett, "'What Are We Defending?': Reina's Talk at the INCITE! COV4 Conference," ReinaGossett.com, April 6, 2015, http://www.reinagossett.com/what-are -we-defending-reinas-talk-at-the-incite-cov4-conference.

19. Snorton, *Black on Both Sides*, 8.

20. Gossett and Huxtable, "Existing in the World," 46.

21. Elsewhere, I discuss how Vivek Shraya also interrogates this double bind in a series of self-portraits titled *Trauma Clown*: see Morse, "A Frown Turned Upside Down."

22. Prosser, *Second Skins*, 49.

23. Prosser, *Second Skins*, 53–54.

24. Halberstam, *Trans**, xiii.

25. Ruti, *The Ethics of Opting Out*, 151.

26. Gossett and Huxtable, "Existing in the World," 54.

27. Gossett and Huxtable, "Existing in the World," 54.

28. Gossett and Huxtable, "Existing in the World," 45.

29. Snorton, "Trapped in the Epistemological Closet."

30. Seid, "Reveal."

31. Gossett et al., "Known Unknowns," xv–xxvi.

32. Griffin-Gracy et al., "Cautious Living."

33. Christian, "The Value of Representation," 1552–74.

34. Keegan, "Review of *Trap Door*," 185.

35. Ahmed, *On Being Included*.

36. autotheoryqueen, Instagram post, August 15, 2018, https://www.instagram.com /p/BmhTPvyBIZWV_K7pzy8pwJEkzJofdnQQmeF9WYo.

37. autotheoryqueen, Instagram post, December 4, 2017, https://www.instagram .com/p/BcRNn7rglPQlb2fxCrGHMTjmBSnz3K-dkafdHko; autotheoryqueen,

Instagram post, February 6, 2018, https://www.instagram.com/p/Be_ET5mn3g9
YN3o4ynzPUg2aTHtdojyhJXr9I4o.

38. autotheoryqueen, Instagram post, December 11, 2017, https://www.instagram
.com/p/BclEkVgnC21o_u9IUodZKuZuCGCQoRNMw9Nq7go.

39. tourmaliiine, Instagram post, October 6, 2017, https://www.instagram.com/p
/BZ7byULA9KA.

40. autotheoryqueen, Instagram post, December 8, 2017, https://www.instagram
.com/p/BaAsSPtnFeT2_6nJGVuap8IAZbtljD_7AEuseAo.

41. Butler, *Gender Trouble*, 188.

42. Muñoz, "'The White to Be Angry,'" 102.

43. I study some of the same images in Morse, "Authenticity, Captioned," which fo-
cuses on the use of captions in Vaid-Menon's work more broadly.

44. Kevin St. John, "DarkMatter: Be the Kill-Joy," *Guernica*, May 2, 2016, https://
www.guernicamag.com/be-the-kill-joy.

45. DarkMatter, "Background," n.d., http://darkmatterrage.com/background-faq.

46. Jason Lamphier, "Artists of DarkMatter: 'Let's Challenge the Standards of Trans
Visibility,'" Out.com, May 17, 2016, http://www.out.com/hit-list/2016/5/17/artists
-darkmatter-lets-challenge-standards-trans-visibility; DarkMatter, Facebook post,
Facebook.com, July 12, 2015, https://www.facebook.com/darkmatterpoetry/photos
/a.450619138352342.1073741831.440542966026626/865726446841607.

47. Snorton, *Nobody Is Supposed to Know*, 3.

48. The relationship between visibility and authenticity in dominant discourse, and
the assumption that invisibility is inauthentic, is apparent in Emmanuel David's de-
scription of the Human Rights Campaign's 2014 publication "Transgender Visibility: A
Guide to Being You," which offers visibility as a critical strategy for "living as authen-
tically as possible": quoted in David, "Capital T," 28. The absence of humor in visibility
politics discourse exposes a desire for control, as well as a rejection of relationality in
favor of individuality. According to Lauren Berlant, humorlessness is "associated with
a bracing contraction of relation. Sovereignty is a fantasy of self-ratifying control over
a situation or space—a stance that might or might not be sanctioned by norm or law.
The sense of relational rigor mortis involved in sovereign-style humorlessness might
take on any form representationally, but it is often associated with a tone drained of
whatever passes for warmth or openness. This is why humorlessness is associated both
with political correctness and with the privilege that reproduces inequality as a casual,
natural order of things. Humorlessness wedges an encounter to control it, creating a
buttress of immobility and impasse": Berlant, "Humorlessness," 308.

49. Morse, "Authenticity, Captioned."

50. Jackson, *Real Black*, 11.

51. Jackson, *Real Black*, 159.

52. DarkMatterPoetry, Instagram post, January 9, 2016, https://www.instagram.com
/p/BAVG-Q3olqs.

53. See, e.g., Collins, *Black Feminist Thought*; Mercer, *Welcome to the Jungle*. Kara
Keeling discusses how femininity and womanhood are primarily available to white
women, in part because dark skin is gendered as masculine, and following Jewel Go-

mez and other scholars, she writes that "hegemonic common senses generally posit femininity as proper to white women": Keeling, *The Witch's Flight*, 83, 111, 131. Evelyn Higginbotham discusses how, under slavery, the "racialized configuration of gender" delegitimized and denied Black womanhood: Higginbotham, "African-American Women's History," 256–58. Reflecting on the twenty-fifth anniversary of Higginbotham's article, Marlon M. Bailey and L. H. Stallings write that Higginbotham articulated that "gender and race are mutually constitutive vectors of social identity and power that shape how white women's lives, structurally, remain different from those of women of color": Bailey and Stallings, "Antiblack Racism and the Metalanguage of Sexuality," 614.

54. See, e.g., Hiltebeitel and Miller, *Hair*.

55. Duriba Khan, "The Politics of Hair Removal for South Asian Women," *Brown Girl Magazine*, November 27, 2015, http://www.browngirlmagazine.com/2015/11 /politics-hair-removal-south-asian-women.

56. Tasnim Ahmed, "The Politics of Hair Removal for Women of Color," *Thought Catalog*, August 19, 2014, http://thoughtcatalog.com/tasnim-ahmed/2014/08/the -politics-of-hair-removal-for-women-of-color.

57. Nish Israni, "Body Hair Politics: A Brown Girl's Point of View," *Shameless Magazine*, January 11, 2016, http://shamelessmag.com/blog/entry/body-hair-politics -a-brown-girls-point-of-view.

58. See, e.g., DarkMatterPoetry, Instagram post, August 19, 2016, https://www .instagram.com/p/BJTp9cNhBPI.

59. DarkMatterPoetry, Instagram post, November 15, 2016, https://www.instagram .com/p/BM27QEFAmBu, analyzed in more detail in Morse, "Authenticity, Captioned."

60. For example, "episode four" features Vaid-Menon in bright red, with red lipstick and a black bindi, with a raised arm to show off their armpit hair: Instagram post, October 1, 2016, https://www.instagram.com/p/BLB8xLzgxGB).

61. Linda Schlossberg describes how Western notions of identity and subjecthood are founded on visibility—fundamentally shaping our scientific, theoretical, and philosophical texts—and argues that, as a result, passing simultaneously disappears marginalized identities and produces a threat to hegemonic structures of identity while exposing the intersections of identities and the porousness of identity categories: Schlossberg, *Passing*, 1–2.

62. Carole-Anne Tyler writes that passing is about the unseen, for "passing has become the sign of the victim, the practice of one already complicit with the order of things, prey to its oppressive hierarchies—if it can be seen at all. For the mark of passing successfully is the lack of a mark of passing, of a signifier of some difference from what one seems to be": Tyler, "Passing," 212.

63. Fuss, *Identification Papers*, 2.

64. Cross, "Surface Tensions," 270–71.

65. Sycamore, *Nobody Passes*, 19.

66. Kroeger, *Passing*, 215.

67. Sycamore, *Nobody Passes*, 8–9.

68. "Becky" has a long history as a name that represents "generic" economically

privileged white women, with Cara Kelly tracing its history from William Makepeace Thackeray's *Vanity Fair*, through Mark Twain's Becky Thatcher, to Daphne du Maurier's *Rebecca*. Entering rap with Sir Mix a Lot's *Baby Got Back*, the name has continued to accumulate connotations of stereotypical white womanhood: Cara Kelly, "What Does Becky Mean? Here's the History behind Beyoncé's 'Lemonade' Lyric That Sparked a Firestorm," *USA Today*, April 27, 2016, http://www.usatoday.com/story /life/entertainthis/2016/04/27/what-does-becky-mean-heres-history-behind-beyoncs -lemonade-lyric-sparked-firestorm/83555996.

69. Yasmin Ibrahim analyzes how photobombing explores the carnivalesque in "The Vernacular of Photobombing."

70. The phrase *criminal punishment system* is often used by prison abolitionists instead of the phrase *criminal justice system* to highlight that there is too often little justice within the system. The phrase is generally attributed to the organizer and activist Mariame Kaba.

71. As of January 26, 2017, seven of the fifty-six comments referenced the final line, while no other line from the video received more than one or two mentions. The vast majority of the comments are simply people tagging others, encouraging them to watch it.

4. Selfie Time(lines)

1. Eliza Steinbock, "Walking into Conflict: Trans Woman and Visual Artist Yishay Garbasz on Chronicling Trauma," *Huffington Post*, May 1, 2015, https://www.huffington post.com/eliza-steinbock/walking-into-conflict-tra_b_7188450.html.

2. Horak, "Trans on YouTube," 581.

3. Julia Serano documents the prevalence of arguments that trans people reinforce patriarchal gender roles, hierarchies, and binaries and deconstructs the faulty logic underlying these arguments: Serano, *Excluded*, 110–37.

4. Rich, *New Queer Cinema*, 276.

5. Rich praises *A Boy Named Sue* (2001) as "one of the best" trans documentaries and notes that it uses creative aesthetic devices to tell a story of transition "from lesbian to gay male," revealing her investment in trans documentaries that describe transition as a journey from one gender to another: Rich, *New Queer Cinema*, 274. Another documentary Rich praises is the trans director Yance Ford's *Strong Island* (2017): Rich, personal communication, November 9, 2017. Although the film is not about Ford's transition but, rather, about the murder of Ford's brother and the failures of the justice system, it is nonetheless put into dialogue with trans self-representational documentary, given that it includes hundreds of family photographs, including many photographs and home videos that depict Ford in childhood.

6. Freeman, "Introduction," 159.

7. Dinshaw et al., "Theorizing Queer Temporalities," 191.

8. cárdenas, "Dark Shimmers," 161.

9. Lee Edelman, in Dinshaw et al., "Theorizing Queer Temporalities," 195.

10. Halberstam, *In a Queer Time and Place*, 18–19.

11. Understanding gender to be fungible is distinct from the fantasy of utter flexibility and total liberation that marks many accounts of trans identity and experience. Rather than such immaterial flexibility, "fungibility" offers a different account of gender and gendered embodiment. According to C. Riley Snorton, transgender identities and experiences expose the fungibility of gender, but gender's fungibility is not only tied to postmodern idealizations of transition as demonstrating a liberatory flexibility of gendered embodiment. Instead, it is also produced by the fungibility—or thingification—of Black people's genders through the violence of slavery: Snorton, *Black on Both Sides*, 126. In Snorton's work, the idea that trans identities reveal gender to be fungible rather than flexible attends to the material realities of trans experiences— material realities that, as Snorton shows, disproportionately impact trans people of color. In addition, these material realities can have differential effects on trans feminine people versus trans masculine people. Jasbir Puar describes how trans people's access to transnormativity is dictated by both race and gender, with white trans masculine people having significantly greater access to experiences of flexibility and fluidity: Puar, *The Right to Maim*, 48.

12. Brilmyer et al., "Introduction," 218.

13. See, e.g., Auricchio, "Self-Promotion in Adélaïde Labille-Guiard's 1785 *Self-Portrait with Two Students*."

14. When Cindy Sherman began sharing selfies on Instagram, the *New York Times* wrote that this exposed "the gap between Ms. Sherman's vital, unsettling practice of sideways self-portraiture and the narcissistic practice of selfie snapping": Jason Farago, "Cindy Sherman Takes Selfies [as Only She Could] on Instagram," *New York Times*, August 6, 2017, https://www.nytimes.com/2017/08/06/arts/design/cindy-sherman-instagram.html.

15. Pham, *Asians Wear Clothes on the Internet*, 77–78.

16. Pham, *Asians Wear Clothes on the Internet*, 93.

17. Horak, "Trans on YouTube"; Raun, *Out Online*.

18. Nelson, "Notes on a Visual Diary, Co-Authored," 149.

19. Indeed, according to Kay Siebler, transition selfies and timelines are politically regressive, since they tend to reproduce binary gender norms as the ultimate goal of transition: Siebler, "Transgender Transitions." Yet trans people are not uniquely or inherently nonbinary, androgynous, or genderqueer. As Serano has argued, there is a profound problem with academic arguments that assume trans people are uniquely obliged always to be transgressive: Serano, *Whipping Girl*, 195–214.

20. Zinnia Jones, "Transition as Gender Freedom (Gender Analysis 03)," *The-Orbit. net/Zinnia Jones* (blog), December 1, 2014, https://the-orbit.net/zinniajones/2014/12 /transition-as-gender-freedom-gender-analysis-03.

21. Nebulous Persona, "Re: Clearing Up a Few Misconceptions . . . (Zinnia/ZJ vs Transgender)," YouTube video, January 13, 2011, https://www.youtube.com/watch ?v=iNCLuRbBX-A. I thank Paul Benzon for suggesting the likely source of the robotic voice in a conversation at the annual conference of the Association for the Study of the Arts of the Present in October 2017.

22. Nebulous Persona under the name Ellen, "The Time I Outed Someone to Her-

self," *Sugar and Slugs* (blog), January 14, 2013, https://sugarandslugs.wordpress.com
/2013/01/14/the-time-i-outed-someone-to-herself.

23. In 2013, Jones revisited this incident in part because a prominent YouTube personality seemed to be in the midst of an unacknowledged transition: Zinnia Jones, Tumblr post, November 29, 2013, http://zjemptv.tumblr.com/post/68472472814/are -you-familiar-with-gregory-gigi-gorgeous. In recalling her own experience with Nebulous Persona, Jones declares that she herself would never pressure someone else to transition more quickly: Zinnia Jones, Tumblr post, November 29, 2013, http://zjemptv .tumblr.com/post/68483462501/honestly-though-im-really-iffy-on-publicly.

24. Zinnia Jones, "Two Years Later: Notes from the Future," *The-Orbit.net/Zinnia Jones* (blog), January 12, 2013, https://the-orbit.net/zinniajones/2013/01/two-years -later-notes-from-the-future.

25. Ruti, *The Ethics of Opting Out*, 87.

26. Jones, "Two Years Later."

27. Katherine Cross, "The Oscar Wilde of YouTube Fights the Alt-Right with Decadence and Seduction," *The Verge*, August 24, 2018, https://www.theverge.com/tech /2018/8/24/17689090/contrapoints-youtube-natalie-wynn.

28. John Herrman, "For the New Far Right, YouTube Has Become the New Talk Radio," *New York Times Magazine*, August 3, 2017, https://www.nytimes.com/2017/08/03 /magazine/for-the-new-far-right-youtube-has-become-the-new-talk-radio.html; "ContraPoints Is De-radicalizing Young, Right-Wing Men (HBO)," *Vice News*, March 14, 2019, http://newsvideo.su/video/10426817.

29. ContraPoints, "The Aesthetic," YouTube video, September 19, 2018, https://youtu .be/z1afqR5QkDM.

30. ContraPoints, "TERFS," YouTube video, August 18, 2017, https://youtu.be /AQPWI7cEJGs; ContraPoints, "Debating the Alt-Right," YouTube video, May 18, 2017, https://youtu.be/zPa1wikTd5c.

31. Halberstam writes that "the transgender body confirms a fantasy of fluidity so common to notions of transformation within the postmodern": Halberstam, *In a Queer Time and Place*, 96.

32. ContraPoints, "Alpha Males," YouTube video, October 9, 2016, https://youtu.be /k6jYB74UQmI.

33. ContraPoints Live, "Commentary on 'Alpha Males,'" YouTube video, October 8, 2017, https://youtu.be/vbE23R1J4ko.

34. ContraPoints, "Degeneracy," YouTube video, October 19, 2017, https://youtu.be /9BlNGZunYM8.

35. ContraPoints, "Why the Alt-Right Is Wrong," YouTube video, December 14, 2017, https://youtu.be/wyVoyeSZ940.

36. Wynn discussed this in videos tracking her transition that she posted on her Live Stream YouTube channel in fall 2017. She has since removed them from the channel.

37. Katie Herzog, "Popular Leftist YouTuber ContraPoints Gets Caught Up in University of British Columbia Free Speech Debate," *The Stranger* (blog), December 5, 2017, https://www.thestranger.com/slog/2017/12/05/25607468/popular-leftist-youtuber -contrapoints-gets-caught-up-in-university-of-british-columbia-free-speech-debate.

38. Wynn has since left Twitter altogether after further controversy while continuing to produce videos for YouTube and share selfies on Instagram. For more information, see Tris Mamone, "The ContraPoints Twitter Debacle Explained," SpliceToday.com, September 9, 2019, https://www.splicetoday.com/politics-and-media/the-contrapoints-twitter-debacle-explained; Jesse Singal, "ContraPoints and the Scandal That Shouldn't Be," ArcDigital.Media, September 6, 2019, https://arcdigital.media/contrapoints-and-the-scandal-that-shouldnt-be-15ac97f330d4.

39. Natalie Wynn, Twitter thread, November 29, 2017, https://twitter.com/Contra Points/status/936092717725122560.

40. Puar, *The Right to Maim*, 61.

41. Haraway, *Simians, Cyborgs and Women*, 151.

5. Trans Feminist Futures

1. Ritchin, *After Photography*, 34.

2. Stryker and Currah, "General Editors' Introduction," 540.

3. Field, "The Archive of Absence."

4. I had the privilege of working as a research assistant on this film, which premiered at the Tribeca Film Festival in 2019.

5. Elsewhere, I discuss how the visual rhetoric of doubling across time is central to Transparent's vision of the relationship between the present and the past: see Morse, "Seeing Double."

6. Stryker and Currah, "General Editors' Introduction," 539.

7. Muñoz, *Cruising Utopia*, 1.

8. Muñoz writes, "I see world-making here as functioning and coming into play through the performance of queer utopian memory, that is, a utopia that understands its time as reaching beyond some nostalgic past that perhaps never was or some future whose arrival is continuously belated—a utopia in the present": Muñoz, *Cruising Utopia*, 37. See also Muñoz, *Cruising Utopia*, 20.

9. Muñoz, *Cruising Utopia*, 11.

10. Ruti, *The Ethics of Opting Out*, 185–92.

11. Freeman, *Time Binds*.

12. Brilmyer et al., "Introduction," 235. Ruti challenges Puar's analysis of the suicide bomber as a queer figure in *The Ethics of Opting Out*, 29–34.

13. Keeling, *The Witch's Flight*, 35.

14. Muñoz, *Cruising Utopia*, 116, 185.

15. KT Hawbaker-Krohn, "Chicago's Black Drag Queens Are Upholding a Radical Gender-Bending Tradition," *Chicago Reader*, August 11, 2016, http://www.chicago reader.com/chicago/black-drag-queens-photo-essay/Content?oid=23101706; Nico Lang, "Shea Couleé's Drag Revolution Will Be Televised," *Windy City Times*, January 15, 2014, http://www.windycitymediagroup.com/lgbt/THE-Q-LIST-Shea-Coulees-drag-revolution-will-be-televised/45856.html; "#Spotlight on Shea Couleé," Open TV Community, n.d., http://www.weareopen.tv/open-tv-community//spotlight-on-shea-coulee.

16. I was involved in planning the premiere party for the film's release when I worked for Open TV–Beta. As of 2018, the research project and web television distributor has been renamed Open Television (OTV).

17. The documentary ambitions of the film were articulated by Shea Couleé at the premiere of *Lipstick City* in Chicago on May 2, 2016, as well as in interviews: see, e.g., Vasia Rigou, "Her Life in Drag: The Glamorous Life of Shea Couleé," *NewCity Design*, April 6, 2016, http://design.newcity.com/2016/04/06/shea-coulee-her-life-in-drag.

18. I thank Gary Kafer for his suggestions and feedback on this section.

19. Jagoda, *Network Aesthetics*.

20. Bukatman, *Terminal Identity*, 315.

21. King, *Virtual Memory*, 70.

22. King, *Virtual Memory*, 69.

23. Muñoz, *Cruising Utopia*, 99.

24. Muñoz, *Cruising Utopia*, 98, 103.

25. For more on Shraya's work about family, see Wiggins, "Encountering Inheritance in Vivek Shraya's *I Want to Kill Myself*." The quote is from Vivek Shraya, *Trisha*, n.d., https://vivekshraya.com/visual/trisha.

26. See, e.g., Muñoz's commentary on Edelman's account of queer time as nonreproductive time in *Cruising Utopia*, 11, and the summary of their debate in Ruti, *The Ethics of Opting Out*, 87–129.

27. Muñoz, *Cruising Utopia*, 35.

28. Maria Cruz, "Diasporic Family Ties and the Queer," *The Medium*, March 9, 2015, https://themedium.ca/arts/diasporic-family-ties-and-the-queer.

29. Vivek Shraya, "Holy Mother, My Mother (Teaser)," Vimeo.com, April 17, 2014, https://vimeo.com/92291204.

30. Laura Fraser, "Toronto Trans Artist Vivek Shraya Steps into Mother's Role in Photo Essay," CBC News, May 2, 2016, http://www.cbc.ca/news/canada/toronto/vivek -photo-mother-1.3561029. At the same time, Shraya notes that her mother's support is not predicated on explicit acceptance of Shraya's trans identity. In fact, Shraya was not out to her mother for some time. "I haven't yet explicitly come out to my parents as trans. A central aspect of my hesitancy is connected to determining how necessary this is for me. Do I need to hear my mom refer to me as 'she'? Does my transness need to be named when she already shares her jewelry with me and I occasionally wear makeup around her? Maybe there is beauty in love that thrives even when difference is unnamed": Vivek Shraya, "Have You Told Your Parents?," Buzzfeed, September 28, 2016, https://www.buzzfeed.com/vivekshraya/have-you-told-your-parents?utm_term =.rjXdjrRVe#.hp693Yjnr.

31. R. L. Goldberg, "Vivek Shraya: Beyond Margins," *Guernica*, January 9, 2017, https://www.guernicamag.com/vivek-shraya-beyond-margins.

32. Vivek Shraya, "On Becoming My Mother," CanadianArt.ca, April 25, 2017, https://canadianart.ca/features/vivek-shraya-on-becoming-my-mother.

33. Anna Cafolla, "The Genderqueer Artist Re-creating Her Mother's Old Photos," DazedDigital.com, April 25, 2016, http://www.dazeddigital.com/photography/article /30874/1/the-genderqueer-artist-recreating-her-mother-s-old-photos.

34. Shraya, "On Becoming My Mother."

35. "According to Shraya, the project began as a way of capturing their likeness, the ways in which the artist appears and acts like her mother. But on seeing the images side by side, Shraya said the project forced her to grapple with the ways they don't look or act alike. She recalls it being hard to see the photos at first, new and old, because all she could see were their differences. With time to digest the photos, though, Shraya has come to realize that their differences are just as important as their similarities": Katherine Brooks, "Artist Vivek Shraya Channels Her Mother in Stunning Re-created Photos," *Huffington Post*, May 19, 2016, https://www.huffingtonpost.com/entry/vivek -shraya-recreated-photos-of-mother_us_573dd064e4b0646cbeec3f38.

36. Vivek Shraya, conversation with Nicole Morse, Center for the Study of Gender and Sexuality, University of Chicago, May 1, 2019.

37. Shraya, "On Becoming My Mother."

38. Shraya, "Have You Told Your Parents?"

39. Shraya, "On Becoming My Mother."

40. In her descriptions of her photographic practice, Cindy Sherman does not mention assistants and even describes herself "bringing my camera and tripod with me"—that is, until she describes the exterior shots, where, she notes, "other people were taking the photos": *Cindy Sherman*, 12–13. These people included Robert Longo, Helene, her father, Diane Bertolo, and her niece Barbara Foster. She notes that Robert Longo at times contributed his own ideas: *Cindy Sherman*, 14. She also says that, because she cropped the images very carefully, she was willing to have other people actually take the photographs: *Cindy Sherman*, 15.

41. Brooks, "Artist Vivek Shraya Channels Her Mother in Stunning Re-created Photos."

42. Shraya, *Trisha*.

43. Cafolla, "The Genderqueer Artist Re-creating Her Mother's Old Photos."

44. Shraya, conversation with Morse.

45. Shraya, "On Becoming My Mother."

46. Bazin, *What Is Cinema? I*, 9.

47. I thank Jamie Saoirse O'Duibhir for her suggestions and feedback on this material.

48. Edelman, *No Future*.

Coda

1. Morse, "Where Do Aliens Pee?," 23–26.

Selected Bibliography

Acocella, Joan. "Selfie: How Big a Problem Is Narcissism?" *New Yorker*, May 12, 2014. http://www.newyorker.com/magazine/2014/05/12/selfie.

After Globalism Writing Group. "Water as Protagonist." *Social Text* 36, no. 1 (2018): 15–23.

Ahmed, Sara. *On Being Included: Racism and Diversity in Institutional Life*. Durham, NC: Duke University Press, 2012.

Ahmed, Sara. *Queer Phenomenology: Orientations, Objects, Others*. Durham, NC: Duke University Press, 2006.

Alexander, Neta. "Rage against the Machine: Buffering, Noise, and Perpetual Anxiety in the Age of Connected Viewing." *Cinema Journal* 56, no. 2 (Winter 2017): 1–24.

Althusser, Louis. *Reading Capital*. New York: Verso, 2009.

Auricchio, Laura. "Self-Promotion in Adélaïde Labille-Guiard's 1785 *Self-Portrait with Two Students*." *Art Bulletin* 89, no. 1 (2007): 45–62.

Azoulay, Ariella. *The Civil Contract of Photography*. New York: Zone, 2013.

Bailey, Marlon M., and L. H. Stallings. "Antiblack Racism and the Metalanguage of Sexuality." *Signs* 42, no. 3 (2017): 614–21.

Baron, Jaimie. *The Archive Effect: Found Footage and the Audiovisual Experience of History*. New York: Routledge, 2014.

Barthes, Roland. *A Lover's Discourse: Fragments*. Translated by Richard Howard. New York: Hill and Wang, 2010.

Barthes, Roland. *Camera Lucida: Reflections on Photography*. New York: Hill and Wang, 1981.

Barthes, Roland. *The Rustle of Language*. Translated by Richard Howard. Berkeley: University of California Press, 1989.

Bashiya, Anirban Kapil. "#NaMo: The Political Work of the Selfie in the 2014 Indian General Elections." *International Journal of Communication* 9 (2015): 1686–700.

Bay-Cheng, Sarah. "'When This You See': The (Anti) Radical Time of Mobile Self-Surveillance." *Performance Research* 19, no. 3 (2014): 48–55.

Bazin, André. *What Is Cinema? I*. Translated by Hugh Gray. Berkeley: University of California Press, 1967.

Bellinger, Matthew. "Bae Caught Me Tweetin': On Selfies, Memes, and David Cameron." *International Journal of Communication* 9 (2015): 1806–17.

Benavente, Gabby, and Julian Gill-Peterson. "The Promise of Trans Critique: Susan Stryker's Queer Theory." GLQ 25, no. 1 (2019): 23–28.

Berger, John. *Ways of Seeing*. London: Penguin, 1977.

Bergo, Bettina. "Emmanuel Levinas." In *The Stanford Encyclopedia of Philosophy*, edited by Edward N. Zalta. https://plato.stanford.edu/entries/levinas/.

Berlant, Lauren. "Humorlessness (Three Monologues and a Hairpiece)." *Critical Inquiry* 43, no. 2 (2017): 305–40.

Bersani, Leo, and Adam Phillips. *Intimacies*. Chicago: University of Chicago Press, 2010.

Bettcher, Talia Mae. "Intersexuality, Transsexuality, Transgender." In *The Oxford Handbook of Feminist Theory*, edited by Lisa Disch and M. E. Hawkesworth, 407–27. New York: Oxford University Press, 2018.

Binnie, Imogen. *Nevada*. New York: Topside, 2013.

Bond, Anthony, ed. *Self Portrait: Renaissance to Contemporary*. Sydney: Art Gallery of New South Wales, 2005.

Bourdieu, Pierre. *Photography: A Middle-Brow Art*. Translated by Shaun Whiteside. Cambridge: Polity, 1990.

Bourriaud, Nicolas. *Relational Aesthetics*. Dijon: Les Presses du Réel, 2002.

Brilmyer, S. Pearl, Filippo Trentin, and Zairong Xiang. "Introduction: The Ontology of the Couple." GLQ 25, no. 2 (2019): 223–55.

Bruno, Nicola, Valentina Gabriele, Tiziana Tasso, and Marco Bertamini. "'Selfies' Reveal Systematic Deviations from Known Principles of Photographic Composition." *Art and Perception* 2, nos. 1–2 (January 2014): 45–58.

Bukatman, Scott. *Terminal Identity: The Virtual Subject in Postmodern Science Fiction*. Durham, NC: Duke University Press, 2005.

Burns, Anne. "Self(ie)-Discipline: Social Regulation as Enacted through the Discussion of Photographic Practice." *International Journal of Communication* 9 (2015): 1716–33.

Butler, Judith. *Bodies That Matter: On the Discursive Limits of "Sex."* New York: Routledge, 2015.

Butler, Judith. *Gender Trouble: Feminism and the Subversion of Identity*. New York: Routledge Classics, 2008.

Campt, Tina M. *Listening to Images*. Durham, NC: Duke University Press, 2017.

cárdenas, micha. "Dark Shimmers: The Rhythm of Necropolitical Affect in Digital Media." In *Trap Door: Trans Cultural Production and the Politics of Visibility*, edited by Reina Gossett, Eric A. Stanley, and Johanna Burton, 161–81. Cambridge, MA: MIT Press, 2017.

Carter, Julian. "Transition." TSQ: *Transgender Studies Quarterly* 1, nos. 1–2 (2014): 235–37.

Chaudhry, V Varun. "Centering the 'Evil Twin': Rethinking Transgender in Queer Theory." GLQ 25, no. 1 (2019): 45–50.

Chen, Jian Neo. *Trans Exploits: Trans of Color Cultures and Technologies in Movement*. Durham, NC: Duke University Press, 2019.

Christian, Aymar Jean. "The Value of Representation: Toward a Critique of Networked Television Performance." *International Journal of Communication* 11 (2017): 1552–74.

Chu, Andrea Long. "On Liking Women." *n+1* 30 (2013). https://nplusonemag.com /issue-30/essays/on-liking-women.

Chu, Andrea Long, and Emmett Harsin Drager. "After Trans Studies." *TSQ: Transgender Studies Quarterly* 6, no. 1 (2019): 103–16.

Chua, Trudy Hui Hui, and Leanne Chang. "Follow Me and Like My Beautiful Selfies: Singapore Teenage Girls' Engagement in Self-Presentation and Peer Comparison on Social Media." *Computers in Human Behavior* 55 (February 2016): 190–97.

Cindy Sherman: The Complete Untitled Film Stills. Exhibition catalog. New York: Museum of Modern Art, 2003.

Clark, T. J. "The Look of Self-Portraiture." *The Yale Journal of Criticism* 5, no. 2 (Spring 1992): 109–18.

Collins, Patricia Hill. *Black Feminist Thought: Knowledge, Consciousness, and the Politics of Empowerment.* London: HarperCollins, 1990.

Cross, Jen. "Surface Tensions." In *Nobody Passes: Rejecting the Rules of Gender and Conformity,* edited by Mattilda Bernstein Sycamore, 270–83. Emeryville, CA: Seal, 2006.

David, Emmanuel. "Capital T: Trans Visibility, Corporate Capitalism, and Commodity Culture." *TSQ: Transgender Studies Quarterly* 4, no. 1 (2017): 28–44.

Derrida, Jacques, and Eric Prenowitz. "Archive Fever: A Freudian Impression." *Diacritics* 25, no. 2 (1995): 9–63.

Dick, Leslie. "On Repetition: Nobody Passes." *X-TRA Contemporary Art Quarterly* 17, no. 1 (Fall 2014). http://x-traonline.org/article/on-repetition.

Dinshaw, Carolyn, Lee Edelman, Roderick A. Ferguson, Carla Freccero, et al. "Theorizing Queer Temporalities: A Roundtable Discussion." *GLQ* 13, nos. 2–3 (2007): 177–95.

DIS Magazine. #artselfie. Paris: Jean Boîte, 2014.

Döring, Nicola, Anne Reif, and Sandra Poeschl. "How Gender-Stereotypical Are Selfies? A Content Analysis and Comparison with Magazine Adverts." *Computers in Human Behavior* 55 (February 2016): 955–62.

Downie, Louise, ed. *Don't Kiss Me: The Art of Claude Cahun and Marcel Moore.* New York: Aperture Foundation, 2006.

Drucker, Zackary. "April Dawn Alison." In *April Dawn Alison,* edited by Erin O'Toole. London: MACK, 2019.

Drucker, Zackary. "ThestoryofZackaRhys." In *Relationship,* by Zackary Drucker and Rhys Ernst, n.p. New York: Prestel, 2016.

Drucker, Zackary, and Rhys Ernst. *Relationship.* New York: Prestel, 2016.

Duguay, Stefanie. "Lesbian, Gay, Bisexual, Trans, and Queer Visibility through Selfies: Comparing Platform Mediators across Ruby Rose's Instagram and Vine Presence." *Social Media and Society* 2, no. 2 (2016): 1–12.

du Preez, Amanda. "When Selfies Turn into Online Doppelgängers: From Double as Shadow to Double as Alter Ego." In *The Digital Arts and Humanities,* edited by

Charles Travis and Alexander von Lünen, 3–21. Switzerland: Springer International, 2016.

Eckel, Julia, Jens Ruchatz, and Sabine Wirth, eds. *Exploring the Selfie: Historical, Theoretical, and Analytical Approaches to Digital Self-Photography*. Cham, Switzerland: Palgrave Macmillan, 2018.

Edelman, Lee. *No Future: Queer Theory and the Death Drive*. Durham, NC: Duke University Press, 2007.

Ehlin, Lisa. "The Subversive Selfie: Redefining the Mediated Subject." *Clothing Cultures* 2, no. 1 (December 2014): 73–89.

Enke, A. Finn, ed. *Transfeminist Perspectives in and beyond Transgender and Gender Studies*. Philadelphia: Temple University Press, 2012.

Espinoza, J. Jennifer. *There Should Be Flowers*. Fairfax, VA: Civil Coping Mechanisms, 2016.

Feder, Sam, and Alexandra Juhasz. "Does Visibility Equal Progress? A Conversation on Trans Activist Media." *Jump Cut* 57 (2016). https://www.ejumpcut.org/currentissue /-Feder-JuhaszTransActivism/index.html.

Field, Allyson Nadia. "The Archive of Absence: Speculative Film History and Early African American Cinema." Paper presented at Humanities Day, University of Chicago, October 15, 2016.

Foster, Thomas. *The Souls of Cyberfolk: Posthumanism as Vernacular Theory*. Minneapolis: University of Minnesota Press, 2005.

Foucault, Michel. *The Order of Things: An Archaeology of the Human Sciences*. New York: Vintage, 1994.

Freeman, Elizabeth. "Introduction." *GLQ* 13, no. 2–3 (2007): 159–76.

Freeman, Elizabeth. "The Queer Temporalities of *Queer Temporalities*." *GLQ* 25, no. 1 (2019): 91–95.

Freeman, Elizabeth. *Time Binds: Queer Temporalities, Queer Histories*. Durham, NC: Duke University Press, 2011.

Fried, Michael. *The Moment of Caravaggio*. Princeton, NJ: Princeton University Press, 2010.

Frosh, Paul. "The Gestural Image: The Selfie, Photography Theory, and Kinesthetic Sociability." *International Journal of Communication* 9 (2015): 1607–28.

Fuss, Diana. *Identification Papers*. New York: Routledge, 1995.

Gerdes, Kendall. "Performativity." *TSQ: Transgender Studies Quarterly* 1, nos. 1–2 (2014): 148–50.

Getsy, David J., and William J. Simmons. "Appearing Differently: Abstraction's Transgender and Queer Capacities." In *Pink Labor on Golden Streets: Queer Art Practices*, edited by Christiane Erharter, Dietmar Schwärzler, Ruby Sircar, and Hans Scheirl, 38–55. Berlin: Sternberg, 2015.

Giroux, Henry A. "Selfie Culture in the Age of Corporate and State Surveillance." *Third Text* 29, no. 3 (2015): 155–64.

Goldberg, Greg. "Through the Looking Glass: The Queer Narcissism of Selfies." *Social Media and Society* (January–March 2017): 1–11.

Goranin, Näkki. *American Photobooth*. New York: W. W. Norton, 2008.

Gossett, Che, and Juliana Huxtable. "Existing in the World: Blackness at the Edge of Trans Visibility." In *Trap Door: Trans Cultural Production and the Politics of Visibility*, edited by Reina Gossett, Eric A. Stanley, and Johanna Burton, 39–56. Cambridge, MA: MIT Press, 2017.

Gossett, Reina, Eric A. Stanley, and Johanna Burton. "Known Unknowns: An Introduction to *Trap Door*." In *Trap Door: Trans Cultural Production and the Politics of Visibility*, edited by Reina Gossett, Eric A. Stanley, and Johanna Burton, xv–xxvi. Cambridge, MA: MIT Press, 2017.

Gossett, Reina, Eric A. Stanley, and Johanna Burton, eds. *Trap Door: Trans Cultural Production and the Politics of Visibility*. Cambridge, MA: MIT Press, 2017.

Griffin-Gracy, Miss Major, and CeCe McDonald, in conversation with Toshio Meronek. "Cautious Living: Black Trans Women and the Politics of Documentation." In *Trap Door: Trans Cultural Production and the Politics of Visibility*, edited by Reina Gossett, Eric A. Stanley, and Johanna Burton, 23–37. Cambridge, MA: MIT Press, 2017.

Gunning, Tom. "What's the Point of an Index? or, Faking Photographs." In *Still Moving: Between Cinema and Photography*, edited by Karen Beckman and Jean Ma, 23–40. Durham, NC: Duke University Press, 2008.

Halberstam, Jack [Judith]. *In a Queer Time and Place: Transgender Bodies, Subcultural Lives*. New York: New York University Press, 2005.

Halberstam, Jack. TRANS*: *A Quick and Quirky Account of Gender Variability*. Oakland: University of California Press, 2018.

Hale, C. Jacob. "Leatherdyke Boys and Their Daddies: How to Have Sex without Women or Men." *Social Text*, nos. 52–53 (1997): 223–36.

Hall, James. *The Self-Portrait: A Cultural History*. New York: Thames and Hudson, 2014.

Hansen, Mark B. N. "Media Theory." *Theory, Culture, and Society* 23, nos. 2–3 (2006): 297–306.

Hansen, Miriam Bratu. "Introduction." In *Theory of Film: The Redemption of Physical Reality*, by Siegfried Kracauer, vii–xlv. Princeton, NJ: Princeton University Press, 1997.

Haraway, Donna. "Awash in Urine: DES and Premarin in Multispecies Responseability." In *Staying with the Trouble: Making Kin in the Chthulucene*, 104–16. Durham, NC: Duke University Press, 2016.

Haraway, Donna. *Simians, Cyborgs and Women: The Reinvention of Nature*. New York: Routledge, 1991.

Harney, Stefano, and Fred Moten. *The Undercommons: Fugitive Planning and Black Study*. New York: Minor Compositions, 2013.

Hayles, N. Katherine. *How We Became Posthuman: Virtual Bodies in Cybernetics, Literature, and Informatics*. Chicago: University of Chicago Press, 1999.

Heaney, Emma. *The New Woman: Literary Modernism, Queer Theory, and the Trans Feminine Allegory*. Chicago: Northwestern University Press, 2017.

Hess, Aaron. "The Selfie Assemblage." *International Journal of Communication* 9 (2015): 1629–46.

Heyes, Cressida J. "Feminist Solidarity after Queer Theory: The Case of Transgender." *Signs* 28, no. 4 (2003): 1093–120.

Higginbotham, Evelyn. "African-American Women's History and the Metalanguage of Race." *Signs* 17, no. 2 (1992): 251–74.

Hiltebeitel, Alf, and Barbara D. Miller, eds. *Hair: Its Power and Meaning in Asian Cultures*. Albany: State University of New York Press, 1998.

Hirsch, Julia. *Family Photographs: Content, Meaning, and Effect*. New York: Oxford University Press, 1981.

Horak, Laura. "Trans on YouTube: Intimacy, Visibility, Temporality." *TSQ: Transgender Studies Quarterly* 1, no. 4 (2014): 572–85.

Ibrahim, Yasmin. "The Vernacular of Photobombing: The Aesthetics of Transgression." *Convergence* 25, nos. 5–6 (2019): 1111–22.

Jackson, John L. *Real Black: Adventures in Racial Sincerity*. Chicago: University of Chicago Press, 2005.

Jagoda, Patrick. *Network Aesthetics*. Chicago: University of Chicago Press, 2016.

Jones, Amelia, and David J. Getsy. "Abstract Bodies and Otherwise: A Conversation with Amelia Jones and David Getsy on Gender and Sexuality in the Writing of Art History." *College Art Association Reviews*, February 16, 2018. dx.doi.org/10.3202/caa .reviews.2018.56.

Jones, Jordy. "The Ambiguous I: Photography, Gender, Self." PhD diss., University of California, Irvine, 2008.

Kafer, Gary, and Daniel Grinberg. "Editorial: Queer Surveillance." *Surveillance and Society* 17, no. 5 (2019): 592–601.

Keegan, Cáel. *Lana and Lilly Wachowski: Sensing Transgender*. Urbana: University of Illinois Press, 2018.

Keegan, Cáel. "Moving Bodies: Sympathetic Migrations in Transgender Narrativity." *Genders* 57 (Spring 2013). https://www.colorado.edu/gendersarchive1998-2013 /2013/06/01/moving-bodies-sympathetic-migrations-transgender-narrativity.

Keegan, Cáel. "Review of *Trap Door: Trans Cultural Production and the Politics of Visibility*." *Journal of Cinema and Media Studies* 58, no. 4 (2019): 183–86.

Keegan, Cáel. "Revisitation: A Trans Phenomenology of the Media Image." *MedieKultur* 61, nos. 1–5 (Fall 2016): 26–41.

Keegan, Cáel, Laura Horak, and Eliza Steinbock. "Cinematic/Trans*/Bodies Now (and Then, and to Come)." *Somatechnics* 8, no. 1 (2018): 1–13.

Keegan, Cáel, and Tobias Raun. "Nothing to Hide: Selfies, Sex and the Visibility Dilemma in Trans Male Online Cultures." In *Sex in the Digital Age*, edited by Paul G. Nixon and Isabel K. Düsterhöft, 89–100. New York: Routledge, 2018.

Keeling, Kara. *The Witch's Flight: The Cinematic, the Black Femme, and the Image of Common Sense*. Durham, NC: Duke University Press, 2007.

Kenaan, Hagi. "Facing Images: After Levinas." *Angelaki* 16, no. 1 (2011): 143–59.

King, Homay. *Virtual Memory: Time-based Art and the Dream of Digitality*. Durham, NC: Duke University Press, 2015.

Koerner, Joseph L. *The Moment of Self-Portraiture in German Renaissance Art*. Chicago: University of Chicago Press, 1993.

Koerner, Joseph L. "Self-Portraiture Direct and Oblique." In *Self Portrait: Renaissance to Contemporary*, edited by Anthony Bond,67–81. Sydney: Art Gallery of New South Wales, 2005.

Kornstein, Harris. "Under Her Eye: Digital Drag as Obfuscation and Countersurveillance." *Surveillance and Society* 17, no. 5 (2019): 681–98.

Koyama, Emi. "The Transfeminist Manifesto." In *Catching a Wave: Reclaiming Feminism for the 21st Century*, edited by Rory Dicker and Alison Piepmeier, 244–62. Boston: Northeastern University Press, 2003.

Kroeger, Brooke. *Passing: When People Can't Be Who They Are*. New York: Public Affairs, 2003.

Kuntsman, Adi, ed. *Selfie Citizenship*. Cham, Switzerland: Springer Science and Business Media, 2017.

Lacan, Jacques. "The Mirror-Phase as Formative of the Function of the I." *New Left Review* 1, no. 52 (1968). https://newleftreview.org/I/51/jacques-lacan-the-mirror-phase-as-formative-of-the-function-of-the-i.

Lasch, Christopher. *The Culture of Narcissism: American Life in an Age of Diminishing Expectations*. New York: W. W. Norton, 1979.

Lavery, Grace. "Trans Realism, Psychoanalytic Practice, and the Rhetoric of Technique." *Critical Inquiry* 46, no. 4 (Summer 2020): 719–44.

Lobinger, Katharina, and Cornelia Brantner. "In the Eye of the Beholder: Subjective Views on the Authenticity of Selfies." *International Journal of Communication* 9 (2015): 1848–60.

Lunbeck, Elizabeth. *The Americanization of Narcissism*. Cambridge, MA: Harvard University Press, 2014.

McKittrick, Katherine, ed. *Sylvia Wynter: On Being Human as Praxis*. Durham, NC: Duke University Press, 2015.

McMullen, Tracy. "The Improvisative." In *The Oxford Handbook of Critical Improvisation Studies*, vol. 1, edited by George E. Lewis and Benjamin Piekut, 115–27. New York: Oxford University Press, 2016.

Mercer, Kobena. *Welcome to the Jungle: New Positions in Black Cultural Studies*. New York: Routledge, 1994.

Mignolo, Walter D., and Catherine E. Walsh. *On Decoloniality: Concepts, Analytics, Praxis*. Durham, NC: Duke University Press, 2018.

Mirzoeff, Nicholas. *How to See the World: An Introduction to Images, from Self-Portraits to Selfies, Maps to Movies, and More*. New York: Basic, 2016.

Morse, Nicole Erin. "Authenticity, Captioned: Hashtags, Emojis, and Visibility Politics in Alok Vaid-Menon's Selfie Captions." *M/C Journal* 20, no. 3 (2017). https://doi.org/10.5204/mcj.1240.

Morse, Nicole Erin. "A Frown Turned Upside Down: Hypervisibility and Obscurity in Vivek Shraya's *Trauma Clown* (2019)." *Public* 62 (2021): 28–37.

Morse, Nicole Erin. "Pornography in Sex Research: The Construction of Sex, Gender, and Sexual Orientation." *Porn Studies* 2, no. 4 (2015): 314–28.

Morse, Nicole Erin. "Review of Ilan Stavans' 'I Love My Selfie.'" *b20: an online journal*, February 21, 2018. https://www.boundary2.org/2018/02/nicole-erin-morse -review-of-ilan-stavans-i-love-my-selfie/.

Morse, Nicole Erin. "Seeing Double: Visibility, Temporality, and Trans Feminine History in Transparent." *Jump Cut* 57 (2016). https://www.ejumpcut.org/archive /jc57.2016/-MorseTransparent/index.html.

Morse, Nicole Erin. "Trans* Cinematic Embodiment: Spectator and Screen." TSQ: *Trans Studies Quarterly* 7, no. 3 (2020): 524–26.

Morse, Nicole Erin. "The Transfeminine Futurity in Knowing Where to Look: Vivek Shraya on Selfies." TSQ: *Transgender Studies Quarterly* 6, no. 4 (2019): 659–66.

Morse, Nicole Erin. "Where Do Aliens Pee? Bathroom Selfies, Trans Activism, and Reimagining Spaces." In *Media Crossroads: Intersections of Space and Identity in Screen Cultures*, edited by Angel Daniel Matos, Paula J. Massood, and Pamela Robertson Wojcik, 21–33. Durham, NC: Duke University Press, 2021.

Morse, Nicole, and Lauren Herold. "Beyond the Gaze: Seeing and Being Seen in Contemporary Queer Media." *Jump Cut* 60 (2021). https://www.ejumpcut.org /currentissue/MorseHerold-BeyondGaze/index.html.

Moser, Charles. "Blanchard's Autogynephilia Theory: A Critique." *Journal of Homosexuality* 57, no. 6 (2010): 790–809.

Moten, Fred, and Stefano Harney. *A Poetics of the Undercommons*. New York: Sputnik and Fizzle, 2016.

Muñoz, José Esteban. *Cruising Utopia: The Then and There of Queer Futurity*. New York: New York University Press, 2009.

Muñoz, José Esteban. "'The White to Be Angry': Vaginal Davis's Terrorist Drag." *Social Text*, nos. 52–53 (1997): 80–103.

Murray, Derek Conrad. "Notes to Self: The Visual Culture of Selfies in the Age of Social Media." *Consumption Markets and Culture* 18, no. 6 (November 2015): 490–516.

Namaste, Viviane K. "Tragic Misreadings: Queer Theory's Erasure of Transgender Subjectivity." In *Queer Studies: A Lesbian, Gay, Bisexual and Transgender Anthology*, edited by Brett Beemyn and Mickey Eliason, 183–203. New York: New York University Press, 1996.

Neely, Sarah. "Making Bodies Visible: Post-feminism and the Pornographication of Online Identities." In *Transgression 2.0: Media, Culture and the Politics of a Digital Age*, edited by Ted Gournelos and David J. Gunkel, 101–17. New York: Continuum, 2012.

Nelson, Maggie. "Notes on a Visual Diary, Co-Authored." In *Relationship*, by Zackary Drucker and Rhys Ernst, n.p. New York: Prestel, 2016.

Nemer, David, and Guo Freeman. "Empowering the Marginalized: Rethinking Selfies in the Slums of Brazil." *International Journal of Communication* 9 (2015): 1832–47.

Nicholson, Nichole. "Tumblr Femme: Performances of Queer Femininity and Identity." *Carolinas Communication Annual* 30 (2014): 66–80.

O'Toole, Erin, ed. *April Dawn Alison*. London: MACK, 2019.

Pellicer, Raynal. *Photobooth: The Art of the Automatic Portrait*. New York: Abrams, 2010.

Pham, Minh-Hà T. *Asians Wear Clothes on the Internet: Race, Gender, and the Work of Personal Style Blogging*. Durham, NC: Duke University Press, 2015.

Pham, Minh-Hà T. "'I Click and Post and Breathe, Waiting for Others to See What I See': On #FeministSelfies, Outfit Photos, and Networked Vanity." *Fashion Theory* 19, no. 2 (2015): 221–41.

Plato. *Symposium*. Translated by Benjamin Jowett. Internet Classics Archive. http://classics.mit.edu/Plato/symposium.html.

Prosser, Jay. *Light in the Dark Room: Photography and Loss*. Minneapolis: University of Minnesota Press, 2005.

Prosser, Jay. *Second Skins: The Body Narratives of Transsexuality*. New York: Columbia University Press, 1998.

Puar, Jasbir K. *The Right to Maim: Debility, Capacity, Disability*. Durham, NC: Duke University Press, 2017.

Rancière, Jacques. *Dissensus*. London: Bloomsbury Academic, 2013.

Raun, Tobias. *Out Online: Trans Self-Representation and Community Building on YouTube*. New York: Routledge, 2016.

Rée, Jonathan. "Tummy-Talkers." *London Review of Books* 23, no. 9 (2001): 14–17.

Rich, B. Ruby. *New Queer Cinema: The Director's Cut*. Durham, NC: Duke University Press, 2013.

Ritchin, Fred. *After Photography*. New York: W. W. Norton, 2010.

Rodowick, D. N. *The Virtual Life of Film*. Cambridge, MA: Harvard University Press, 2007.

Rothblatt, Martine Aliana. *Virtually Human: The Promise—and the Peril—of Digital Immortality*. New York: Picador, 2015.

Ruti, Mari. *The Ethics of Opting Out: Queer Theory's Defiant Subjects*. New York: Columbia University Press, 2017.

Santana, Dora Silva. "Transitionings and Returnings: Experiments with the Poetics of Transatlantic Water." *TSQ: Transgender Studies Quarterly* 4, no. 2 (2017): 181–90.

Scarry, Elaine. *The Body in Pain: The Making and Unmaking of the World*. New York: Oxford University Press, 1985.

Schlossberg, Linda. *Passing: Identity and Interpretation in Sexuality, Race, and Religion*. New York: New York University Press, 2001.

Seid, Danielle M. "Reveal." *TSQ: Transgender Studies Quarterly* 1, nos. 1–2 (2014): 176–77.

Senft, Theresa M., and Nancy K. Baym. "What Does the Selfie Say? Investigating a Global Phenomenon." *International Journal of Communication* 9 (2015): 1588–606.

Serano, Julia. "The Case against Autogynephilia." *International Journal of Transgenderism* 12, no. 3 (2010): 176–87.

Serano, Julia. *Excluded: Making Feminist and Queer Movements More Inclusive*. Berkeley, CA: Seal, 2013.

Serano, Julia. "Reclaiming Femininity." In *Transfeminist Perspectives in and beyond Transgender and Gender Studies*, edited by A. Finn Enke, 170–83. Philadelphia: Temple University Press, 2012.

Serano, Julia. *Whipping Girl: A Transsexual Woman on Sexism and the Scapegoating of Femininity*. Berkeley: Seal Press, 2007.

Shaw, Jennifer. *Reading Claude Cahun's Disavowals*. Burlington, VT: Ashgate, 2013.

Shelley, Mary Wollstonecraft. *Frankenstein; or, The Modern Prometheus*. Project Gutenberg e-book. https://www.gutenberg.org/files/42324/42324-h/42324-h.htm.

Siebler, Kay. "Transgender Transitions: Sex/Gender Binaries in the Digital Age." *Journal of Gay and Lesbian Mental Health* 16, no. 1 (January 2012): 74–99.

Snorton, C. Riley. *Black on Both Sides: A Racial History of Trans Identity*. Minneapolis: University of Minnesota Press, 2017.

Snorton, C. Riley. *Nobody Is Supposed to Know: Black Sexuality on the Down Low*. Minneapolis: University of Minnesota Press, 2014.

Snorton, C. Riley. "Trapped in the Epistemological Closet: Black Sexuality and the 'Ghettocentric Imagination.'" *Souls* 11, no. 2 (2009): 94–111.

Snyder, Joel. "'Las Meninas' and the Mirror of the Prince." *Critical Inquiry* 11, no. 4 (1985): 539–72.

Solomon-Godeau, Abigail. "The Equivocal 'I.'" In *Inverted Odysseys: Claude Cahun, Maya Deren, and Cindy Sherman*, edited by Shelley Rice, 111–25. Cambridge, MA: MIT Press, 1999.

Sontag, Susan. *On Photography*. New York: Picador, 1977.

Spade, Dean. "What's Wrong with Trans Rights?" In *Transfeminist Perspectives in and beyond Transgender and Gender Studies*, edited by A. Finn Enke, 184–94. Philadelphia: Temple University Press, 2012.

Stavans, Ilan. *I Love My Selfie*. Durham, NC: Duke University Press, 2017.

Steinbock, Eliza. "Catties and T-selfies." *Angelaki* 22, no. 2 (2017): 159–78.

Steinbock, Eliza. *Shimmering Images: Trans Cinema, Embodiment, and the Aesthetics of Change*. Durham, NC: Duke University Press, 2019.

Steinbock, Eliza. "The Wavering Line of Foreground and Background: A Proposal for the Schematic Analysis of Trans Visual Culture." *Journal of Visual Culture* 19, no. 2 (2020): 171–83.

Steyerl, Hito. *The Wretched of the Screen*. Berlin: Sternberg, 2012.

Stiegler, Bernard. "Memory." In *Critical Terms for Media Studies*, edited by W. J. T. Mitchell and Mark B. N. Hansen, 64–87. Chicago: University of Chicago Press, 2010.

Stiles, Kristine. "Kicking Holes in the Darkness." In *Whitney Biennial 2014*, 56–61. New Haven, CT: Yale University Press, 2014.

Storr, Will. *Selfie: How We Became So Self-Obsessed and What It's Doing to Us*. New York: Overlook, 2018.

Stryker, Susan. "More Words about 'My Words to Victor Frankenstein.'" GLQ 25, no. 1 (2019): 39–44.

Stryker, Susan. "My Words to Victor Frankenstein above the Village of Chamounix: Performing Transgender Rage." GLQ 1, no. 3 (1994): 237–54.

Stryker, Susan, and Paisley Currah. "General Editors' Introduction." TSQ: Transgender Studies Quarterly 2, no. 4 (2015): 539–43.

Stryker, Susan, and Paisley Currah. "Introduction." TSQ: Transgender Studies Quarterly 1, nos. 1–2 (2014): 1–18.

Stryker, Susan, and Nikki Sullivan. "King's Member, Queen's Body: Transsexual Surgery, Self-Demand Amputation and the Somatechnics of Sovereign Power." In Somatechnics: Queering the Technologisation of Bodies, edited by Nikki Sullivan and Samantha Murray, 49–64. New York: Routledge, 2016.

Stryker, Susan, and Stephen Whittle, eds. The Transgender Studies Reader, Volume 1. New York: Routledge, 2006.

Sullivan, Nikki, and Samantha Murray, eds. Somatechnics: Queering the Technologisation of Bodies. New York: Routledge, 2016.

Sundén, Jenny. "On Trans-, Glitch, and Gender as Machinery of Failure." First Monday 20, no. 4 (2015). http://firstmonday.org/ojs/index.php/fm/article/view/5895/4416.

Sycamore, Mattilda Bernstein, ed. Nobody Passes: Rejecting the Rules of Gender and Conformity. Emeryville, CA: Seal, 2006.

Tiidenberg, Katrin. "Bringing Sexy Back: Reclaiming the Body Aesthetic via Self-Shooting." Cyberpsychology 8, no. 1 (2014): art. 3.

Tiidenberg, Katrin. Selfies: Why We Love (and Hate) Them. West Yorkshire, UK: Emerald, 2018.

Tompkins, Avery. "Asterisk." TSQ: Transgender Studies Quarterly 1, nos. 1–2 (2014): 26–27.

Tyler, Carole-Anne. "Passing: Narcissism, Identity and Difference." differences 6, nos. 2–3 (1994): 212–48.

van Dijck, José. "Digital Photography: Communication, Identity, Memory." Visual Communication 7, no. 1 (February 2008): 57–76.

Wang, Ruoxu, Fan Yang, and Michel M. Haigh. "Let Me Take a Selfie: Exploring the Psychological Effects of Posting and Viewing Selfies and Groupies on Social Media." Telematics and Informatics 34, no. 4 (2016): 274–83.

Warfield, Katie. "Making Selfies/Making Self: Digital Subjectivities in the Selfie." Paper presented at the Fifth International Conference on the Image and the Image Knowledge Community, Freie University, Berlin, October 30, 2014.

Warnke, Georgia. "Transsexuality and Contextual Identities." In "You've Changed": Sex Reassignment and Personal Identity, edited by Laurie Shrage, 28–42. Oxford: Oxford University Press, 2009.

Wiggins, Tobias B. D. "Encountering Inheritance in Vivek Shraya's I Want to Kill Myself." TSQ: Transgender Studies Quarterly 4, nos. 3–4 (2017): 668–74.

Zuromskis, Catherine. Snapshot Photography: The Lives of Images. Cambridge, MA: MIT Press, 2013.

Index

Instagram, 4; affordances of platform, 17, 46, 74, 94, 120, 122–23, 146n50; Alok Vaid-Menon, 86, 90, 93–94, 156n60; and art, 11, 142n37, 158n14; Che Gossett, 82–85; Shea Couleé, 104, 119–20

intersubjectivity, xi, 1, 5, 50, 72; *Relationship* series, 32, 35; in self-portraiture, 10–11; in self-representation, 6–10, 12, 21

Israni, Nish, 90

Jackson, John L., Jr., 88

Jenner, Caitlin, 136–37

Johnson, Marsha P., 75–76, 84, 116, 153n9

Jones, Zinnia, 19–20; and Nebulous Persona, 70–72, 99–103, 151n62, 159n23; and "NSFW" selfies, 56–64; and posthumanism, 65–68; and selfies, 2, 51–53, 148n26; and "TERFs," 68–69

Kafer, Gary, 16

Keegan, Cáel M., 14, 26, 42, 48, 81, 149n33

Keeling, Kara, 49, 78, 117, 155–56n53

Kenaan, Hagi, xi

Kennedy, Satana, 58. *See also* doppelgängers; Jones, Zinna

Khan, Duriba, 89–90

King, Homay, 122

Koerner, Joseph Leo, 10

Koyama, Emi, 4

Kracauer, Siegfried, 15

Kyri, Daniel, 42

Lacan, Jacques, 18–20, 25–26, 31, 34–35, 145n31. *See also* mirror(s)

Latimer, Tirza True, 9

Lavery, Grace, 26

Levinas, Emmanuel, xi–xii, 145n31

Lipstick City, 117–23, 134, 161n17

McMullen, Tracy, 20, 55–56, 147n1. *See also* improvisative

McNamara, Lauren, 52. *See also* Jones, Zinnia; Kennedy, Satana

Merlo, Marina, 30

mirror(s), viii, xiii, 4, 7–8, 10–11, 24, 28–30, 34–48, 59, 65, 124, 141n23, 146n50, 146–47n52; mirroring, 6, 10, 25, 30–34, 40, 43, 144n2, 145n32; mirror scene (in trans representation), 26, 41–42, 49; mirror stage (psychoanalysis), 20, 25–26, 31, 34–41, 49, 144n10, 145n31

mise en abyme, xiv, 19–20, 25–26, 28, 31, 33, 40–43, 46–49

Mock, Janet, 136, 148n29

Moore, Marcel, 7–9, 11, 141n23

Moten, Fred, 74–75, 82, 153n6

Muñoz, José Esteban, 86, 116–17, 122–24, 160n8

narcissism, as allegory for selfies, vii, ix, xi, 1, 5, 139n1, 139n4; and misogyny, ix, 3, 10, 99; in myth, vii–ix; and temporality, 49

Narcissus, vii–xiv. *See also* echo

Nebulous Persona, 70–72, 101–3, 151n62, 159n23

Nelson, Maggie, 100

Nothing, Ehn, 75

Paris Is Burning, 79

performance, contrasted with performatives, 54, 56, 79; drag and queer performance spaces, 54–55, 119–23, 147–48n12, 160n8; as formal technique, 89–94, 103–4; of the self, 11, 58, 73; and Susan Stryker, x–xi, xiii–xiv

performatives, 54–56, 59, 79–80

performativity, 20; and Blackness, 78–80; in relation to power, 59, 147n1, 147n7; theory of gender, 51, 53–56, 73, 80; and visibility, 85–86; and whiteness, 77

Phạm, Minh-Hà T., 99

politics of respectability (or respectability politics), 58, 64, 76, 78, 80, 86. *See also* Higginbotham, Evelyn

pornography, 64, 151n59

posthumanism, xi, 56, 65–67, 149–50n43. *See also* cyborgs; Haraway, Donna; Hayles, N. Katherine; Foster, Thomas

Puar, Jasbir K., 114, 117, 158n11, 160n12

queer theory, 1, 55, 72, 82; and performativity, 51, 80; and resistance, 77; and temporality, 98; and trans as figure of fluidity, 12–13, 15, 20, 26, 42, 80, 113–16

Raun, Tobias, 99, 149n33

reflection, as formal technique, 7, 10–11, 19–20, 25, 29–30, 38–41, 59, 65, 141n23; in *Frankenstein*, vii–viii, xii; mirror stage, 26, 31–34, 145n31; and mise en abyme, 40–49; in Narcissus myth, vii, xii

Relationship (self-portraiture series), 23–26, 31–41

reveal, trope of. *See* genitalia

Rich, B. Ruby, 97

Ritchin, Fred, 115

Rivera, Sylvia, 29, 75

Rodowick, D. N., 14

Ruti, Mari, 13, 56, 79, 103, 160n12

Salacia, 29, 116

Santana, Dora Silva, xiii, 49

self-portraiture, vii, 4, 19; intersubjectivity of, 8–10, 12, 30–32, 43, 141n23; *Relationship* series, 23, 25, 31; and trans identity, 27–28, 52, 149n33; *Trisha* series, 123, 128–30

self-representation, 1–9, 100, 139n1; agency and, 50, 56–58, 64, 70–72, 95, 111, 113; intersubjectivity of, 12, 84, 130; self-constitution and, 31, 49, 103, 106; self-marketing and, 97–99; and technology, 17–18; by trans people, 19–20, 49, 97, 115, 157n5; and trans futurity, 118–19; and trans realism, 26–28; and visibility politics, 75–76, 95, 136–37

Senft, Theresa M., 5

Serano, Julia, 2, 55, 47n11, 151n59, 157n3, 158n19

seriality, 2, 5, 20; and improvisation, 17; and visibility politics, 85–95

series: *Relationship*, 23–24, 31–42; of selfies, 17, 20, 59, 76–77, 82–85, 95; vlogs by Contrapoints, 106–12; *Trisha*, 128–35

sex work, 4, 29, 58, 64, 79, 153–54n9

shadows (formal technique), 19, 24–25, 32–33, 40, 49, 144n2

Sherman, Cindy, 11, 98, 130, 141n26, 142n37, 158n14, 162n40

Shraya, Vivek, 19, 21, 25; *Holy Mother, My Mother*, 124–28; *I Want to Kill Myself*, 161n25; and mirroring 41, 43–46; and selfies, 17–18, 21, 27, 49; *Trauma Clown*, 154n21; *Trisha*, 117, 123–24, 128–35, 161n30, 162n35

Snapchat, 46

Snorton, C. Riley, 78, 81, 87, 98, 143n48, 158n11

social media, xiv, 2, 17, 18; archival fragility of, 53, 64; capitalism, 98–99; constructing relationships, 2, 58, 67, 119, 123; intellectual labor and, 82, 86; network aesthetics of, 121–22; as performance space, 122–23; technical capacity of, 95, 96; temporality of, 96–98, 100, 114, 117–20, 122–23, 135; relative time markers on, 120; and visibility politics, 75. *See also* Facebook; Instagram; Snapchat; Twitter; YouTube

Sontag, Susan, 50, 143n64

speculative archives, 21, 115–18, 124, 128, 130, 133, 135. *See also* Field, Allyson Nadia

Steinbock, Eliza, 1, 5, 14, 76, 146n50

Steyerl, Hito, 16–17, 37–38

Street Transvestite Action Revolutionaries (STAR), 75

Stryker, Susan, x–xiv, 14, 27, 115, 140n12, 149–50n43

surveillance, 16, 77, 143n64, 152n1

Sycamore, Mattilda Bernstein, 91

Talusan, Meredith, 35, 145n32

Taylor, Mya, 76, 80–81

temporality, 2, 19–21, 32, 49, 91, 96–104, 106, 108–9, 114–23, 128, 134–35; linear, 97, 100, 128; nonlinear, 2, 5, 19–21, 35, 68, 96–101, 104, 114–23; queer temporality, 21, 98, 114, 117; selfie temporality, 20, 96–99, 135

TERF (trans-exclusionary radical feminist), 68–69. *See also* feminism

Tourmaline, 19, 25, 29; and controversy with David France, 76, 83–85, 153–54n9; and doubling, 28–30, 41, 46–49, 83, 146n50; *Salacia*, 29, 116, 145n18; *Trap Door*, 76; and visibility politics (as Reina Gossett), 78. *See also* Gossett, Reina

trans conspiracy, 74–75, 82

trans exceptionalism, 13–14

transmisogyny, 2, 16, 64, 68–69, 81

transnormative, 13, 158n11

trans of color critique, 3, 20, 75, 77–81, 124, 158n11

transphobia, 27, 54, 81, 107